EDWARD LEAR

EDWARD LEAR

LANDSCAPE PAINTER

AND

NONSENSE POET

(1812-1888)

by

ANGUS DAVIDSON

NEW YORK

BARNES & NOBLE, Inc.

PUBLISHERS AND BOOKSELLERS SINCE 1873

First Edition 1938
Reprinted 1968

© *Preface Angus Davidson 1968*

First published in the United States, 1968
by Barnes & Noble, Inc.
New York, New York

Printed in Great Britain

CONTENTS

ILLUSTRATIONS

PREFACE

FOR over a hundred years Edward Lear has been famous as a writer of limericks and other 'nonsense' songs and stories, which are still loved by the children of today (and not only by children) and have become a household word throughout the English-speaking world. He has also been known, in a lesser degree, as a brilliant illustrative draughtsman, remarkable for precise scientific knowledge and observation, of parrots and other birds, and, to a limited public, as the painter of large and rather rigid topographical landscapes which were generally worked out later from the water-colour sketches he made on his travels. Indeed, from the professional point of view, it was a 'topographical landscape-painter' that Lear considered himself to be.

His travels have brought him a further measure of fame. He visited India and Ceylon, Egypt and Arabia and Asia Minor, Syria and Palestine and Corsica; he explored Italy from end to end; but it was Greece, whose 'divinest beauty' enchanted him from the first, that remained always the country he loved best. These journeys were often made under conditions of formidable discomfort, sometimes of danger, and the sketches and journals which resulted from them were produced under great difficulties. His versatility and his industry were phenomenal. Some of these travel journals have been recently republished. And since this book first appeared, the water-colour landscapes have come to be more and more highly appreciated; they are now much sought after and fetch high prices.

There were two influences upon Lear's painting, one un-
natural to him and almost wholly bad—the Pre-Raphaelite
influence which his exaggerated veneration for his friend
Holman Hunt imposed upon the large oil paintings; and the
beneficent influence, upon his water-colours, of the earlier
work of Turner, whom he also deeply admired. The big oils,
competently painted as they are—in parts, at any rate, for he
was apt to include groups of somewhat wooden figures in his
foregrounds, and figure-painting was not his forte—were
formal, accurate illustrations of carefully chosen ' views.' In
the water-colours, however, he was creating, not copying;
they were painted for his own pleasure or as studies for his
larger works, and here he could be wholly himself and could
evolve a true personal style. Draughtsmanship remained his
chief concern; and his line is always supple and expressive.
His sense of space, his feeling for the ' bones ' of a landscape
and the sculptural forms of mountains are entirely individual.
His colour, too, is delicate and subtle, playing an essential
though secondary part in the design.

Lear's genius—for genius he undoubtedly had—showed
itself in two forms, his ' nonsenses ' and his water-colours.
These latter, whose excellence has taken a long time to be
recognized, are worthy descendants of the great tradition of
19th-century English water-colour painting, of Turner, Girtin
and De Wint.

ANGUS DAVIDSON, 1968

ACKNOWLEDGMENTS

My acknowledgments and thanks are due to the following:

To Mr. Franklin Henry Lushington, Lear's literary representative, for his kind permission to quote from Lear's unpublished writings.

To Mrs. Bowen (*née* Gillies), Lear's great-great-niece, for the loan of unpublished papers, photographs, etc., in the possession of the Gillies family, and for her generous help.

To Mr. William B. Osgood Field, for permission to quote from the Lear diaries in his collection and from his own book *Edward Lear on My Shelves*.

To Lord Strachie and Messrs. Ernest Benn, for permission to quote from *Letters of Edward Lear* and *Later Letters of Edward Lear*, edited by the late Lady Strachie, and to Lord Strachie for permission to quote from the late J. St. Loe Strachey's foreword to *The Lear Coloured Bird Book for Children*. Also to Mr. Henry Strachey—who actually knew Lear personally—for his kind interest and help.

To the Tennyson Trustees, for the loan of Lear's letters to, and from, Tennyson and Lady Tennyson.

To Lord Northbrook, for the loan of Lear's unpublished journals of his tour in India and Ceylon.

To the family of the late Canon C. M. Church, Sub-Dean of Wells, for the loan of Lear's unpublished journals of his tours in Greece.

To Mr. Cyril Drummond, for the loan of Lear's letters to his father, Edgar Drummond, and to his uncle, Captain Alfred Drummond.

To Mrs. Biggins, for the loan of Lear's letters to her father, F. T. Underhill; and to Mrs. Tuck Powell, Miss Rolleston, the Misses Jeffery Edwards, Miss Wyatt, Mr. Arthur Jaffé, Mrs. Walthall, and Professor Holbrook Jackson, for the loan of letters and drawings.

To the Librarian, Windsor Castle, for permission to quote passages from Queen Victoria's diary.

To Mrs. Ralph Partridge, for permission to include the unpublished fragment entitled ' The Children of the Owl and the Pussy-Cat '; and to Mr. H. F. B. Sharp, for the hitherto unpublished verses of ' The Pobble.'[1]

To Mrs. David Gourlay, for allowing me to reproduce a number of drawings made by Lear for her aunt Janet Symonds, daughter of John Addington Symonds.

To all the owners, acknowledged in the List of Illustrations, for their kind permission to reproduce the Edward Lear paintings; and to Messrs. Thomas Agnew for their most valuable help.

To Mrs. Winthrop Chanler, for permission to quote from *Roman Spring*; to Mr. Charles Graves and Messrs. Macmillan, for permission to quote a letter and reproduce a drawing from Mr. Graves' *Life and Letters of Sir George Grove*; to Messrs. Macmillan also for permission to quote from *Pre-Raphaelitism and the Pre-Raphaelite Brotherhood*, by W. Holman Hunt, from *Tennyson: a Memoir, By His Son*, and from *Macmillan's Magazine*; to Messrs. Hodder and Stoughton, for permission to quote from *Mid-Victorian Memories*, by R. E. Francillon, and from *The Life of Lord Cromer*, by the Marquess

[1] This permission had been given me by Mr. Sharp before his death: the MS. is included in his collection which has now been presented, as a permanent memorial, to the National Library of Scotland.

ACKNOWLEDGMENTS

of Zetland; to Messrs. Heinemann, for permission to quote from *Punch and Judy and Other Essays*, by Maurice Baring; and to Messrs. Jonathan Cape, for permission to quote a short passage from Doughty's *Travels in Arabia Deserta*.

" *How pleasant to know Mr. Lear !* "
 Who has written such volumes of stuff !
Some think him ill-tempered and queer,
 But a few think him pleasant enough.

His mind is concrete and fastidious,
 His nose is remarkably big ;
His visage is more or less hideous,
 His beard it resembles a wig.

He has ears, and two eyes, and ten fingers,
 Leastways if you reckon two thumbs ;
Long ago he was one of the singers,
 But now he is one of the dumbs.

He sits in a beautiful parlour,
 With hundreds of books on the wall,
He drinks a great deal of Marsala,
 But never gets tipsy at all.

He has many friends, laymen and clerical,
 Old Foss is the name of his cat ;
His body is perfectly spherical,
 He weareth a runcible hat.

When he walks in a waterproof white,
 The children run after him so !
Calling out, " He's come out in his night-
 gown, that crazy old Englishman, oh ! "

He weeps by the side of the ocean,
 He weeps on the top of the hill ;
He purchases pancakes and lotion,
 And chocolate shrimps from the mill.

He reads but he cannot speak Spanish,
 He cannot abide ginger-beer :
Ere the days of his pilgrimage vanish,
 How pleasant to know Mr. Lear !

<div align="right">EDWARD LEAR.</div>

CHILDHOOD AND YOUTH

ON the evening of May 12th, 1820, a little boy of eight years old sat at one corner of the long table in the dining-room of his home at Highgate. To-day was his birthday and, instead of having supper with his younger sister in the nursery, for the first time he had been allowed a glimpse into the mysterious grown-up life that went on downstairs after his usual bed-time. He was a plain little boy, with a nose too large for his pale face and small eyes which, though short-sighted, were twinkling and very observant as he sat there quietly watching the long row of his brothers and sisters down each side of the table. His sisters—nine of them, varying in age from twenty-nine to fourteen—were dressed demurely, all alike, in white, with pale blue bows, and his brothers, too, were all in correct evening dress, for their father was very particular about such matters. The boy, over-excited, sat almost without speaking, feeling a little disturbed at the unfamiliarity of the familiar room ; but his eyes, wandering hither and thither, watching every movement of the company round the table and of the footmen as they served dishes or poured wine, kept turning back instinctively, as though for security and comfort, to the sister he loved best, who sat beside him. Ann, the eldest of that large family, mattered to him more than any of them : it was she, twenty-one years older than himself, who had always looked after him ; and when the attacks of the ' Terrible Demon ' (as he called it later in his diaries), which

EDWARD LEAR

was to pursue him all through life, and which had so pro-
found an effect on his character, began to come upon him
soon after his seventh birthday, it was always Ann, rather
than his mother, whom he wanted to be with him.

The boy loved this large, comfortable house where he had
been born—Bowman's Lodge it was called : it has long since
been destroyed—that stood pleasantly among gardens and
trees at the edge of the quiet village and looked out from the
top of its steep hill over all London spread beneath it. To
it his earliest, and some of his happiest, memories were attached
—such as being wrapped in a blanket and taken out of bed to
see the illuminations after the Battle of Waterloo, when he
was three years old. Here, preferring his own occupations to
the noisy games of his numerous brothers and sisters, he
loved to pore over picture-books of birds and animals and
plants ; and here, in the big 'painting-room,' his favourite
room in the house, his first efforts in drawing and painting
were made under the instruction of his gifted sister Sarah.
In the afternoons he would often go for a drive through the
country lanes about Highgate with his mother or his sister
Ann, in one of the twelve carriages that were kept for the
use of the family : if it was with Ann, they would stop the
carriage and look for flowers, and she would tell him their
names and the names of the birds they saw.

Every morning little Edward and his younger sister Cather-
ine would wave from the nursery window to their father as
he drove away to his business in the City. Mr. Lear was a
wealthy stockbroker, but, apart from producing and supporting
his children and ruling his household with strict discipline,
he meant little to his family, or they to him. Perhaps there
were too many of them. His weekdays were spent at his
office, his Sundays at work in the blacksmith's forge which

2

he had installed at the top of the house, where none of his daughters was ever allowed to penetrate. Jeremiah Lear's family was of Danish origin, but his father had become a naturalized Englishman and had changed his name from Lør to Lear. 'My Danish Grandfather,' says Edward Lear, 'picked off the two dots and pulled out the diagonal line and made the word Lear (the two dots and the line and the O representing the sound—ea). If he threw away the line and the dots only he would be called *Mr. Lor*, which he didn't like.' (And if the Danish grandfather had happened to combine a knowledge of Greek with an ability to read the future, he could hardly have chosen a more suitable surname for the most distinguished of his grandchildren—for the Greek word λῆρος means nothing more nor less than 'nonsense.') Jeremiah Lear was born in 1757 : in 1788 he met and fell in love with Miss Ann Skerrit, whose father was a sea-captain and whose family belonged to Durham. She was barely nineteen and still at school, but, not to be thwarted, they ran away together and were married at Wanstead Church in Essex—an elopement which, however rash, turned out successfully, for she bore him twenty-one children in twenty-five years and they remained a devoted couple.

<div align="center">*　　*　　*　　*　　*</div>

But the comfort and security of this pleasant family life were to be rudely shattered before many years had passed, for, when Edward was thirteen, financial disaster descended suddenly upon his father, and the brothers and sisters who had sat round the dinner-table five years before were scattered, many of them never to meet again. It seems that Mr. Lear had become involved, beyond hope of re-establishing himself, in unfortunate speculations, and one day, while he was away in the City, the bailiff put in his appearance at Highgate.

<div align="center">3</div>

The family was ruined : Mr. Lear, instead of returning home, was lodged in the King's Bench Prison. Mrs. Lear's position —with a large household, numbers of servants, and fifteen children on her hands (six of the twenty-one had died in infancy)—was such as to dismay even the most dauntless heart. But she was a woman of courage and resource, and she rose bravely to the occasion. She sold Bowman's Lodge, the horses, the twelve carriages and the furniture, including many of her own possessions, dismissed the servants, and moved her sorrowing and crestfallen family into London. The youthful Edward wrote an *Eclogue* in the manner of Collins' *Hassan, or the Camel-Driver*, to celebrate this melancholy event :

> *In dreary silence down the bustling road*
> *The Lears, with all their goods and chattels, rode ;*
>
> ★ ★ ★ ★ ★
>
> *With grief heart-rending then, those mournful folk*
> *Thrice sighed, thrice wiped their eyes, as thus they spoke :*
> *" Sad was the hour—and luckless was the day*
> *" When first from Bowman's Lodge we bent our way ! "*

The ' mournful folk ' took up their abode in ' horrid New Street,' within reach of the prison where their father languished. But it appears, on the whole, that Mr. Jeremiah Lear had the best of it during the years that followed. His devoted wife allowed him to want for nothing : every day she visited him, bringing with her ' a full six-course dinner, with the delicacies of the season.' It was the children who suffered. The girls were sent out into the world as governesses and companions, and these handsome, well-educated, accomplished young women, brought up with every comfort and refinement, were unable to withstand the hardships of

4

their new life. One after another succumbed within the next few years ; four of them died within four months. In the meantime Mrs. Lear, having disposed as best she could of her children, devoted herself, not merely to visiting her husband and taking him his dinner, but also to the less congenial undertaking of paying off his debts. In this, after prolonged efforts and economies, she was at length successful : after four years every claim had been settled, and Jeremiah Lear was released. They retired to live quietly at Gravesend, where he died four years later. Mrs. Lear removed to Dover, where she died and was buried in 1844.

Only three of the daughters—Sarah, Mary and Eleanor—succeeded in getting married and thus escaping a life of drudgery and dependence. Sarah's marriage was due to a curious accident. Her father, walking one day in the City (before the period of his misfortunes), had seen, outside the door of an office, a plate with 'Jeremiah Lear' inscribed upon it, and, struck by the odd coincidence of the repetition of his own peculiar name, had entered and made the acquaintance of his namesake. A friendship sprang up between the two Lear families (who were unrelated), and it was while staying with these new friends in Sussex that Sarah met her future husband, Charles Street. They lived for many years at Arundel : after his death she went out to New Zealand with her son and his wife and their little daughter Emily, who later became Mrs. Gillies ; and there some of her descendants are still living. She was the only one of the sisters to have any children. Mary, who married only to escape misfortune, was unfortunate in her husband, Richard Boswell—'poor Mary's unpleasant husband' as her brother Edward called him. He was an eminent amateur naturalist who cared for nothing but his own interests and comforts, and they were

5

not happy. Many years later, when they were both already over sixty, they followed Sarah to New Zealand and lived for two years in a hut in the Bush, which they built with their own hands : but that too was an unlucky venture, and Mary Boswell died at sea on the way home. Eleanor was more successful. She married William Newsom, a director of the Bank of England ; they lived prosperously at Leatherhead, where she died, at a ripe old age, in 1885.

The two eldest sons, Henry and Frederick, were twenty-seven and twenty at the time of their father's bankruptcy. Accustomed to wealth and idleness and a gay life, they felt the family misfortunes so keenly that they decided it was impossible to remain in England. Leaving their mother and sisters to help their father, they therefore departed to the United States, Henry to New York, Frederick to Springfield, Missouri. Both married and had large families ; both were unsuccessful and made constant demands on their brother Edward, and on Ann and Eleanor. The next brother, Charles, went as a Medical Missionary to West Africa. His activities there having been cut short by a serious attack of malaria, he was placed on board ship for England ; but at the last moment the captain refused to take him without a nurse. Adjouah, the native girl who had been attending him, immediately offered her services, but Charles, for propriety's sake, ill as he was, insisted upon marrying her : so the captain performed the necessary ceremony and they proceeded forthwith to England. On arrival they went to Leatherhead, to Charles's sister Mrs. Newsom, who—though she must have been somewhat surprised—received her brother and his black wife kindly. Adjouah, though her manners, in Early Victorian Surrey, were unconventional—she astonished her new relations by pouring the contents of her bedroom jug

6

over her head—was of a lovable nature, and they soon grew very fond of her ; she was sent to school for three years, while Charles, recovered from his illness, returned to the Mission Field, and shortly afterwards died there. Adjouah, her education completed, also became a missionary and returned to West Africa to work amongst her own people.

* * * * *

When her father was ruined and the home at Highgate broken up, the eldest daughter, Ann, was saved from the dreary fate of her sisters by the fortunate fact of having a small income of her own, for her grandmother, Florence Skerrit, had left her £300 a year. There had always been a close bond between her and her small brother Edward, twenty-one years younger than herself ; his upbringing and the charge of his health, since his earliest childhood, had been her especial province, and he rewarded her loving care with a respectful and lifelong devotion, regarding her more as a mother than a sister. She was a woman who combined strict principles and a considerable force of character with a great sweetness of nature : in appearance she and her brother Edward (except for his spectacles and, later, his beard) strongly resembled each other. In the years to come, whenever Edward was away from England—and a very large part of his life was spent abroad—he wrote her long, detailed letters, at least once a fortnight, with the most scrupulous regularity. These letters, full of tenderness and affectionate teasing, are those of a devoted and dutiful son who wishes to spare his mother all worry and anxiety. Discomforts and disasters—such as a minor railway accident in which he was involved—illnesses, financial difficulties, and his frequent attacks of acute depression, are minimized or ignored altogether ; but he tells her every practical detail of his life, describing all his move-

7

ments, the rooms in which he is living (with little plans at-
tached), his domestic troubles, and the person he sat next
to at dinner. These letters continue up to the time of Ann's
last illness and death in 1861. ' She brought me up from the
leastest childhood,' he wrote to Lady Tennyson at that time,
' and when she goes, my whole life will change utterly . . .
She has always been as near to Heaven as it is possible to be.'

On more than one occasion, even before the family was
scattered, Ann had taken Edward for long periods to Margate
for the sake of his health. To him, these journeys brought
a satisfaction deeper than he could then understand. Alone
with his dear Ann, to whom he could confide his troubles
and who alone could comfort him in his sicknesses, away from
the bustle and noise of family life at Highgate—which, though
he loved the place, sometimes laid too great a strain on his
excitable nerves—in these visits to the seaside he found a
respite and a joy. And at Margate there were plenty of
interesting things to look at. He had made friends with a
Mr. Cox, who had a hawk, and there were the windmills,
and the boats, and—as he reminded Ann thirty years later—
' the chimney-sweep you so *cruelly made* me walk round and
round to be sure he was not smoking. Shocking ! My
imperfect sight in those days—ante spectacled—formed every-
thing into a horror.' But imperfect sight was not the only
disability from which he suffered. There were already signs
of the chronic complaints which made so many years of his
life a continual, bitter struggle against ill-health, and which
later made residence in England, in the winter at least, im-
possible for him—bronchitis and asthma. It was for these,
no doubt, that the air of Margate was prescribed. And
there was the other more terrible, more insidious infirmity
which pursued him through life from the age of seven

onwards, that strange infirmity which has so often been the concomitant of genius—epilepsy. He never alludes to this in his letters to Ann or to his most intimate friends : it is only in his private diaries that he speaks of it. Sometimes he uses the word ' epilepsy ' ; generally he refers to it as ' the Demon,' or ' the Terrible Demon.' ' I suppose the ever-presence of the Demon,' he writes, ' since I was seven years old, would have prevented happiness under any sort of circumstances. It is a most merciful blessing that I have kept up as I have, and have not gone utterly to the bad mad sad.' Even in childhood the early knowledge that he was different from other children made its mark upon him. Ill at ease in the presence of strangers, he had formed a habit of retiring into himself, of finding his own private interests and amusements : his infirmity produced fits of quite un-childish depression ; it also produced a kind of gentleness, and an understanding and consideration of the feelings of others which were to become an important part of his character. The difficulties of his own childhood impressed upon his memory the essential qualities of childhood, so that he was always able to understand and be at ease with children—with the result that all children were at ease with him and loved him instinctively. " Comme il est charmant, ce monsieur, avec ses beaux yeux de verre ! " exclaimed a little girl in Corsica, many years later. " Que vos grandes lunettes vous donnent l'air d'un grand hibou ! " And there was another child who recalled, in later life, the impression made upon him. " I remember perfectly the towering, bearded, spectacled man standing in the drawing-room at Sutton Court, and talking in a way which made one feel at once that he was ' all right,' that is, on the side of the angels—or, as we should probably have expressed it then, the demons—of the nursery and the

schoolroom, and in no possible sense a member of the grown-up Opposition. I cannot remember a single word of what he said. There only remains a general, but very strong, pervading sense of well-being and innate rectitude from the standpoint of eight years old. I knew he was ' safe ' and that I was safe and that we were all safe together, and that suspicion might at once be put aside." [1] And it was this ability to enter into the minds of children that made it possible for him to write the *Nonsense Books*, for he remained always, himself, something of a child.

The exact form of the disease from which Lear suffered he does not specify—it was probably the type known as the ' petit mal ' : that its attacks were frequent—sometimes as many as eighteen in a month, and generally in the early morning or late evening—is shown by the crosses with numbers which he used in his diaries to indicate them. This malady, on the other hand, seems to have interfered singularly little with his work or his social activities : perhaps, even, his remarkable energy, his restless passion for work, may have been in some degree attributable to his unsettled nervous condition. That he felt it an almost intolerable burden there is no doubt : it is equally certain that his whole subconscious life was coloured by it, and that it was largely responsible for the deep melancholy which constantly beset him and for those fits of irritability of which no one was more guiltily conscious than himself. His undaunted courage in facing his disabilities, his perseverance in undertakings that would have broken the spirit of far stronger men, were signs of a character which—apart from its other aspects of lovableness and whimsicality—contained much of unyielding strength, something of greatness.

[1] J. St. Loe Strachey : foreword to *The Lear Coloured Bird Book for Children.*

Chapter II

BIRDS, ANIMALS, AND LIMERICKS

When the Lear family was scattered, it was natural that Ann, being herself independent, should take complete charge of Edward ; and thenceforward his upbringing and education lay entirely in her hands. His mother, preoccupied with her own and her husband's affairs, faded gradually into the background, and the beloved elder sister—herself old enough to be his mother—took her place. Of education (in the ordinary sense of going to school) he received but little—a lack which he sometimes deplored later in life. All his teaching came from Ann, who wisely preferred to keep the delicate child under her own careful supervision : the roughness of school life, for a boy with such physical disadvantages, might have had disastrous consequences. Left to develop very much along his own lines, he spent much time in studying books of natural history, in writing poetry, and, above all, in drawing and painting. His early poems, though they show a certain ear for rhythm, are mostly the characteristic effusions of adolescence, many of them in the Byronic-romantic manner then in vogue :

> *Aegina ! with the dead*
> *Thy fame hath perishèd !*

There are also journals and letters in verse (one of the latter, dated January, 1826, and addressed to Ann on her birthday, consists of over a hundred lines, every one terminating in a

11

word ending in -ation—no mean feat of ingenuity for a boy not yet fourteen), and a few comic poems which, though themselves of no outstanding merit, begin to suggest the Nonsense poet of later days.

His drawing, however, he took more seriously, and at fifteen he was already beginning to earn his living by it. 'I began to draw, for bread and cheese, about 1827,' he tells us, ' but only did uncommon queer shop-sketches—selling them for prices varying from ninepence to four shillings : colouring prints, screens, fans ; awhile making morbid disease drawings, for hospitals and certain doctors of physic.' He stayed frequently at this time with his sister Sarah Street at Arundel, and with other friends in that neighbourhood, including the other Lear family. When in the country he would occupy himself in making minutely detailed drawings of birds, butterflies and flowers, and it was the fine perfection of his technique in this type of work which was soon to obtain him his first regular employment. He and Ann were living in London, and by the time he was eighteen years old he was already taking pupils. And soon he was to be given his first great opportunity, when, through the offices of a friend, the Zoological Society engaged him to make drawings of the parrots at the Zoo in Regent's Park : this was his first regular commission, and he and Ann moved to Albany Street in order that he might be nearer his work.

The fruits of his labour appeared in a noble folio volume entitled *Illustrations of the Family of Psittacidae*, with forty-two lithographic plates—the first complete volume of coloured drawings of birds on so large a scale to be published in England. All his life Lear had a particular horror of noise ; yet the sufferings he must have undergone during that year in the Parrot House do not seem in any way to have affected the delicate

accuracy and beauty of his drawings. They are more than mere illustrations of parrots ; minutely exact in every detail of plumage and colouring, exquisitely fine in drawing, they display the precise knowledge of a naturalist joined with the perception and decorative sense of an artist. Lear's reputation as a draughtsman of natural history subjects was made, and his work at once drew the attention of such eminent zoologists as Dr. John Edward Gray of the British Museum, Professors Bell and Swainson, and Sir William Jardine. (Professor Swainson, alluding to one of the parrot drawings, wrote to Lear : ' The red and yellow macaw . . . is in my estimation equal to any figure ever painted by Barrabaud or Audubon, for grace of design, perspective, or anatomical accuracy.') During the next two or three years he was employed by Dr. Gray to make the plates for his volume entitled *Tortoises, Terrapins and Turtles* (which was not published till 1872). He also made drawings for Bell's *British Mammalia,* and for some of the volumes, including those on parrots, monkeys and cats, of the *Naturalist's Library,* of which the editor was Sir William Jardine. To John Gould, the famous ornitho-logist, he was already known. Gould had employed him to make drawings for his *Indian Pheasants, Toucans* and *Birds of Europe,* and they had travelled together to Rotterdam, Berne, Berlin and other places, in the course of their collaboration.

But Lear's drawings of parrots were to have a result of far greater ulterior importance than these commissions, useful and flattering though they were. A very fine collection of animals and birds had been brought together by the 12th Earl of Derby, a keen naturalist, who had formed a unique private menagerie at his country house, Knowsley Hall, near Liverpool. Lord Derby was now contemplating the publi-cation of a book to illustrate his collection, and was casting

about for some suitable artist to undertake the work. Naturally enough, he applied to Dr. Gray of the British Museum, and Dr. Gray mentioned the name of Edward Lear as that of a promising young draughtsman who was at the moment in the employment of the Zoological Society. Lord Derby went off to the Zoo and watched Lear at work there on his parrot drawings, with which he was so much impressed that he introduced himself and engaged him on the spot to come and draw for him at Knowsley. This was the beginning of Lear's connection with the Stanley family, who were close friends and generous patrons to him all his life. Fifty years later he wrote to another eminent naturalist, Sir John Lubbock (our fathers were brought up on his learned treatises, with their characteristic moral bias, concerning the busy bee, the wicked wasp, the exemplary ant) : ' Lord Derby is always employing me in one way or another, as did his father, his grandfather, and his great-grandfather. Fancy having worked for 4 Earls of Derby ! '

The parrots finished and published, Lear went to Knowsley, and though he and Ann kept on the rooms in London he spent most of the next four years at Lord Derby's house in Lancashire. Knowsley was, for him, the entrance to a new world, and the years that he spent there changed his whole outlook on life, for he found friends and patrons whom it is unlikely that he would ever otherwise have met. It is a significant fact, and one which testifies to the naturally lovable qualities in Lear's character, that, throughout his life, his best patrons remained his greatest friends. He had the knack of endearing himself to people of all sorts, irrespective of rank or age : for he possessed the indefinable but priceless gift of charm—and this in spite of his appearance, which was not altogether in his favour, for he had few of the outward

qualities by which a young man of twenty is commonly considered attractive. The extreme short sight of his small, peering eyes, which necessitated the use of strong spectacles and caused a slight stoop in his tall figure, accentuated in later years ; his large and rather shapeless nose ; and a colour which, even at this age, cannot have been improved by constant ill-health—these combined to make him absurdly sensitive about his physical appearance, which he considered to be ' more or less hideous.' But there was a twinkle in the short-sighted eyes, a humorous sensitiveness in the mouth, which were of more service to him than the most classical of noses could have been. When he arrived at Knowsley as a humble and unknown artist he was a figure of very little importance in the vast and complex organization of the great house, which was a sort of small town in itself : he came as an employee rather than as a guest, and took his meals in the steward's room. But, though he saw little of Lord Derby and was occupied all day with his drawings in the menagerie, he soon made the acquaintance of Lord Derby's grandsons. The latter were in the habit of dining every day with their grandfather, but soon Lord Derby remarked that they now seemed anxious, instead of sitting with him during the evening, to make their escape as soon as possible after dinner was over. On his inquiring the reason for this they replied, with the candour of youth, that it was so much more amusing downstairs. " And why ? " asked Lord Derby. " Oh, because that young fellow in the steward's room who is drawing the birds for you is such good company, and we like to go and hear him talk." Old Lord Derby was a wise man, and was not offended : instead, he invited Lear to dine with him upstairs, and thenceforward the young draughtsman became an intimate friend of the family and, by his charm and the wit

of his conversation, popular with the many visitors who came to the house.

Entertaining at Knowsley was carried on in the grand manner. An enormous house, part of it of great antiquity, it has grown with the growing fortunes of the Stanleys. With its great galleries containing magnificent Rembrandts and Holbeins and a fine collection of the English water-colourists, its fine library, its suites of noble rooms, it was well adapted for hospitality, and was often filled with guests, besides the large population of its permanent inhabitants. Here, as Lear tells us, he ' saw half the fine people of the day ' ; and many of these fine people remained his faithful friends and patrons for years afterwards. His anecdotes about some of them were, as he says, ' queer enough.' ' The Earl of Wilton has been here for some days,' he wrote to his sister Ann. ' He is extremely picturesque if not handsome, and dresses in crimson and a black velvet waistcoat, when he looks like a portrait of Vandyke. Miss —— says, and so does Mrs. —— , that he is a very bad man, tho' he looks so nicely. But what I like about him, is that he always asks me to drink a glass of champagne with him at dinner. I wonder why he does. But I don't much care as I like the champagne.' Lear consulted his friend Miss —— about the reason of his lord-ship's odd conduct : she ' began to laugh, and said, " because he knows you are a clever artist and he sees you always look at him and admire him : and he is a very vain man and this pleases him, and so he asks you to take wine as a reward." Ha ! ha ! ha ! '

Lear was very happy at Knowsley—happy in Lord Derby's friendly kindness, enjoying the novelty of fashionable life, and absorbing its impressions with all the eagerness of intelli-gent youth. But there were moments when he found the

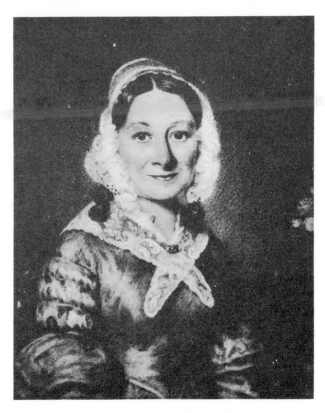

Ann Lear from a photograph

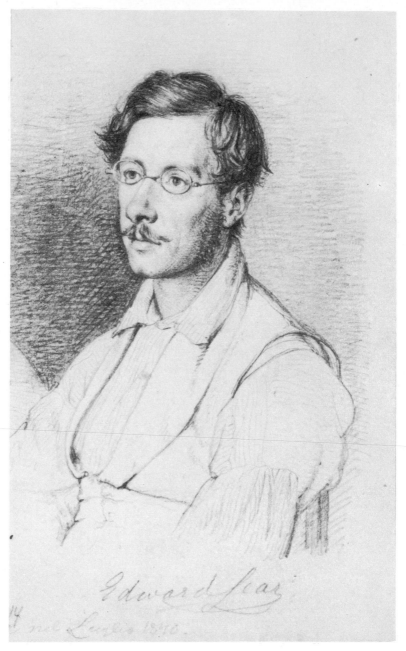

Edward Lear, a sketch by W. N. Marstrand, 1840

atmosphere a little oppressive to his high spirits. 'The uniform apathetic tone assumed by lofty society irks me *dreadfully*,' he wrote to a friend : 'nothing I long for half so much as to giggle heartily and to hop on one leg down the great gallery—but I dare not.' There were, however, certain compensations, for in the same letter he makes flattering and gallant allusions to a beautiful Miss Hornby, with whom he was on very friendly terms and whom he much admired. (The Hornbys were related to the Stanleys and lived near Warrington ; Lear saw them often at Knowsley and in later years.) Moreover, the permanent inhabitants of the house included a number of Lord Derby's grandchildren and great-nephews and -nieces, who were all brought up together, in a sort of miniature kindergarten, by a retinue of nurses and governesses. They were, as yet, entirely unaffected by the 'apathetic tone' of the grown-ups, and when the atmosphere of the Great Gallery became too heavy, Lear would take refuge in the nurseries, where his jokes and funny drawings produced peals of laughter, and where he could hop on one leg as much as he pleased. With the children he was always welcome : with them, his popularity and success were assured and he could feel completely at his ease. Seldom a day passed that he did not pay them a visit.

The results of Lear's four years of work at Knowsley were published in 1846 in a magnificent volume (privately printed, and now a rare and valuable book) entitled *Gleanings from the Menagerie and Aviary at Knowsley Hall* and containing a large number of lithographs. The volume was edited by Dr. Gray, who, speaking of Lear's drawings in his preface, remarks somewhat severely : 'their chief value consists in their being accurate representations of living specimens.' But those four years also saw the beginnings of another and a very different

book, a book that was to bring Lear a fame and an immortality that all his drawings of animals and birds could never have given him—*The Book of Nonsense.*

* * * * *

There had been published about 1820 by the house of Marshall, well known for its editions of books for children, a small pamphlet of verses, gaily illustrated with coloured woodcuts which were almost certainly the work of the caricaturist Robert Cruikshank, elder brother of the more famous George Cruikshank. It was called *Anecdotes and Adventures of Fifteen Gentlemen:* two other small books in the same series related the adventures of *Fifteen Young Ladies* and of *Sixteen Wonderful Old Women . . . their principal Eccentricities and Amusements.* The verses contained in these little books were in what is commonly known as the ' limerick ' form, of which they are some of the earliest known examples. How and where the form originated, and why it came to be known as the ' limerick ' remains uncertain. There is a theory that the name is derived ' from a custom at convivial parties, according to which each member sang an extemporized " nonsense-verse," which was followed by a chorus containing the words " Will you come up to Limerick ? " '[1] It is possible that these extemporized nonsense-verses were in the limerick form and took their name from the words of the chorus, though the latter are not themselves in the limerick metre.

Be that as it may, it is certain that Lear did not invent the limerick, as has sometimes been stated—though, ever since the publication of his first *Book of Nonsense,* which introduced the form to general notice, it has been associated, *par excellence,*

[1] *Oxford English Dictionary.*

with his name. Owing to its peculiar aptness for a certain type of epigrammatic *conte drolatique*, it at once became popular, and everybody, from Tennyson downwards, began to compose limericks ; so that, since the appearance of the *Book of Nonsense*, thousands have been produced, good and bad, publishable and unpublishable. The direct source from which Lear drew his inspiration was the *Anecdotes and Adventures of Fifteen Gentlemen*. ' Long years ago,' he tells us in his Introduction to *More Nonsense* (published in 1872), ' in days when much of my time was passed in a country house where children and mirth abounded, the lines beginning " There was an Old Man of Tobago " were suggested to me by a valued friend as a form of verse lending itself to limitless variety for rhymes and pictures ; and thenceforth the greater part of the original drawings and verses for the first *Book of Nonsense* were struck off with a pen, no assistance ever having been given me in any way but that of uproarious delight and welcome at the appearance of every new absurdity.' Whether Lear ever actually saw the *Fifteen Gentlemen* we do not know : it is quite likely that a copy found its way into the nurseries at Knowsley : but the thanks of posterity are due to the ' valued friend '—whoever he or she may have been—who drew his attention to the rhyme of the ' Old Man of Tobago ' which occurs in it :

> *There was an Old Man of Tobago,*
> *Lived long on rice gruel and sago ;*
> *But at last, to his bliss,*
> *The physician said this—*
> *To a roast leg of mutton you may go.*

Others among the limericks in this little book have a very Learish ring about them :

19

There was a young man of St. Kitts,
Who was very much troubled with fits :
 An eclipse of the moon
 Threw him into a swoon ;
Alas ! poor young man of St. Kitts.

There was an old soldier of Bicester
Was walking one day with his sister ;
 A bull, with one poke,
 Toss'd her up in an oak,
Before the old gentleman miss'd her.

(It will be noticed that the first and third of these limericks have the third rhyme in the last line, which Lear occasionally used ; generally, however, he repeated in the third line the final word of the first—or sometimes of the second—line. On this subject there are two schools of thought, one of which maintains that Lear was right in repeating the first rhyme, the other that, by doing so, he weakened the effect, and that the use of the third rhyme is preferable, or even essential.)

Most of the limericks in the first *Book of Nonsense*, with their accompanying drawings, were produced during the four years at Knowsley, for the entertainment and delight of the children of Lord Derby's household. Others, written and illustrated for other children, were added, and the *Book of Nonsense*, dedicated to the Knowsley children, was published in 1846. It was an immediate success, but gave rise to many absurd rumours as to its authorship and contents—that, for instance, it was the work of several different hands, that the rhymes had a symbolical, or a political, meaning, that the drawings were caricatures of real people, some of them in public life. Lear absolutely denied these reports. 'More care,' he tells us, ' than might be supposed has been given to

make the subjects incapable of misinterpretation : " Nonsense,"
pure and absolute, having been my aim throughout.' In
later years he composed, for the amusement of some of his
friends (but not for publication) some verses of a topical
nature, directed against Mr. Gladstone, of whom he bitterly
disapproved. One of these, parodying Goldsmith, begins :

> *When ' Grand Old Men ' persist in folly,*
> *In slaughtering men and chopping trees,*
> *What art can soothe the melancholy*
> *Of those whom futile ' statesmen ' teaze ?*

And—however Lear may protest to the contrary—there
can be very little doubt that the limerick (published in *More
Nonsense*) :

> *There was an Old Man at a Station,*
> *Who made a promiscuous oration ;*
> *But they said, ' Take some snuff !—*
> *You have talked quite enough,*
> *You afflicting Old Man at a Station ! '*

refers, again, to Mr. Gladstone, who had a habit of making
speeches at railway stations.

The most widespread theory of the authorship of the *Book
of Nonsense*, and one which persisted for many years and even
appeared in print, was that it was composed by Lord Derby.
Lear was somewhat annoyed by this rumour, and it was not
until several years after the publication of the book that he
at last understood the rather ingenious argument upon which
the theory was based. His discovery of it was purely
accidental.

' I was on my way from London to Guildford,' he wrote,
' in a railway carriage containing, besides myself, one passenger,

an elderly gentleman. Presently, however, two ladies entered, accompanied by two little boys. These, who had just had a copy of the *Book of Nonsense* given them, were loud in their delight, and by degrees infected the whole party with their mirth.

' " How grateful," said the old gentleman to the two ladies, " all children and parents too ought to be to the statesman who has given his time to composing that charming book ! "

' (The ladies looked puzzled, as indeed was I, the author.)

' " Do you not know who is the writer of it ? " asked the gentleman.

' " The name is ' Edward Lear '," said one of the ladies.

' " Ah ! " said the first speaker ; " so it is printed, but that is only a whim of the real author, the Earl of Derby. ' Edward ' is his Christian name, and, as you may see, LEAR is only EARL transposed."

' " But," said the lady doubtingly, " here is a dedication to the great-grandchildren, grand-nephews, and grand-nieces of Edward, thirteenth Earl of Derby, by the author, Edward Lear."

' " That," replied the other, " is simply a piece of mystification ; I am in a position to know that the whole book was composed and illustrated by Lord Derby himself. In fact, there is no such a person at all as Edward Lear."

' " Yet," said the other lady, " some friends of mine tell me they know Mr. Lear."

' " Quite a mistake ! completely a mistake ! " said the old gentleman, becoming rather angry at the contradiction, " I am well aware of what I am saying. I can inform you, no such person as ' Edward Lear ' exists ! "

' Hitherto I had kept silence, but as my hat was, as well as

22

my handkerchief and stick, largely marked inside with my name, and as I happened to have in my pocket several letters addressed to me, the temptation was too great to resist, so, flashing all these articles at once on my would-be extinguisher's attention, I speedily reduced him to silence.'

Chapter III

ITALY AND QUEEN VICTORIA

DURING the four years of his work at Knowsley—years which had deeply affected his outlook on the world and which had given him an established, if humble, position in society— Lear had made several journeys which had had an equally important effect on his life as a painter and were destined to change the whole course of his career. He had been two or three times, during those years, to the Lakes : in the summer of 1835 he went, also, to Ireland. His companion on this occasion was Arthur Stanley, who, at this time, was only twenty and not yet ordained into the Church, in which he was to have so successful a career. In later years, when, as Dean of Westminster, he and his wife, Lady Augusta, enter- tained most of the distinguished people of the day, Lear was often a guest at their house. He and Lear were lifelong friends.

During their tour in Ireland the two young men went through the Wicklow Mountains, visiting, among other places, Glendalough and the Seven Churches, one of the most ancient relics of the early Celtic religion in Ireland ; and Lear, who could never bear to be idle and who regarded no pleasure as complete unless he could bring back from it some concrete result, was busy sketching. The summer before, in the Lakes, he had already found himself growing more and more interested in landscape—a branch of painting which he had hitherto attempted but little—and now, inspired by the

beauties of the Wicklow Mountains, he decided to become, for better, for worse, a landscape-painter. There were to be no more parrots, no more lemurs or terrapins or Whiskered Yarkes: 'topographical landscape' should be his study and should afford the means of his livelihood. There were other reasons also which influenced him in this decision. His eyesight was never strong ; and he realized that the strain imposed upon it by the minute accuracy and detail required in drawings of birds and animals might, if long continued, cause irreparable harm. Also his general health had not improved during the last few years : the climate of the north of England had aggravated the tendency towards asthma and bronchitis, and landscape-painting would provide him with an excuse and an opportunity of going abroad, for the winters at least, to a warmer climate.

His work at Knowsley finished, Lear returned to London and Ann. His decision to go abroad for an indefinite period must have been a sad blow to his devoted sister, though she submitted cheerfully to its obvious good sense. The best years of her life had been dedicated entirely to him : she had kept a home for his use whenever he wanted it ; and now, at the age of forty-six, the object of her motherly care removed, she must have felt her life to be empty and aimless. The rooms which they had shared were given up, and henceforth Ann led a wandering existence, without fixed abode. We hear of her in Brussels, in Brighton, in London or in Margate, or staying with her sister Eleanor Newsom at Leatherhead ; keeping in touch always with such members as survived of the scattered and depleted family, sending money to the unsuccessful brothers in America, writing long letters regularly to Edward, embroidering slippers for him, or doing his little commissions in London. He, too, felt keenly the separation

from her : he even, perhaps, felt rather guilty about it, conscious that she had given him everything and that he seemed to be repaying her by deserting her. ' I wish we could have lived together,' he wrote to her many years later, '—but it would not have done for either of us, I believe, for we are both nervous and fidgety . . . and one of us—I shall not say which— has not the best temper in the world ! ! '

In the summer of 1837 he left for Italy. Travelling through Germany and Luxemburg, he was forced by illness to stay some time at Frankfurt ; yet in spite of this was able to make some drawings. By the time he reached Italy it was early autumn : the great heat was over, the grape-harvest in full swing, and he could hardly have chosen a more favourable moment for his first introduction to a land which at once captivated him and which, for many years of his life, was to be his home. The impression Italy made upon him was immediate and profound, and his letters to Ann are full of ecstatic descriptions. The superb line of the Alps seen from the Lombard Plain, the costumes of the peasants gathering grapes on every side, the olive trees and the clear sunlight, the boats on the Lake of Como with their red, blue or white sails, the flowery hills about Lugano, the ' Capuchin friars in quantities '—everything was new and exciting, everything was filled with a kind of beauty which he had never encountered before—and which was in no way dimmed by the horror he felt at the dirt of the Italian village inns. He went first to Milan, then took a walking and sketching tour round about the Lakes of Lugano and Como ; by the beginning of November he was in Florence, whither he travelled from Milan by way of Bologna with its leaning towers and arcaded streets, Bologna ' in the Pope's dominions, whose empire is as full of beggars as Russell Square used to be.' In Florence he

27

discovered friends, Sir William Knighton 'who knows Art so well,' the Tattons, the Russells ; and almost immediately found four pupils. Florence impressed and bewildered him. 'It is| all a hurly-burly of beauty and wonder,' he told Ann. 'The Grand Duke rides about everywhere, and the whole place is like an English watering-place . . . There is a nice church here. On Sunday, 300 English, besides servants, were there ! ! ! ! ! ' But Florence, in spite of these advantages, was cold and wet and he began to cough, and about the end of November, as soon as he could find two suitable travelling-companions who would share a *vetturino* with him, Lear set off for Rome. In a slow carriage, it was a 'sadly weary journey of 5 mortal days—from 3 or 4 in the morning till 5 at night,' a journey which was something of an adventure (a contemporary phrase-book prepared the English traveller with the correct translation of 'Good Heavens ! The postilion has been struck by lightning ! ') : and there were rumours of cholera and highway robbers, which might cause further delay and unpleasantness. However they reached Rome at last, without mishap, and Lear soon found rooms— a studio and a bedroom—in the Via del Babuino, the middle of the artists' quarter.

Rome, at that time, was the centre of a large colony of artists of many nationalities, who lived and worked mainly in the quarter round about the Piazza di Spagna—a sober and respectable equivalent, in many ways, of the modern Mont-parnasse. It was also a fashionable winter resort for wealthy English people, and it was this, as well as the climate, which caused Lear to make it his headquarters for the next ten years. For, among the wealthy and aristocratic English of the type who spent their winters there, 'Art' was the fashion, and an English artist had a good chance both of selling his pictures

28

and of finding pupils. Indeed, Lear seems to have had no financial difficulties during these years—a state in which he seldom found himself in later life.

For the next three years he remained entirely in Italy. His summers were spent away from Rome, in painting expeditions, his winters in teaching and in making finished drawings and lithographs from his summer's sketches, which he also used for the large oil-paintings that he now began to produce. In the summer of 1838 he made a long tour, on foot, to Naples. Naples did not at all come up to the expectations which everything he had so far seen and rapturously admired in Italy had aroused in him : he took an instant dislike to the place, largely on account of its extreme noisiness—a characteristic particularly distasteful to him, and which has not modified in a hundred years—and of its dirty, swarming population. ' 60,000 people died of the Cholera—but they say no one can tell the difference ; it is reputed the noisiest city in the world— judge how I, who hate noise, must like it ! There is not a good looking building in the place. . . . One can hardly believe the whole population are not stark mad—raving. They yell and shout—nobody in Naples speaks—in a manner quite superhuman. . . . The Royal family are continually scampering up and down, in 2 carriages and 4—and troops of soldiers and kettledrums.' He went on to Amalfi, Salerno and Paestum, and stayed some weeks at Corpo di Cava, which he described, in contrast to its noisy neighbour, as ' a sort of Paradise.' On other occasions he made expeditions into the country all round Rome, staying for long periods at Tivoli, Frascati, Albano or Subiaco, or wandering with his sketch-book in the Campagna. It was a pleasant enough existence, on the whole, but Lear's industrious nature sometimes found the social life of Rome in the winter—which,

for reasons of his profession, he judged it prudent to frequent
—to be tedious in itself and occupying too great a proportion
of his time. 'Half the English peerage is here, I think,' he
tells Ann : 'dinners and balls abound.' But, as a result, he
had no less than seven pupils, most of them ladies of title ;
and, being a young man without a penny of private resources,
he could not afford to neglect his opportunities.

Soon he had amassed a sufficient number of lithographs,
made from his drawings of Rome and the surrounding country,
to form a book, and he returned to England to supervise its
publication. *Views in Rome and its Environs* was published
during 1841 ; its twenty-four plates are in the characteristic
style of the best landscape-drawing of the period, and have a
delicacy and freshness which are lacking in his work in oil.
They have also the quality, as has all his landscape-painting,
of giving a vivid idea of the places represented. But Lear's
qualities as a painter will be discussed in a later chapter.

He returned in the autumn to Rome. During the next two
years he made long tours in Sicily and the Abruzzi, and in
1844 was so prosperous that he invited Ann to come out, at
his expense, and stay with him for the whole winter, returning
with him to England in the following spring. The letter
in which he writes to invite her, giving her the minutest
instructions for her journey, is characteristic of his preciseness ;
and his careful advice about her clothes has something in it
of the anxiety of a schoolboy who is afraid of being 'let
down' by his parent. 'I hope you will dress *very nicely*
(although we shall be both in deep mourning)'—Mrs.
Jeremiah Lear had died recently—' and I advise you to get . . .
good walking boots and shoes, etc. etc. *at Paris* . . . Do not
forget to bring good *warm clothing*, and if you want any
handsome, plain shawl or dress in Paris (not odd looking, my

dear old sister !) buy it, and keep it as a present from me.
You know that I am very much known here, and live in the
" highest respectability "—and so you *must not* be too dowdy.
Do not forget a thick veil—for cold winds.' But Ann could
not be persuaded : perhaps she felt that her clothes were not
smart enough, and that she could no longer live up to her
brother's standards.

In May of the next year Lear left for a long visit to England,
where he had many affairs to attend to, chief among which
was the preparation for publication of another travel-book
and of the first *Book of Nonsense*, both of which (as well as
the *Knowsley Menagerie*) appeared during 1846. But before
he left Rome he had made the acquaintance of a young man
who was to be one of the two most intimate and beloved
friends of his life. Chichester Fortescue had just left Oxford,
and before entering on the parliamentary career for which he
was intended, was making, in accordance with the usual
practice of the period, the ' grand tour.' He arrived in
Rome in March, and was taken by a friend to Lear's studio.
Lear was thirty-three, Fortescue twenty-two : they took to
each other immediately, and the acquaintance thus begun
ripened quickly into a close friendship that was never broken
till Lear's death. During the few weeks before Lear's depar-
ture for England they saw each other almost daily : Fortescue
was a keen amateur artist, and spent many evenings looking
over Lear's drawings and receiving lessons from him ; they
went for long walks together, talking and sketching, and for
a longer expedition of two or three days to Tivoli and
Palestrina. Fortescue recorded in his diary his impressions of
Lear during this time. ' I like very much what I have seen
of Lear ; he is a good, clever, agreeable man—very friendly
and *getonable* with.' And later : ' Lear a delightful com-

panion, full of *nonsense*, puns, riddles, everything in the shape of fun, and *brimming* with intense appreciation of nature as well as history. I don't know when I have met anyone to whom I took so great a liking.' He was very sorry when Lear had to leave for England. ' Lear came to say good-bye just before our dinner—he has gone by diligence to Cività Vecchia. I have enjoyed his society immensely, and am very sorry he is gone. We seemed to suit each other capitally, and became friends in no time. Among other qualifications, he is one of those men of real feeling it is so delightful to meet in this cold-hearted world.'

Lear also had been strongly attracted to the brilliant, good-looking young Irishman from Oxford who was so enthusiastic about the things he himself loved best. It was a pleasure to be able to act as his guide round the sights of Rome and the surrounding country, a pleasure to have a companion who was not only appreciative of natural and architectural beauty, but also sympathetic to his own whimsical sense of humour. Lear was charmed by his combination of quick, sensitive intelligence, high spirits, and deep underlying seriousness of character, and though he sometimes felt, both now and later, that Fortescue was too indolent in the application of his gifts, that in itself—in contrast to his own feverish industry—may have been an attraction. In appearance, too, Fortescue, with his straight, finely-shaped nose and large clear eyes, was a complete contrast to Lear, who, morbidly conscious of his own plainness of feature, was always ready to admire good looks in others. After his Italian tour Fortescue returned to England to find a seat in Parliament awaiting him for his native county of Louth, and he was immediately launched into political and social life in London. He filled many public offices during his career, conscientiously, if without

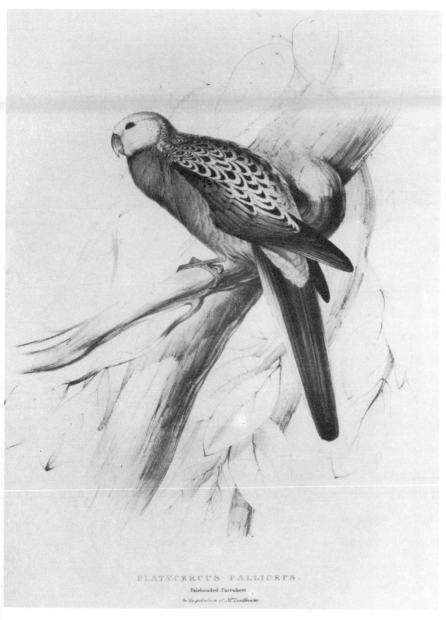

PLATYCERCUS PALLICEPS.

Palehraded Parrakeet

In the collection of Mr Leadbeater

Platycercus Palliceps, from a lithograph, 1831

Syracuse, watercolour, 1847

conspicuous *éclat*, and when his services to the Liberal Party were rewarded, in 1874, with a peerage, he became Lord Carlingford. The different courses of their lives prevented frequent meetings, but he and Lear were regular correspondents for over forty years, and the two volumes of their letters are one of the very few published documents on Lear's life.

Lear was a most industrious letter-writer and had a vast and ever-growing number of correspondents. He mentions, many years later, that he had kept 'specimens' of letters from no less than 'four hundred and forty individuals,' and, when his eyesight began to be a serious trouble, he made a plan—to which he did not keep—for corresponding only with those to whom he had been in the habit of writing for more than thirty years before. To keep up this vast correspondence without interfering with his work he would rise, often at four or five in the morning, and sometimes wrote as many as thirty-five letters before breakfast. And his letters to his friends, though the great number of them necessarily resulted in some repetition, were not the short, abrupt notes of a later and more restless age : generally they were long and discursive, and filled with detail and comment and anecdote—as well as a good proportion of nonsense. In his letters to Fortescue he was more completely at his ease than with any of his other regular correspondents—even Franklin Lushington, whom he met four years later, and who was the second of his two most intimate friends. Though Lear's friendship with Lushington was—on his own side— of a deeper, more emotional kind, it was at the same time, owing to Lushington's character, of necessity more reserved. But with Fortescue he felt himself free to let his pen run on in the endless nonsense and bad puns, the complaints and

D 33

absurdities, the jumble of serious and comic, with which the letters are filled. Fortescue, in fact, with his sympathetic understanding, was for Lear a sort of safety-valve.

★ ★ ★ ★ ★

Illustrated Excursions in Italy was published in 1846, while Lear was in London. It is in two volumes, the first illustrating the Abruzzi Provinces of the Kingdom of Naples, the second, the Papal States, and each containing a large number of lithographs and vignettes, drawn out by Lear himself from his sketches. But this book—or rather, its first volume, for the second, apart from its plates, has only the briefest of topographical and historical notes—differs from Lear's previous travel-book, *Views in Rome*, in that it is enlivened by an account of his tour taken from the journals he kept on the spot, which is full of interest and intelligent observation and gives a spirited account of life in the remote towns and villages of Italy, as well as of their architecture, history and scenery. The three journeys described in the first volume cover all the different provinces of the Abruzzi, then, as still, one of the most primitive and inaccessible parts of Italy, a region ' remota e inculta,' as D'Annunzio, one of its sons, has called it. Travelling mostly on horseback, Lear and his companion found the discomfort and filth of the village inns almost unbearable : but Lear, delicate though he was, was indomitable, and would endure almost any misery to obtain a drawing on which he had set his heart. When they could procure introductions, they were given the kindest (if sometimes primitive) hospitality by local dignitaries : Lear was charmed with the singular name of one of his hosts—Don Romeo Indelicato. On the second and third tours he was alone. He gives a lively description of the great centennial *festa* at Tagliacozzo which

he was lucky enough to come upon, and records, at first with amusement, later with increasing boredom and irritation, that the sole and undeviating subject of conversation, when his hosts discovered him to be English, was the recently completed Thames Tunnel. Apart from that interesting novelty, their ignorance about England was absolute. Travellers were rare in those parts, and there were endless passport difficulties, requiring endless patience, at the boundary of every province and district. On one occasion, at a small town near Aquila, he was supremely amused and delighted at being taken for Lord Palmerston. (Palmerston, then Foreign Secretary, was well known in Italy for his championship of the Liberal ideas which were to triumph a few years later in the ' Risorgimento,' and which were already gaining ground, rapidly though secretly : he was therefore, not unnaturally, detested by the official classes in such Monarchist centres as the Kingdom of Naples.) Lear was sketching, when a policeman descended upon him and demanded to see his passport. Finding that it was signed ' Palmerston,' the policeman was delighted at his important capture and marched him off in triumph through the village, crying out : " Ho preso Palmerstone ! " (" I have taken Palmerston ! "). Lear was only saved from being thrown into prison by the arrival of the *sott'intendente*, who knew him.

It was through having seen these two volumes that Queen Victoria sent for Lear, during that same summer of 1846, to give her a course of twelve drawing-lessons. These took place first at Osborne, then at Buckingham Palace. Lear, on his first arrival at Osborne, as usual rather untidily dressed and awkward in appearance, simply rang the bell and said he wished to see the Queen. A puzzled servant showed him into a room where he was received by an equerry, to whom

35

he again repeated that he had " come to see the Queen."
The equerry, convinced that he was dealing with an amiable
lunatic, inquired his business, to which he replied, " Oh, I'm
Lear " : and further questioning at last revealed the fact,
which he had forgotten to mention, that he had an appoint-
ment to give Her Majesty a lesson. The Queen mentions
him several times in her diary. ' July 15. Osborne. Had a
drawing lesson from Mr. Lear, who sketched before me and
teaches remarkably well.' . . . ' Copied one of Mr. Lear's
drawings and had my lesson downstairs with him. He
was very much pleased with my drawing and very encouraging
about it.' . . . ' After luncheon had a drawing lesson and am,
I hope, improving.' . . . ' Mr. Lear . . . much praised my 2nd
copy. Later in the afternoon I went out and saw a beautiful
sketch he has done of the new house.' The ' new house '
was the new wing of Osborne House which had just been
completed, and of this sketch the Queen had an engraving
made. During the spring of the next year Lear wrote to Ann
from Rome : ' One of the Queen's Ladies-in-Waiting, who
is here, has delivered to me a little print engraved from one
of my drawings—of Osborne House—at Her Majesty's
desire. This is one trait of many that have come under my
notice that Queen Victoria has a good memory for any little
condescension and kindness. I am really quite pleased with
my little engraving, and shall have it placed in a good frame
as soon as I can get one made :—you need not, however, tell
the incident to everybody : for it would look like boasting
upon my part, who have done little enough to deserve so
gratifying a notice.'

Two stories Lear himself told of the time when he was
giving Queen Victoria drawing-lessons. It seems he was one
of those whose habit is always, when possible, to stand on

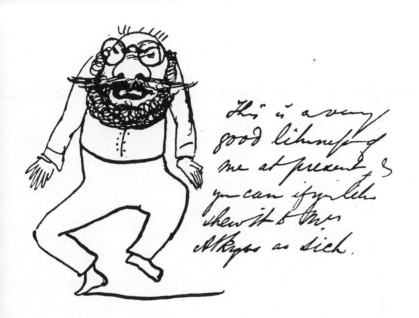

This is a very
good likeness of
me at present, &
you can if you like
shew it to Mrs
Atkyns as such.

the hearthrug, and accordingly he managed, when in a room alone with the Queen and a Lord-in-Waiting, to edge his way to his favourite position. The Lord-in-Waiting at once lured him away to look at a picture or some other object of interest ; after which Lear again made for the hearthrug. This was repeated several times, Lear returning each time to the same place, until at last it began to dawn upon him that the behaviour of the Lord-in-Waiting had some ulterior motive. But it was only afterwards that he discovered that it was a breach of etiquette of which he had been guilty. On another occasion the Queen was showing him the priceless Royal collection of miniatures. Lear was so completely absorbed in studying them that, in the excitement of the moment, he quite forgot where he was and exclaimed, " Oh ! where *did* you get all these beautiful things ? "—as though Her Majesty had ' picked them up ' at an antique shop. The Queen's answer, as he remarked, was an excellent one, kind, but dignified and completely conclusive : " I inherited them, Mr. Lear."

And Queen Victoria did not forget her drawing-master. Later in the year she and the Prince Consort were on a yachting cruise and visited Mount Edgcumbe near Plymouth. ' We walked about the garden near the house,' she noted in her diary, ' and then drove to the " Kiosk," by beautiful stone pines and pinasters, which interested Albert very much, and put me so much in mind of Mr. Lear's drawings.'

ROME ; CALABRIA ; CORFÙ

THE climate of Italy does not always live up to its reputation. When Lear arrived in Rome at the end of the year, after a cold and wearisome journey of three weeks (travelling by coach to Marseilles, boat to Leghorn, and coach again to Florence and Rome) he found the weather so dismal, the inundations of the Tiber so disagreeable, that he longed to be back in England. He was thoroughly out of humour. ' I must confess that Rome looks filthier and duller than ever after England, and if I were to tell truth, I should very willingly be transported back to England forthwith. However, it is my duty to be here for a time, past all doubt.' Many of the English there were suffering from ' rheumatic complaints and slow fevers.' But things improved in time : he sold one or two pictures, had a few small commissions, a few pupils, and was fairly prosperous. From his publications, he tells Ann, he had ' laid by a whole £100 '—which seems little enough, considering how great a success the *Book of Nonsense* had had. And, as usual, when he had any money to spare, he gave away a large part of it—a habit which, combined with his loathing, and consequent mismanagement, of financial affairs, may have been to a great extent responsible for his frequent crises of what he called ' tinlessness.' He gave money, during this time, not only for the victims of the Irish famine and for the English church in Rome, but also sent a sum to Ann to be divided into presents for herself, ' poor dear

Mary' and another sister, Harriet, and a contribution to some of Ann's pet charities—'the blind man and the blanketty coaly people.' His sentiments, as expressed to Ann, on the subject of giving away money, though they may sound a little formal to modern ears, are nevertheless the feelings of true charity. 'I am not so rich as in other years ; in fact, I have just enough to go on with—but I don't see what one wants more ; and the more one gives away the better. . . . I am thankful to feel that every succeeding year has fresh and fresh claims on one's mere humanity, and I trust I may never feel so less. . . . It is perfectly astonishing what comfort one may give if one only moves and does not sit torpid. But the more one does as to giving away, the more one is ashamed at not giving away *more*. I am sure I hope I shall do so more and more.' Charity, he considered, should begin at home, and to Fortescue he says : ' Like a nass I gave away all I could, so as usual have none over to spare. One of my sisters is horridly poor, and another is going with all her children and grandchildren to New Zealand, and another wants some port wine, being ill, and so on. But the fact is, I only wish for money to give it away, and there's lots to be done with it here if people wouldn't be above looking at what they *should* do, and wouldn't keep fussing about those fooly blacks. I've been reading Brooke's *Borneo* lately. What do you think of a society for clothing and educating by degrees the Orang Outangs ? '

These excellent sentiments express a good deal of Lear's attitude of mind at this time of his life, when he was in many ways a typical product of the period—a period in which the slightly self-conscious virtue of the Queen and her Consort was exercising a steadily increasing influence on English society. This is shown especially in his attitude towards

religion, which, though not insincere, was the conventional, Church-on-Sunday attitude of the time. His opinions on this subject changed completely in later life ; he never lost a profound sense of the true spirit of Christianity, but expressed himself very strongly against the pompous self-satisfaction and dogmatism of the Church and many of its ministers, and even went so far as to exclaim : " Alas ! alas ! going to church is my *bête noire.*" But during these first years in Italy, whether in Rome, or Florence, or any other town where he happened to be, he was a regular attendant at the ' English Church '—if there was one. And if there was not, he would read a sermon of Archdeacon Manning, or a passage from the works of Dr. John Abercrombie (author of *The Philosophy of the Moral Feelings* and other forgotten volumes of high moral value) for whose writings he had, at this time, a great admiration. On a tour in Sicily in the spring of 1847 he tells Ann that he has brought with him ' your little book of texts— Abercrombie's essays—and my old Bible and Prayer Book ; I wish I may read them regularly—and derive some benefit and pleasure from doing so.'

His companion on this tour was a certain John Proby, whom he had met by chance in Rome. Liking each other, and both being anxious to go to Sicily, they had joined forces for convenience' sake, knowing very little about each other. The experiment began well. ' My companion is a very good young man,' Lear assured Ann, ' and I am wonderfully fortunate in having such a one, as he draws constantly, and is of a perfectly good temper.' In the summer they went on to Southern Calabria, and here relations between them were, for a time, less happy. Proby was no longer the perfect combination of piety and artistic enthusiasm. ' I am sorry my companion, as his health improves, *does not* in temper;

he is sadly imperious and contradictory at times, which is rather trying, as his visit to Calabria is entirely dependent on my letters of introduction. However, there is some allowance to be made, as I find he is heir to a rank which I had no knowledge of as being about to be his, or I should not have travelled with him.' What is inexcusable in a commoner must, of course, be indulged in a lord ; and ' Mr. John Proby,' as Lear now discovered, was in reality John, Lord Proby, eldest son and heir of the Earl of Carysfort. Lear, no doubt, had been irritable—and we have seen that he had every excuse for being so : and the quarrel, whatever its cause, ended characteristically, with his taking the blame upon himself. A few days later he writes again to Ann : ' Proby makes a perfectly excellent companion—and we now go on with perfect comfort and smoothness ; indeed I now like him so much, that I do not at all like to think of his leaving me. . . . I am sorry I said anything so hasty about my companion, whom I find one of the best creatures possible, and I daresay it was my own ill-temper that made him seem hasty.' Their friendship was cut short ten years later by Lord Proby's early death, and Lear's regrets were renewed. ' I did love him very much,' he told Fortescue, ' but I myself was never kind to John Proby as I should have been, for which I suffer now.'

Calabria was a part of the Kingdom of Naples, and, at the time when Lear visited it, the whole province was seething with carefully suppressed excitement. In every town and village there were undercurrents of intrigue and revolutionary propaganda ; everywhere were secret preparations for the blow which was soon to be struck at the tyranny of the Bourbons. During the next year, 1848, the critical moment arrived. For a few weeks the towns were in the hands of

the revolutionary idealists and patriots : but their hopes were soon to be utterly shattered by the military forces of the reactionary party, and such of the leaders as escaped imprisonment or death fled the country. Garibaldi himself escaped to Tangier, going later to America and then to England. The revolution was an ignominious and apparently hopeless failure ; nevertheless it laid the foundations of the future unification of Italy, of the ' Risorgimento ' of twelve years later, under the three great leaders :

> . . . those
> *Who blew the breath of life into her frame :*
> *Cavour, Mazzini, Garibaldi : Three :*
> *Her Brain, her Soul, her Sword. . . .*

In the meantime, in Calabria, there was everywhere an atmosphere of suspicion : no man dared trust his neighbour, his friend, even his brother. Lear was provided with introductions from a friend in Reggio, his starting-point, to the leading citizens of almost every town he intended to visit, but it was not surprising, in such circumstances, that some of them scarcely gave him the welcome he looked for. In his published journals of the tour he confines himself almost entirely to the consideration of landscape, and purposely avoids all mention of political events, but remarks : ' It is but right to add, that some provincial families, whose suspicions and apparent want of hospitality marked them in our eyes as unlike their compatriots, were but too well justified in keeping themselves aloof from any strangers, whose motives for visiting this country were but little understood, and whose presence might possibly have compromised them in the event of disturbances which, they may have been aware, were on the eve of occurring.'

45

Apart from this, the state of affairs seems to have affected him singularly little. With his usual thoroughness before starting on a tour in new country, he had studied all the available authorities and had a perfectly clear idea of where he intended to go ; and there were few points of interest in that little known region of South Italy which he and his companion failed to see. They visited Bova, perched on the top of its high mountain, last remnant of Magna Graecia, which claims to be the birthplace of Praxiteles and where a corrupt Greek was at that time still spoken ; the monastery of Santa Maria di Polsi in a lonely ravine of the mountains of Aspromonte ; Gerace ; Rocella ; Stilo ; then crossed the mountains by the Passo del Mercante into Western Calabria and came down to Palmi and so back to Reggio. Lear and his companion then parted for a few days, Proby going to Messina, Lear to Pentedatilo, so called from the ' five fingers ' of the giddy rock to which it clings, which points like a great hand to the sky. When he arrived back at Reggio, he found it entirely disorganized by a minor, and premature, revolution : he had left some of his possessions there at the hotel, and the waiter whom he asked for the key of his room could only with the greatest difficulty be shaken out of his dreams of a golden age and brought down to the dull realities of daily life. " O che chiave ? " he exclaimed. " O che roba ? O che camera ? Non c'è più chiave ! Non c'è più roba ! Non c'è più camera ! Non c'è più niente ! Tutto è amore e libertà ! O che bella rivoluzione ! " [1] (" What," remarked Lear, " *is* the use of all these revolutions which lead to nothing, as the displeased turnspit said to the angry cookmaid ? ")

[1] " O, what key ? What possessions ? What room ? There are no more keys ! No more possessions ! No more rooms ! No more anything ! All is love and liberty ! O, what a beautiful revolution ! "

The same state of things prevailed in Messina, and it was only after much bribery and delay that Lear was able to find a boat to take him across the Straits to join Proby there. They were forced to abandon the tour of Northern Calabria which they had planned : as soon as they could, they made their way to Naples, where things were quieter, and went, instead, into the provinces of Campania and Basilicata. They visited the strange sulphur springs of Le Mofette ; at Melfi they stayed some days in the great romantic castle of Prince Doria— which, with the town, was almost completely destroyed by an earthquake four years later ; then Castel del Monte, built by Frederick Barbarossa ; and so back to Naples by Potenza, Eboli and Paestum. Lear's journals of these tours, together with a large number of lithographs of the places visited, were published in 1852 under the title of *Journals of a Landscape Painter in Southern Calabria, etc.* The book gives an entertaining and well-informed account of a region which comparatively few travellers, even since Lear's day (and very few before him) have described : it has been highly esteemed in Italy, and the editors of *La Patria : Geografia dell'Italia* (a serious and exhaustive guide-book published, in twenty-nine volumes, between 1890 and 1903) quote largely from it in the volume dealing with Calabria. It was on one of these tours that Lear overheard a conversation between two young Englishmen in the inn where he was staying. " I say, Dick, do you know what that fellow is that we were talking to last night ? " " No." " Why, he's nothing but a d——d dirty landscape-painter." Lear's fancy was greatly tickled by this description of himself, and he adopted it as a kind of professional title—' Edward Lear, Dirty Landscape-painter.'

Events and rumours, in the following spring, were disturb-

ing, and Lear decided that the time had come to leave Rome for good. For the last ten years it had been his headquarters : he had been, on the whole, very happy there and had found no difficulty in making a comfortable living. But his patrons and pupils had been his own fellow-countrymen and women, and though the winter season of 1847-8 had been as fashionable and crowded as ever before, it now seemed unlikely that, in a few months' time, there would be any English left in Rome. It was with regret that he gave up his rooms in the Via Felice—with regret, and yet with a certain feeling of relief, even of exhilaration that, for his restless spirit, always accompanied an uprooting, a breaking of material ties. He sent off a quantity of baggage, including books and pictures, to Ann's charge in England : his furniture he sold to his old landlady, who was much attached to him, ' at a mere nominal price.' But before he left he had made the acquaintance of a young man who was to play a considerable part in his life, a friend of Fortescue's, Thomas George Baring, who had been spending a part of the winter in Rome. Baring was fourteen years younger than Lear, and was an excellent amateur draughtsman ; it was this interest in common that first drew them to each other. ' Thank you for your intro-duction to Baring,' Lear wrote to Fortescue ; ' he is an extremely luminous and amiable brick, and I like him very much, and I suppose he likes me or he wouldn't take the trouble of knocking me up as he does, considering the lot of people he might take to instead. . . . He would draw very well, and indeed does, but has little practice.' There were sketching expeditions in the Campagna, evenings spent together, and the friendship thus begun became one of the most important of Lear's life. Baring later became first Earl of Northbrook ; throughout a long and varied public

career he remained not only a true friend to Lear, but a most generous patron. In 1872 he was made Viceroy of India, and it was at his invitation that Lear went there shortly afterwards and spent eighteen months touring the country, painting, as usual, indefatigably, though he was by that time well over sixty.

Lear had been invited, when he left Rome, to go to Corfù to stay with George Bowen, another friend of Fortescue's, who was rector of the university there. The Ionian Isles, of which Corfù was the chief, were at that time (and until they were finally ceded to Greece in 1864) under British protection : there was a British Lord High Commissioner, a garrison of British troops, and a fairly numerous British colony, in which George Bowen, owing to his official position as a sort of Minister of Education for the whole of the Ionian Isles, was a figure of some importance. Lear found that it was impossible for him to travel, as he had intended, by Ancona, owing to all communications in the north having been broken by the revolution in Lombardy. In the south, however, the state of affairs had improved ; he went, therefore, by Naples and Malta. 'My journey down to Naples by diligence was most extremely pleasant. . . . A few short months have changed all things and persons in Italy. . . . Restraint and espionage has given universal place to open speaking and triumphant liberal opinions. One of my fellow-passengers was a Neapolitan noble, exiled for 16 years ; when he saw Vesuvius first, he sobbed so that I thought he would break his heart. Naples I found yet more unsettled and excited than I had left Rome. No one could tell what would happen from one hour to the next. The King still reigns, but I cannot think he will long do so. All the English are running away. . . .' Malta, on the other hand—

E

Byron's 'little military hothouse'—was full of English, and he spent a gay week there before sailing for Corfù. 'It is impossible to tell you how kind people are to me ; every day I have at least one invitation to dinner, and for some days—3 and 4.'

Corfù, exquisite isle of orange and lemon and olive groves, looking across a stretch of blue water to the mountains of Albania and Greece, enchanted Lear in the same way that Italy had enchanted him ten years before. And it also, later, was to be his home for several years. His descriptions to Ann are, according to the epistolary fashion of the day, full of superlatives and underlinings ; but, apart from their rapturous and, perhaps, rather indiscriminate enthusiasm for the more obvious kinds of picturesque beauty—mountains, sunsets, ruins—they are full of detailed and delicate observation on such matters as trees and flowers and gardens, and, especially, on the colour and combinations of colour in the landscape. He stayed in Corfù about two months, working as hard as the exigencies of the social life into which he was somewhat unwillingly led would allow him. During this time his host, Bowen, had to make a tour of inspection of some of the other islands, and Lear accompanied him to Zante, Ithaca and Cephalonia. Ithaca, 'Ulysses' kingdom,' he tells Ann, 'is a little island, and charmingly quiet. I delight in it . . . In the afternoon we went to the fountain of Arethusa. . . . I went up to the ancient ruins of Ulysses' city and castle ; vast walls of Cyclopean work . . . and sufficient left to attest the truth of the renown of Old Ithaca.' In Cephalonia he visited Metaxata, 'the last place Lord Byron lived in before he crossed to Greece.' Returning again to Corfù, he bought a Greek grammar and began to study modern Greek, a language in which he later attained great

proficiency. Many of his letters to Fortescue, who was a good classical scholar, are interspersed with Greek phrases ; occasionally he would write a letter, for practice, entirely in Greek ; and he had a habit of making notes in Greek on the preliminary sketches from which he intended afterwards to make oil-paintings. He had, in later years, ample opportunities of exercising his knowledge. Meanwhile, enjoying the luxuriant beauties of Corfù and walking on ' the most beautiful esplanade in the world,' he thought of Ann on the ramparts of Chester, whither she was on the point of going. ' I am very glad . . . you are going to Chester ; when there, walk round the ramparts—but not *late*, as it is rather a notoriously incorrect place for ladies to walk in ; ·the view is very pretty.'

CONSTANTINOPLE ; ALBANIA ; GREECE

LEAR had intended, after his visit to Corfù, to cross to the mainland and make a tour through Albania ; but this plan was, for the moment, postponed by the arrival in Corfù of Sir Stratford and Lady Canning. He had met them several times before, in London and in Italy, and Lady Canning had invited him to visit them in Constantinople—for which kindness he was ' obliged to her . . . but thought I had as much chance of visiting the moon.' Sir Stratford Canning (afterwards Lord Stratford de Redcliffe) was British Ambassador in Turkey, and had already been for some years a very important figure in the complicated diplomacy relative to England's position in the Near East. Later, when the situation between Russia and Turkey became critical, it was upon his shoulders—rightly or wrongly—that a large part of the responsibility for the Crimean War was laid.

The Cannings were now returning from England to Constantinople, and Lady Canning insisted that Lear should come with them. It was, for him, a heaven-sent opportunity : his journey would be made in the greatest comfort and at no expense to himself in the ambassador's private ' man-of-war steamer ' ; and his position in Constantinople, as a guest at the embassy, would carry with it unique advantages. And, even apart from the attractiveness that their position inevitably lent them in his eyes, he found the society of the Cannings and their three daughters both cultivated and sympathetic.

Moreover, they were to stay a week, on the way, at Athens, which he had not yet seen. He started off from Corfù in the highest spirits.

The Cannings' stay at Athens was prolonged, and Lear took the chance, after a fortnight there ' working like mad,' to see some more of Greece. He had found in Athens a friend called Charles Church, nephew of General Sir Richard Church who had led the Greek army in the struggle for independence which had cost Lord Byron his life, and whom Lear describes as ' one of the great Athenian senators and movers of the new country.' Charles Church himself was later Canon of Wells, and one of the large number of Lear's lifelong friends. He was a good Greek scholar and linguist and an ideal companion in the tour which they now decided to take together. But this journey was marred by misfortune, and ended in disaster. The first day Lear's horse fell and he was thrown over its head, hurting his arm and shoulder. He refused to go back, and they visited Marathon, Chalcis, Thermopylae and other places, Lear indomitably drawing and sketching all the time, in spite of the continued pain of his sprained shoulder, which made it impossible for him to ride—impossible also to sleep, in the extreme discomfort of the ' khans ' in which they stayed (and which provoked him to a characteristic bad pun : ' " khan "—so called generally because one tries to live there but *can't* '). Then he was bitten by a ' centipede or some horror,' which caused a great swelling on his leg. Then he went to Plataea ' forgetting my umbrella, where the sun finished me.' By the time they reached Thebes he was in a high fever : he remained there for ten days, dangerously ill, and was brought back to Athens ' by 4 horses on an indiarubber bed.' But his spirit was unbroken by all these misfortunes, and even in spite of them he had managed

to extract a large amount of enjoyment and profit from his tour. 'I have made many drawings of great value,' he tells Ann, 'and hope my time and money are well spent in ensuring me a stock of classical subjects for future paintings.'

By the time he was well again, the Cannings had gone on to Constantinople, and he embarked upon the steamer *Alexandre* to follow them. But no sooner on board than he was prostrated by a second attack of fever combined with erysipelas, and, on arrival in Constantinople, had to be 'put in a Sedan chair and carried forthwith to the English hotel, which is at the top of the hill of Pera.' Lady Canning came to the rescue and he was removed by boat to the embassy at Therapia on the Bosphorus, where he gradually recovered under her kindly care. 'Lady Canning feeds me and spoils me in the kindest way possible . . . she is as kind as 70 mothers to me.' The fever had made him bald and 'very venerable.' It had also, it seems, prejudiced him against the local land-scape, of which he was very contemptuous. 'Could I look out on any scene of beauty, my lot would be luminous ; bless you, the Bosphorus . . . is the ghastliest humbug going ! Compare the Straits of Menai or Southampton Waters or the Thames to it ! It has neither form of hill nor character of any possible kind in its detail. A vile towing-path is the only walk . . . all the beauties of this far-famed place savour of picnics, etc. . . . But lest you think ennui or illness disgust me let me say that Thebes and Athens shed a memory of divinest beauty over much worse and more tedious sufferings than those I have endured.' When he grew better, however, and was able to see more of the place, he found many things to look at and admire—and to draw.

He was fortunate, during the time that he spent there after his recovery, in being able, in company with the Cannings

(it seems they were the first Christians ever allowed to do so), to witness the great ceremony of 'foot-kissing' in the second court of the Seraglio. He gives Ann a literal and somewhat unimaginative account of this rite, by whose inner significance he was entirely unmoved. (But Lear, in many ways, remained always the typically 'insular' Englishman of his period.) 'I never saw so grand a spectacle for novelty and magnificence,' he writes : 'it gave one a wonderful idea of the Barbaric Despot sort of thing one has read of from a child.' After an endless procession of ' scores and scores of officers of state, generals, etc. on superb horses, whose hangings of velvet and gold beat anything I ever saw . . . there was a space—and then came 2 by 2 on horseback all the Pashas (there is a great silence in all this—and it is very like a funeral for solemnity). The Pashas have a magnificent bunch of diamonds in their scarlet caps, and their blue uniform is most richly embroidered in gold. . . . A long space followed—and a dead silence ; and lastly, surrounded by scarlet-and-gold-dressed guards, with halberts or pikes, and carrying most wondrous crescent-like plumes of green and white feathers, rode the Grand Seignor himself, as if he were in a grove of beautiful birds. I can't say much for His Sublimity's appearance. He is about 25, of a mild, but worn-out look, as if he cared for nothing or nobody. Wrapped in a long blue cloak, he looked positively shabby.' In the Second Court, to which the Sultan now proceeded, was 'a throne of gold tissue, and all around were the infinity of Pashas, generals, etc. etc. . . . The chief Emir—next in blood to the Sultan's family—clad in green from top to toe came before the throne and offered incense (after we had waited an hour or more), and then he stood there like a statue. Presently the music struck up, and the Sultan dashed

out of the dark Kiosk and sat down on the throne, but rose again instantly and stood upright. Then the green man rushed towards him and went down on the ground—and so he did 3 times ; then reading a line or 2 from the Koran off he went and down sat the Sultan. . . . After that for a mortal hour or more filed away the Pashas and generals and colonels, in a most endless circle. The first kissed his foot while he stood ; the second rank he sat down to and the last only threw some dust on their heads. When this was all over (and I was glad it was) the Priesthood passed in review. . . . After all these, other inferior officers passed by, till the Sultan rose, and shot into the Kiosk all of a sudden, and the troops roared out Allah something. It was over. The Sultan never moved a muscle of his face or a limb—like an automaton he was.'

His health completely recovered, Lear spent two or three weeks busily sight-seeing and sketching. He was no longer disgusted, as he had been at first, with Constantinople and the Bosphorus, which he now found to be as picturesque and exotic as his heart could desire. His excitement and enthusiasm acted as a tonic to him after his illness, and the time left to him was all too short for the work he was determined to carry out. Soon after the beginning of September he left for Salonika, his intention being to join Charles Church at Mount Athos and return with him to Athens through Thessaly, Epirus and Acharnania. But this plan was frustrated by his finding that there was an outbreak of cholera at Salonika. Three-quarters of its inhabitants had deserted the city in a panic and were ' living in tents and eating melons. Nearly the whole place is shut up.' Mount Athos was, as a result, entirely closed to travellers : the only road left open was the road across Macedonia to Monastir and Albania, and Lear,

therefore, anxious to escape as quickly as possible, turned his face westwards instead of eastwards and resolved to make his way right across the Peninsula and then southwards to Yanina and Athens. He had secured the services of a Bulgarian dragoman who was an accomplished cook, spoke seven languages, and was in all other ways competent to conduct the enterprising traveller through the wild and unfrequented mountains which they would have to cross. Their first halting-place was Yenidje, and Lear, armed as usual with letters of introduction, was staying with the postmaster. As they were drinking coffee in the evening an incident occurred which, though unfortunate in itself, provided an example of Oriental good manners which filled him with delight. In his awkward, short-sighted way (in a room where there was neither table nor chair) he stepped heavily on his host's handsome pipe-bowl. He apologized profusely through his interpreter, to which the postmaster, bowing as he sat cross-legged on the floor, replied : " The breaking such a pipe-bowl would indeed, under ordinary circumstances, be disagreeable ; but in a friend every action has its charm. . . ."

Yenidje, indeed, was highly civilized compared with the towns to which they soon came, where travellers were almost unknown. Set in the midst of superb mountain scenery, among lakes and rivers and great forests of walnut and oak, beech and chestnut, their inhabitants were picturesque but primitive. Under Turkish dominion and Mohammedan by religion, they were violently hostile to Christians ; and drawing and painting savoured, to them, of evil magic. At Monastir crowds surrounded the innocent artist as he sat sketching, with cries of " Shaitan ! " (" Devil ! ")—till he was forced to seek a guard, armed with a whip, from the local

Pasha : at Ochrida, in Albania, he was pelted with stones and sticks, and forced, in self-defence, to take to a fez ; at Tirana he was attacked, ballet-wise, by a Dervish who denounced him with frantic imprecations. He gives the following account of his adventures in another of these remote Albanian towns, Elbassan.

' No sooner had I settled to draw—forgetful of Bekir the guard—than forth came the population of Elbassan, one by one, and two by two, to a mighty host they grew, and there were soon from eighty to a hundred spectators collected, with earnest curiosity in every look ; and when I had sketched such of the principal buildings as they could recognize, a universal shout of " Shaitan ! " burst from the crowd ; and strange to relate, the greater part of the mob put their fingers into their mouths and whistled furiously, after the manner of butcher-boys in England. Whether this was a sort of spell against my magic I do not know ; but the absurdity of sitting still on a rampart to make a drawing, while a great crowd of people whistled at me with all their might, struck me so forcibly, that come what might of it, I could not resist going off into convulsions of laughter, an impulse the Gheghes seemed to sympathize with, as one and all shrieked with delight, and the ramparts resounded with hilarious merriment. Alas ! this was of no long duration, for one of those tiresome Dervishes—in whom, with their green turbans, Elbassan is rich—soon came up, and yelled " Shaitan scroo ! shaitan ! " (" The Devil draws ! the Devil ! ") in my ears with all his force ; seizing my book also, with an awful frown, shutting it, and pointing to the sky, as intimating that heaven would not allow such impiety. It was in vain after this to attempt more ; the " Shaitan " cry was raised in one wild chorus— and I took the consequences of having laid by my fez, for

comfort's sake, in the shape of a horrible shower of stones, which pursued me to the covered streets, where, finding Bekir with his whip, I went to work again more successfully about the walls of the old city.

'Knots of the Elbassaniotes nevertheless gathered about Bekir, and pointed with angry gestures to me and my " scroo." " We will not be written down," said they. " The Frank is a Russian, and he is sent by the Sultan to write us all down before he sells us to the Russian Emperor ".'

At Croia his reception was more kindly. ' Croia, the once famous city of the Greek Scanderbeg, who resisted the Turks for so long a time . . . is a charming little town all up in the sky . . . and it takes a good 4 hours to get up to it. On the highest point is now a beautiful palace belonging to Ali Bey—and there we went. He is a mere lad of 16 or 18, but most good-natured and well-bred—poor little fellow. The way he showed me the contents of a common writing-desk as wonderful curiosities, was droll enough. We could not say a word to each other but through Giorgio—so I drew for him, and amused him immensely by drawing a steam-carriage and saying—rattlerattlerattlerattle—and a ship-steamer—saying wishwashsquishsquash—at which the poor boy laughed immensely. All this is only odd, because the state and ceremony about him makes such a contrast; when you see old men kneeling, and great brawny fellows looking frightened out of their lives when he speaks, you naturally suppose a superior being is before you—and are amazed to find he is little more instructed than they are. . . . I gave Ali Bey a pencil and some needles for his mother, which delighted the poor child. He showed me all the rooms in the Harem, no one being there—so that is an opportunity I may never

have again. Here this boy is to live, doing nothing but smoke from morning to night all his life ! ! '

After visiting Scutari, Durazzo and Berat, which lies close under the great Mount Tomohrit, Lear went southwards to the Khimara province, in which lies the Promontory of Akrokeraunium, into whose utter remoteness no English traveller had ever before penetrated. Here, he told Church, he ' lived on rugs and ate with gipsies and unclean persons, and performed frightful discrepancies for 8 days.' Khimara itself (the ancient fortress of Chimaera), perched on its towering black precipice above the sea and almost inaccessible, had become a hiding-place of refugees and exiles. On entering the gloomy hall of the fortress Lear realized almost immediately that the dark, stealthy figures silently surrounding him were those of men who, from some cause or other, had fled from justice in other lands. ' Of these there was one who, with his face entirely muffled excepting one eye, kept aloof in the darker part of the chamber, until having thoroughly scrutinized me, he came forward, and dropping his capote, discovered, to my horror and amazement, features which, though disguised by an enormous growth of hair, I could not fail to recognize. " The world is my city now," said he ; " I am become a savage like those with whom I dwell. What is life to me ? " And covering his face again, he wept with a heart-breaking bitterness only life-exiles can know.' Unhappily Lear gives us no clue to the identity, or even the nationality, of this mysterious figure—a notorious swindler ? A murderer ? An Italian revolutionary leader ? A disgraced royalty ?—who, from his appearance, his behaviour, his surroundings, might be taken straight from the pages of Mrs. Radcliffe or some other of the Tales of Terror of fifty years before—or from Byron's *Giaour* :

Dark and unearthly is the scowl
That glares beneath his dusky cowl.
The flash of that dilating eye
Reveals too much of times gone by ;
Though varying, indistinct, its hue,
Oft will his glance the gazer rue.

 ＊ ＊ ＊ ＊ ＊

And here it soothes him to abide
For some dark deed he will not name. . . .

Byron, again, came to Lear's mind when he visited the palace of Tepeleni, birthplace and stronghold of the notorious Ali Pasha of Yanina, 'Ali the Lion,' the robber chieftain celebrated for his courage, his savage cruelty, his treachery, his avarice, who for many years had defied the Turkish rule —until at last, defeated, his venerable head had been exposed on a silver dish to auction in the markets of Constantinople. Beneath ' the glittering minarets of Tepalen ' Ali had received Byron in all the spectacular barbarism of his court—a visit which Byron described in *Childe Harold's Pilgrimage :*

Amidst no common pomp the despot sate,
While busy preparation shook the court,
Slaves, eunuchs, soldiers, guests and santons wait ;
Within, a palace, and, without, a fort.

 ＊ ＊ ＊ ＊ ＊

In marble-paved pavilion, where a spring
Of living water from the centre rose,
Whose bubbling did a genial freshness fling,
And soft voluptuous couches breathed repose,
ALI reclined, a man of war and woes :
Yet in his lineaments ye cannot trace,
While Gentleness her milder radiance throws
Along that aged venerable face,
The deeds that lurk beneath, and stain him with disgrace.

Now—only forty years later—the glories had vanished, and Tepeleni was nothing but a desolate heap of ruins.

Lear concluded his Albanian tour with a visit to Yanina, where he still hoped to find Charles Church, but missed him by two days. He had been invited by another friend, John Cross, to meet him in Malta and spend the winter with him (at his expense) in Egypt and Palestine. So he hurried on to Prevyza, but—what with storms and earthquakes and quarantines—missed the Malta boat, and when he eventually arrived there, found that Cross had already left. He was forced to spend Christmas in Malta, and pursued his friend, as soon as he could, to Cairo. Cairo astonished him. ' I shall never be surprised again at anything after the streets of Cairo,' he wrote to Ann. He visited the Pyramids, which he found equally surprising. ' The biggest of all possible things ! !—and as for the Sphinx, oh dear me ! what a size ! and the world of sand ! I really am so surprised I don't know what to do ! ' But he and his friend spent only a few days there, sight-seeing and buying necessary equipment for their expedition to Mount Sinai. They bought ' beds, carpets, pipes, eatables, etc.' and Lear a ' capital hat lined with green [was this the " runcible hat " of later days ?] and a double umbrella, and a green gauze veil, and an Arab cloak, and a thick Capote.' Thus equipped, they set off, travelling along the overland route from Cairo to Suez, the usual road for all travellers to India and the East before the days of the Suez Canal. Lear found the camel, as a steed, easy and comfortable, but in other ways unsatisfactory. ' I give my camel a bunch of green morning and evening—but all attempts at making friends are useless.' They reached Mount Sinai and spent three days in the monastery there, but this, for Lear, was the end of the expedition. On the

way back, at Suez, he fell ill with a bad chill and threatenings of fever : bitterly disappointed, he returned, as soon as he was able, to Cairo and then to Malta, while his friend went on to Palestine without him.

Fate, however, had arranged this momentary frustration of his plans in order to bring about an event of far more enduring importance ; for it was during the few brief days of his visit to Malta that Lear first came to know the young man who, for the rest of his life, was to be his closest and most dearly loved friend—a closer friend even than Chichester Fortescue. Franklin Lushington, a young barrister, was staying there with his brother Harry, who was secretary to the Governor : he was twenty-seven—ten years younger than Lear. This was another instance—like those of Fortescue and Baring—of Lear's remarkable faculty for making an intimate friendship, with a man much younger than himself, that was no less lasting because it was quickly formed. Within a week he and Lushington had left Malta together for a tour in Greece.

In a life in which there was little of passion, much of melancholy and loneliness, Lear's friendships were of supreme emotional importance to him. Of less intimate friends he had a great number—with whom he kept up a regular correspondence, with whom he went to stay when he came to England, who bought his pictures. To them he was known as a popular social figure, who 'knew everybody' and was a welcome guest in country houses all over England and at dinner-parties in London. But he never liked purely 'social' life ("I am sociable, but not gregarious," he would say), and as he grew older it was his few intimate friendships which, apart from his work and his great love of children, occupied his whole interest. As for marriage, the idea of it

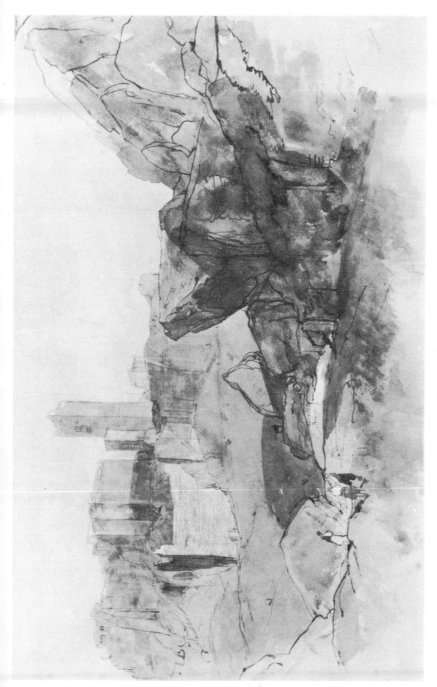

Athens, the Acropolis, watercolour, 1848

Tivoli, watercolour, 1849

did not attract him in his younger days : twice he considered it seriously—once in middle life, once again when he was nearly sixty—but more for the friendly comfort and companionship it might provide than for any romantic feeling towards the ladies concerned. The deepest feelings of his heart were reserved for his friends, his greatest sadness that, through the changes and chances of life, he could see them but seldom and have so little of the true companionship that he craved. Yet—even if circumstances had been different—it is doubtful whether it was in Lushington's nature to have given Lear the close, unquestioning intimacy he desired. Probably he never understood how much Lear loved him, nor that he held the supreme position in his heart. His extreme reserve and apparent lack of affection were often, in spite of—and because of—Lear's devotion to him, exasperating to a more demonstrative nature. 'A diamond as to value,' Lear describes him, ' yet hidden in a tortoise's shell, and doing nothing so little as contributing an iota of personal experience for the benefit of others.' Lushington was one of those whose feelings, though solid and loyal, were so little shown that his friends were sometimes provoked to question their existence. Some of his silence and moroseness, in later years, may perhaps be attributed to the succession of sorrows which overtook his family, of whom he himself seems to have been the most robust member. Two of his brothers died young, one of his sisters was a chronic invalid, and the atmosphere of the Kentish home where he had been brought up (where now his elder brother Edmund lived) was one of gloom and of a proud suffering that neither asked nor accepted sympathy.

But Lear, at the dawn of this new and stimulating friendship, little suspected the difficulties it would give rise to in the future, when each fresh cloud of misunderstanding would

bring him to despair and wretchedness, each reconciliation
to a new conviction of his friend's perfections and his own
supposed morbidity and quickness of temper. Now, in
March of 1849, they left Malta together for Patras in high
spirits. The tour, like his tour in Greece with Church the
year before, began badly. Lear was a very poor sailor, and
the passage extremely rough. 'Pitching and rolling;
utterly disabled,' he wrote. 'In bed all day—very ill. Yet
ate red herrings " on principle ".' And no sooner arrived at
Patras than he caught a bad chill and fever. However he
recovered quickly, and after these first troubles everything
went well—apart from the usual discomfort of the 'khans.'
'A sleepless night. Andrea's terrific snoring ; a squally baby
in the next room ; dogs out of doors ; goats and horses below ;
and fleas innumerable. Also rain.' But, on the other hand,
'I do not know when I have enjoyed myself so much. My
fellow-traveller draws as much as I do, and we only complain
that the days are too short. . . . Mr. Lushington has been so
constantly the most merry and kind travelling companion. . . .'
During the two months of their tour they traversed the
whole of the Peloponnese, visiting Bassae, Sparta, Mycenae,
Corinth : then to Athens : then Aegina and Sunium : then
northwards to Thebes and Delphi, and back again to Athens.
Lushington records an instance, during this journey, of Lear's
unquenchable humour. 'I remember one night in Greece,'
he wrote many years later, 'when, after scrambling for 15
hours on horseback over the roughest mountain paths, we
had dismounted and were waiting in black darkness for our
guide to find among a few huts a tolerably weather-tight
shelter for us to sleep in, Lear, who was thoroughly tired,
sat down upon what he supposed to be a bank ; but an instant
grunt and heave convinced him of error as a dark bovine

quadruped suddenly rose up under him and tilted him into the mud. As Lear regained his feet he cheerily burst into song :

" *There was an old man who said, Now*
I'll sit down on the horns of that cow. . . ." '[1]

The tour was a great success. To see more of Greece, whose ' divinest beauty ' had already charmed him (so that, although he was no archæologist, it remained, all his life, the country he loved best), and to see it in company with one whose growing friendship, as yet unmarred by differences, was becoming daily more precious to him—this was a combination of circumstances that produced what were probably the happiest weeks of all his life. Among all his many journeys this one stood out always as the best. He was passionately interested in every detail, whether of landscape or flowers, or peasants' costumes, and came back with two hundred sketches large and small. Lushington had to leave him towards the end of April, and Lear, anxious to complete his material for the travel-book he had in mind, went on alone to Southern Albania to visit the places he had missed the year before. Starting from Prevyza he went up to Yanina, thence eastwards over the Pindus range into Thessaly ; to Larissa, the Vale of Tempe and Mount Olympus. He had hoped to visit Mount Athos, but was again prevented, this time by bad weather which pursued him all the way as he re-crossed the Peninsula to Yanina and Corfù.

In his various tours during 1848 and 1849 he had covered the whole of the Greek Peninsula, from Salonika in the north-east and Scutari in the north-west to the extreme southerly points of Messene in the Peloponnese and Sunium in Attica. During the next two years he busied himself in

[1] *Macmillan's Magazine.* April 1897.

drawing out lithographs from his sketches and in writing up the diaries which he had kept on the spot, and *Journals of a Landscape Painter in Greece and Albania* appeared in 1851. It was well received. 'I should think,' he wrote, 'that little book has had as much good said of it as any ever have.' It deserved its reception, for it provides a lively and very readable account of regions which, even to-day, are comparatively little known. He paid a tribute to his travelling-companions which does honour, not only to them, but to his own good feeling. 'Anyone—it is certain—more quiet and good and full of all sorts of intelligences and knowledges than Lushington a man could not travel with. Charles M. Church, John E. Cross, and F. Lushington are three companions within 12 months such as few could fall in with. How this fly got into all that amber I can't understand—" one wonders how the devil it got there ".'

Lear saw much of Lushington during the next two years, which were spent mostly in London, and it was through him that he first met Alfred Tennyson, whose sister Cecilia had married Lushington's elder brother Edmund. The beauties of Park House, near Maidstone, where they lived, were described by Tennyson in the Prologue to *The Princess*:

> *. . . the house*
> *Greek, set with busts : from vases in the hall*
> *Flowers of all heavens, and lovelier than their names,*
> *Grew side by side ; and on the pavement lay*
> *Carved stones of the Abbey-ruin in the park. . . .*

In 1850 Tennyson—whom Lear had admired, as a poet, long before he met him—was made Laureate : in the same year he married Emily Selwood, and the friendship between

68

him and Lear was strengthened by the affection and sympathy which quickly grew up between his friend and his wife. When Lear was in England he never failed to pay them a visit ; and he wrote frequently to Emily Tennyson, for whom he entertained a devoted admiration all the rest of his life. 'I should think,' he told Fortescue, 'computing moderately, that 15 angels, several hundreds of ordinary women, many philosophers, a heap of truly wise and kind mothers, 3 or 4 minor prophets, and a lot of doctors and schoolmistresses, might be boiled down, and yet their combined essence fall short of what Emily Tennyson really is.' She had the gift of true sympathy, and became, for him, an angel of consolation to whom he poured out his troubles. Illness, financial worries, grief for the death of a friend, depths of melancholy and loneliness—all brought a ready response from one who herself suffered much from ill-health and who had her own difficulties and sorrows ; for to be married to Alfred Tennyson was no sinecure, and the early death of her son Lionel was a grief from which she never fully recovered. She understood Lear's character better, perhaps, than anyone : she understood, also, the bitter loneliness that often beset him, and the difficulties of his relationship with Lushington. 'You are not alone, Mr. Lear,' she wrote to him at a time when depression seemed to have vanquished him ; 'you cannot be while you can be so much to those so very dear to you, to those to whom so few are anything but the mere outside world. But one would be all, and, in that one cannot be, here is the loneliness.' It was Frank Lushington to whom she was alluding, Lushington of whom, fond as she was of him, she was a little afraid. 'Sometimes when with Frank I grow just as silent as he is,' she told Lear, 'unless it happen that I am with him alone, and

then I can generally conquer the shyness which his silence brings.'

When his Greek and Albanian journals were published, Lear sent a copy of the book to Tennyson, who expressed his appreciation of it in a poem :

To E. L. on his Travels in Greece

Illyrian woodlands, echoing falls
Of water, sheets of summer glass,
The long divine Peneïan pass,
The vast Akrokeraunian walls,

Tomohrit, Athos, all things fair,
With such a pencil, such a pen,
You shadow forth to distant men,
I read and felt that I was there :

And trust me while I turn'd the page,
And track'd you still on classic ground,
I grew in gladness till I found
My spirits in the golden age.

For me the torrent ever pour'd
And glisten'd—here and there alone
The broad-limb'd gods at random thrown
By fountain-urns ;—and Naiads oar'd

A glimmering shoulder under gloom
Of cavern pillars ; on the swell
The silver lily heav'd and fell ;
And many a slope was rich in bloom

From him that on the mountain lea
By dancing rivulets fed his flocks,
To him who sat upon the rocks,
And fluted to the morning sea.

Chapter VI

HOLMAN HUNT AND THE TENNYSONS

It was the day of the English country house. Every afternoon through the summer months, over the length and breadth of the land, whiskered footmen were spreading teatables under the ancient trees, bonnets were bobbing under fringed parasols, crinolines swaying across velvet croquet lawns. It was a time when the leisured class really was leisured, when life, undisturbed by social conscience, passed smoothly and peacefully as did the golden days of summer. It was Victorian England. And who better to invite to stay than dear Mr. Lear, who could make everyone laugh and make everyone happy—especially the children ; who could entertain the company with stories of the strange places he had visited, or, sitting down after dinner at the piano, could bring a lump to every throat as he sang, in his plaintive voice, his settings of the Poet Laureate's songs ?

So it was that, on his return to England after so long an absence, Lear's many friends were all anxious to see him, and he spent a long, happy summer in a round of visits to country houses. 'I trust to get through 14 or 15 visits out of my 68,' he wrote to Fortescue. He went, among other places, to James Hornby's in Lancashire (he was Lord Derby's brother-in-law), and to Knowsley, where Lord Derby himself, though failing in health, gave him a warm welcome. 'All this time I have been living in a constant state of happiness,' he wrote. 'Immense fun we have had, one has done little

but laugh, eat, drink and sleep. . . .' Everywhere he was a welcome guest, and especially where there were children ; and now he was making nonsense pictures and rhymes for the next generation of Stanley children, whose fathers and mothers he had amused when he was working at Knowsley nearly twenty years before. He could, if he had wished, have gone on leading this gay, sociable, country-house life almost indefinitely ; but its pleasant idleness began to pall and he longed to be at work again. By the middle of September he was back in London, having taken rooms in Stratford Place where he could live and work and also hold exhibitions of his paintings. He had 'nearly, all but' inherited a large fortune. 'However,' he tells Fortescue, 'I have never, it seems, been attentive enough to the old Lady who always said she would enrich me, so she has died and left all to 30 poor widows for ever and ever, and much better too that she has left it thus, for I should not have made as good use of it. I thought directly I heard of this matter that I would instantly marry one of the 30 viddies, only then it occurred to me that she would not be a viddy any more if I married her.'

He had deeply regretted, during his recent tours in Albania and elsewhere, that he had never made a study of figure-drawing. What his work demanded, he had written, was ' *hard study* beginning at the root of the matter, the human figure, which to master alone would enable me to carry out the views and feelings of landscape I know to exist within me. Alas ! if real art is a *student*, I know no more than a child, an infant, a foetus.' Accordingly, now that he was settled in London, he set about to remedy this defect. In order to become a student at the Academy Schools it was necessary to pass an examination. ' What fun ! pretty little

74

dear !' he wrote to Fortescue; 'he got into the Academy he did. Yes, so he did. . . . I tried with 51 little boys, and 19 of us were admitted. And now I go with a large book and a piece of chalk to school every day like a good little boy. . .'

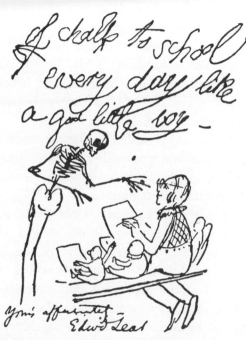

And so, for the next four years, his life was spent—working hard in London most of the year, holding exhibitions in his studio at Stratford Place, preparing his travel-books on Calabria and Albania. His oil-painting, 'Claude Lorrain's House on the Tiber,' was hung at the Royal Academy in 1850—the first of his pictures to be exhibited there. Each summer he would pay visits to his many friends in the country—including always the Tennysons and his sister Mrs.

Newsom, where, generally, he would see Ann : in 1851 he
took a tour in Cornwall with Lushington, and stayed for
several weeks by himself at the little village of Lydford in
Devon. He went there for the sake of health and economy,
but the bad weather seems, at that moment, to have fully
justified his horror of the English climate ; he was bored and
miserable, and his work did not progress. ' There is only one
fine day out of 15,' he wrote, ' and all the rest are beyond
expression demoralizing and filthy. My " straitened circum-
stances " forbid moving now I am here, and besides, I hate
giving up a thing when I try it, and having declared I *would*
paint the Glen scene, I *will*, I'll stay till I do. . . . I don't
improve as I wish, which, added to the rain, and the view,
prevents " happiness and tranquillity." It is true I don't
expect to improve, because I am aware of my peculiar incapa-
cities for art, mental and physical. . . .' He was saddened,
also, at this time, by the death of his old friend and patron
Lord Derby.

Lear's dissatisfaction with his own work, his feeling of
hopelessness and ineptitude, were soon, however, to receive
a new stimulus of a kind that was vitally necessary to him.
He had been, to a great extent, self-taught : he was now
aware that he had learned all that he was capable of teaching
himself, and was searching, unconsciously, for the guidance
and encouragement of someone who should combine a
knowledge of technique superior to his own with a person-
ality and a seriousness of aim ʳhat he could respect. These
qualities he found almost ideally united in William Holman
Hunt, who, though only twenty-five, had already made a
certain reputation. He was one of the original members
of the recently-formed Pre-Raphaelite Brotherhood, whose
works were causing the scandal and uproar which is accorded

with monotonous regularity to every form of artistic innova-
tion. The words of *The Times* critic on the subject of the
Pre-Raphaelite paintings in the Royal Academy of 1851
may seem, in relation to them, hardly credible ; but it must
be remembered that almost identically the same words have
been written and spoken many times since—in relation to
the ' decadent ' artists of the 'nineties, Whistler, the
Impressionists, the Post-Impressionists, the Cubists, and
' modern ' art in general ... ' The public may fairly require
that such offensive jests should not continue to be exposed
as specimens of the waywardness of these artists who have
relapsed into the infancy of their profession.' The centre
of the storm, the *ne plus ultra* of horror, was Millais' ' Christ
in the Carpenter's Shop '—a picture so inoffensive, to our
eyes, as to be insipid. Ruskin, however, was on the side of
the innovators. He wrote a letter replying to the hysterical
outbursts of the critics, and his powerful championship did
much to establish the position of the Pre-Raphaelite Brother-
hood.

The friend who brought Lear and Holman Hunt together
was Robert Martineau—himself a painter, now almost
forgotten, whose large canvas ' The Last Day in the Old
Home ' (in the Tate Gallery) is one of the masterpieces of
Victorian literary-sentimental art. The meeting, and the
friendly association which grew out of it, are described by
Hunt himself in his *Pre-Raphaelitism and the Pre-Raphaelite
Brotherhood :* his account, incidentally, throws some interesting
light both on his own, and on Lear's, methods of work.

' About this time [1852] Robert Martineau spoke to me
of Edward Lear, and gave me an invitation to his chambers
in Stratford Place to see his numberless drawings, which
were in outline, with little to indicate light or shade. Lear

overflowed with geniality, and at the same time betrayed anxiety as we turned over the drawings, avowing that he had not the ability to carry out the subjects in oil ; in some parts of them he had written in phonetic spelling the character of the points which the outlines would not explain—" Rox," " Korn," " Ski," indulging his love of fun with these vagaries.'

Lear asked Hunt his opinion as to whether such slight sketches could be used as material for large oil-paintings, admitting that his attempts to do so often reduced him to despair. Hunt, quite frankly, said that he would never attempt such a thing himself. Taking up a drawing of the Quarries of Syracuse, he pointed out that all the necessary ingredients—weather-worn escarpments of limestone, fig trees, clouds and azure firmament, and, finally, rooks—could be found in England. Indeed, they could all be found in the neighbourhood of Hastings, whither he himself was going almost at once to paint a picture of sheep with the cliffs of Fairlight as a background. Finally it was decided that they should take rooms together in some farm-house, and Hunt, with great good-nature, promised to become Lear's artistic adviser. It was the beginning of a long associa-ation. Although Hunt was fifteen years younger, their relation was that of master and pupil : Lear looked up to him with the admiration—almost the hero-worship—of a school-boy, and addressed him always as ' Daddy ' or ' Pa ' (just as he addressed Millais as ' Uncle '—or even ' Aunt '), for he came to consider himself, as a landscape-painter, to be a child of the Pre-Raphaelite Brotherhood. Hunt became henceforth one of Lear's regular correspondents. Lear's letters to him, full of affection and humour, are mainly concerned with painting, about which he is continually

asking his advice ; he admired his technique (but not always his subjects) so whole-heartedly that he strove, not altogether to his own advantage, to imitate it.

In the meantime Lear went on to Sussex and found suitable rooms. But, shortly before he left London, Hunt was puzzled to receive a letter from him ' of a perplexing nature, saying that it was unwise to do things on the impulse of the moment, and that he felt we ought at once to take precautions not to make our living together a cause of possible discord ; that we should arrange to divide the house and each have his own sitting-room, only meeting at meals. I was too busy to give special attention to this caprice, and acceded. William Rossetti, having a week's vacation, had agreed to come with me, and we went down together. It was curious to see the unexpected guardedness of Lear's reception of us, but he gradually thawed, and by the end of dinner he was laughing and telling good stories. When the cloth was cleared he said : " Now I had intended to go to my own room, but, if you do not mind, I'll bring down some of my drawings and pen them out here, so that we may all be together." This was agreed to, and while going over his pencil lines with ink he continued his conversation with William in Italian, principally in order to begin a course of lessons which he found I was desirous to receive. The proposed separate apartments soon became a joke, and then he explained laughingly that a dread had suddenly seized him that I might be a great lover of bulldogs, and that I might come down with two devoted pets of this breed. Dogs of all kinds, small and especially great, were his terror by night and day.

' The Martineaus lived close by, and had at that time a handsome dog called Caesar, a large Newfoundland, and a

great favourite of the family. . . . To Lear, a man of nearly six feet, with shoulders in width equal to those of Odysseus, the freaks of this dog were truly exasperating. "How can the family," said he, "ask me to call upon them when they keep a raging animal like that, who has ever his jaws wide open and his teeth ready to tear helpless strangers to pieces? They say it is only his play. Why, in the paper I lately read of a poor old woman who was set on by just such a beast! It was only his play, they said. Yes, but the poor old creature died of it nevertheless; such monsters should not be allowed to go at large. . . ." For the first week or ten days he accompanied me to the cliffs, painting the same landscape which I was using for my background. Thus he obtained acquaintance with my manner of work, professing himself satisfied with this; he soon after found some limestone rocks that had been extensively cut away, which served exactly for the principal feature of his "Quarries of Syracuse." He began this on a canvas some five feet in length, and his occupation separated us till the evening meal. Later, in the intervals of his other work, with a great deal of joking he exercised me in Italian, and beat out new Nonsense Rhymes which afterwards found a place in his well-known volumes.

'Lear certainly showed no sign of delicacy at first sight, although he had only saved his health by making Rome his home for thirteen years. . . . While we were at work out of doors he would tell stories of the incidents of his many wanderings, and surprised me by showing that he was uncombative as a tender girl, while at the same time the most indomitable being in encountering danger and hardship. Nothing daunted him, and yet no one could be more fearful than he of certain difficulties he had to face as the fixed conditions of travelling. He would rather be killed than

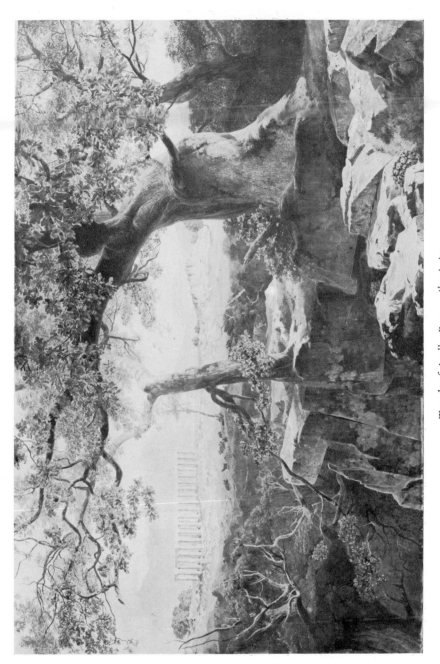

Temple of Apollo, Bassae, oil painting

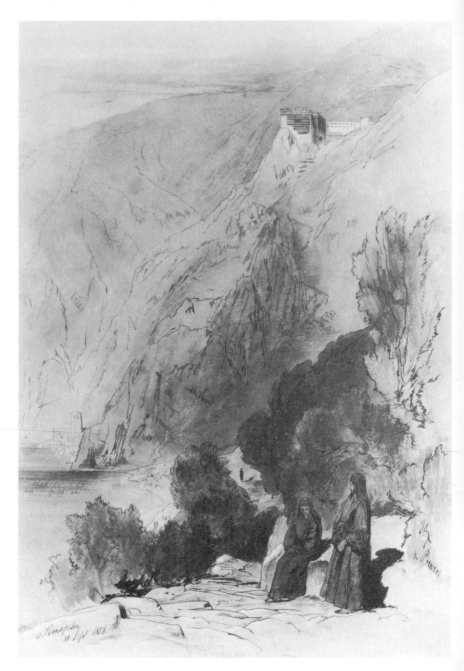

Simopetra, watercolour, 1856

fire a pistol or gun ; horses he regarded as savage griffins ; revolutionists, who were plentiful just then, he looked upon as demons, and Customs officers were of the army of Beelzebub. On the other hand, he had the most unquench-able love of the humorous wherever it was found. Recog-nition of what was ridiculous made him a declared enemy to cant and pretension, and an entire disbeliever in posturers and apers of genius either in mien or in the cut of the coat and affectation of manners.'[1]

While the two painters were thus happily occupied, Lear's spirits and self-confidence restored by companionship and encouragement, a letter came from Millais announcing his arrival at the farm. Lear had not yet met him, but Hunt had described him ' so glowingly that Lear remarked he was indeed a fit being to bring in the " Millaisneum " of art, but he inquired : " Is he disposed to lord it over others ? " " Well," I replied, " you know there are men who are good-nature itself, but who have a knack of always making others carry their parcels." " Oh, but I won't carry his ! " said Lear. " Yes, you will," I returned. " You won't be able to refuse."

' When the visitor arrived good comradeship was quickly established. The next day was perfect for a good walk, and we started early to reach Winchelsea and Rye, and take our chance for luncheon at the inn. We descended to the beach by Fairlight Cliffs, and had not walked far when we came upon cuttlefish bones lying about, clean and unbroken. Millais, when he had picked up a few, declared that he would take them home. The argument that they could be bought at any chemist's in London availed nothing, neither did the

[1] W. Holman Hunt. *Pre-Raphaelitism and the Pre-Raphaelite Brother-hood.*

remark that with our system of painting they were scarcely wanted. Millais said he had never before seen such good ones, and that a painter never knew when he might find them essential, so he filled a large handkerchief with the spoil. At the end of ten minutes he came up to me and coaxingly said : " I say, carry these for me now, like a good fellow, do." Lear was already exploding with laughter, while I said, " I am not going to spoil you. I will put them down here ; no one will take them, and you can get them on our return, or carry them yourself, my dear boy." Millais said : " They might be trodden upon," and could not understand why Lear laughed so helplessly, but his ardent good-humour urged Millais to appeal to him : " You carry it for me, King Lear," he said. At which that monarch of merriment, doubled up with laughter, declared that he would take the bundle, which he did with such enjoyment that he was incapable of walking sedately while the memory of my prophecy was upon him. " He doesn't carry his own cuttle-fish " passed into a proverb amongst us.'[1]

Lear, by painting in different places of the neighbourhood, was able to find all the necessary components of his picture—in one place the right kind of rocks with ' abundance of fig branches rooted in the fissures,' in another place ' rooks in hundreds.' With Hunt's advice and help the ' Quarries of Syracuse,' ' with ½-starved Athenians judiciously introduced here and there,' was finished : it received the Art Union Prize at the Royal Academy the next summer, and was bought by Earl Beauchamp for £250.

The two months at Clivevale Farm had been a time of great contentment for Lear, combining, as they did, many

[1] W. Holman Hunt. *Pre-Raphaelitism and the Pre-Raphaelite Brotherhood.*

of the things he loved best ; for hard work, congenial com-
panionship and pleasant surroundings were, for him, the ideal
of life. And there had been visits from Frank Lushington
and other friends : Coventry Patmore ' was to have come but
didn't ' ; and Lear tried to persuade Tennyson also to come,
being anxious for him to meet Hunt. ' The man living here
with me,' he wrote to Emily Tennyson, ' is Holman Hunt the
Pre-Raphaelite painter : he was the originator of that style
and (let Mr. R[uskin] say as he may) the most original in
idea, and the most thoroughly full of understanding concern-
ing portions of nature and art of any young man I have of
late seen. He is very plain and uneducated, except by his
own exertions—and if all Tennyson's poems happened to
be burned by a casualty he might supply their place as I
really think he knows all. I am much indebted to him for
assistance in art.' But Tennyson was unable to come, and
Lear went to visit him, instead, at Seaford, where he and his
wife and the baby Hallam were staying.

Tennyson, at the age of forty-three, was already famous.
The year 1850—two years before this time—had been a
memorable one for him. It had brought him the Laureate-
ship and a wife : and *In Memoriam* had run into three editions.
(Lear had sent some drawings as a wedding present, and the
bride had written to him : ' Very often shall we delight
ourselves by looking upon those beautiful drawings, which
give one, as Alfred said of one in particular, something of
the glory of nature herself looking upon them.') And now,
with fame and middle age, Tennyson was assuming more and
more the role of the Great Man—and in the days of Queen
Victoria it was possible for a Great Man to look and behave
as such without misgivings or false modesty. He liked to be
thought of, and even addressed, as the ' Immortal Bard ' ;

and his friendship made demands of subjection and uncritical admiration which were sometimes a little provoking. Of his friends Lear was one of the most constant, but it was for Emily Tennyson that he felt a closer personal sympathy, a more devoted respect, and to her that his letters were more often addressed. His admiration for Tennyson as a poet dated back to a period long before the general public had acclaimed him, and continued to be one of the strongest influences in his painting. It was Tennyson's true feeling for landscape which chiefly appealed to him. 'Alfred Tennyson's poetry,' he wrote, 'with regard to scenes, is as real and exquisite as it is relatively to higher and deeper matters : . . . his descriptions of certain spots are as positively true as if drawn from the places themselves, and . . . his words have the power of calling up images as distinct and correct as if they were written from those images, instead of giving rise to them.' Some of Lear's landscapes were described by his friend Lushington as 'Lear's sermons on texts taken from Tennyson.'

It was while he was at Clivevale Farm with Holman Hunt that he first conceived the project of illustrating Tennyson's poems—a project to which he clung with the greatest pertinacity, which was to occupy him on and off during the remaining thirty-five years of his life and was only to be partially realized, and that after his death. It was to be a complete edition of the poems, with one hundred and twenty-four landscape illustrations : he had worked out the whole scheme in detail, and wrote to Emily Tennyson asking her to obtain the approval of the Laureate. He spoke of Tennyson's 'genius for the perception of the beautiful in landscape,' which 'I am possibly more than most in my profession able to illustrate, not—pray understand me—from

84

any other reason than that I possess a very remarkable collection of sketches from nature in such widely separated districts of Europe, not to say Asia and Africa. But,' he added, ' my powers of execution do not at all equal my wishes, or my understanding of the passages I have alluded to.' Permission was given, and Lear, delighted, set to work. ' I don't want to be a sort of pictorial Boswell,' he wrote, ' but to be able to reproduce certain lines of poetry in form and colour.'

There had been trouble at the lodgings in Stratford Place : first the ceiling of the front room had fallen, and now, soon after Lear returned to London, the ceiling of the back room followed. So he packed up his belongings—such as the ruin had spared—and retired in disgust to Hastings, ' where at least there are fresh air and muffins.' There he spent most of the winter, seeing hardly anyone but Gurney Patmore, brother of the poet, who had been sent there for his health. ' G. Patmore and I ate up the Hare together . . . G. P. is better, but if he sits in a room heated to 180 degrees, why should he be exempt from consumption ? ' Lear was working at some of his large oils, painting, thanks to Holman Hunt, ' on an oly different principle, and so far with gt. success.' He had, in fact, become a Pre-Raphaelite. ' I really cannot help again expressing my thanks to you,' he writes to Hunt, ' for the progress I have made this autumn. . . . I am now beginning to have perfect faith in the means employed, and if the Thermopylae turns out right I am a P.R.B. for ever.' Lear could scarcely be called a true Pre-Raphaelite in his outlook : his affinities with Mantegna and Botticelli were highly questionable ; but, since the nature of his painting was essentially literary and descriptive, there is no doubt that Hunt's technical advice, especially in matters of detail, was

of great service to him in his oil-painting. Above all, it had restored his self-confidence. But Hunt's advice was not always easy to apply. During the next summer Lear went to stay at Windsor in order to paint a large picture of the castle which Lord Derby had commissioned from him. In the old days he would have made two or three sketches and some notes, and painted the picture comfortably in his studio ; now everything had to be done out of doors, on the spot. He wrote to Hunt complaining that the weather was so changeable that painting direct from nature was almost hopeless, and that it was 'utterly impossible to do this view on a strictly P.R.B. principle.' (Indeed, he did not finish the picture till a year later.) His devotion to Pre-Raphaelite ideals had also resulted in a bad cold. ' I went to church— late—just as the sermon was beginning,' he wrote, ' and having a cold in my throat and moreover feeling a draught, I put up my coat collar all round. What do you think the clergyman·instantly gave out as his text ?—" Be not stiff-neckéd "(!)—a personality he instantly followed up by— " Are *you* also stiff-neckéd, my brother ? "— ! ! ! '

In the summer, in London (where he had now taken new rooms in Oxford Terrace), there was the usual round of dinners and parties, to which he never lacked an invitation. He often grew weary of this kind of social life, but his being to a certain extent ' lionized ' helped the sale of his pictures on which his livelihood depended. He was very popular, too, as an after-dinner singer, when he would generally perform some of his own settings of Tennyson's songs. These compositions (four of which, ' Edward Gray,' ' A Farewell,' ' Tears, Idle Tears,' and ' Sweet and Low,' were published in 1853, dedicated to Mrs. Tennyson) have a considerable charm of their own and show a musical taste that is quiet

and distinguished without the over-sentimentality of the Victorian drawing-room ballad. His knowledge of music was limited, but he was able to accompany himself as he sang, which he did, we are told, ' with little voice, but with intense feeling and individuality,' so that he seldom failed to bring tears to the eyes of his hearers. Severer critics did not quite approve, and when he performed at a musical party at Millais' house in Cromwell Place ' the really musical people there were quite surprised at the eulogistic terms in which Tennyson spoke of the compositions.' Some of them were unkind enough to think that ' it was regard for the man rather than the music which caused this unexpected outburst of praise.' But others were enthusiastic. Archbishop Tait (then Dean of Carlisle), Lear tells us, ' once said, in a big party when I had been singing " Home they brought her Warrior " and people were crying : " Sir, you ought to have half the Laureateship ".'

EGYPT ; CORFÙ ; MOUNT ATHOS

To study the course of a man's life is like looking at one of those temperature-charts that hang above the beds of hospital patients. Some charts are dull, the line following an even track, with but minor fluctuations at intervals : others are a whole series of dramatic rises and falls, a range of peaks and ravines, exciting to the eye. Lear's life may be said to resemble both kinds. His outward life was made up of singularly few sensational heights and depths ; he travelled, he returned, he visited his friends, he wrote his 'nonsenses' and painted his pictures, and external events affected him but little as he pursued his even and industrious way. But his inner life was of a wholly different order. Here the chart-line oscillates violently : for a brief moment—when he has the companion-ship of a friend, when his work brings him success, when he forgets his troubles in the presence of children—it touches a lofty peak of happiness, only to drop giddily, a moment later, into the abysses of melancholy and loneliness.

That autumn, for him, was a bad one. 'I shall wait to see my friends with comfort in heaven—for in England is none for me,' he wrote to Emily Tennyson. The English climate had again brought him to despair, for he had gone to Leicestershire to finish his large canvas of Bassae, and, though the 'rox and oax' were of the proper Greek kind, the weather was not. Even a visit from Lushington, who had come up to Leicester for the Sessions, hardly brought

89

him comfort ; and renewed attacks of asthma and bronchitis further depressed him.

In December he left for Egypt. Letters to Ann from Gibraltar, Malta and Alexandria show a steady rise in spirits, a steady improvement in health, and by the time he arrived at Shepheard's Hotel—the journey from Alexandria to Cairo was by canal and river : ' the moon was full and our party sat up all night, singing glees and songs '—he was in a state of the highest enthusiasm. ' I can hardly believe I am in the same world. . . . I soon had a ride in the most wonderful streets of Cairo—than which there is nothing more marvellously picturesque in the world.' He joined Thomas Seddon, the landscape-painter, and together they awaited the arrival of ' Daddy ' Holman Hunt, who was expected by the next boat. But in the meantime Lear, falling in with some other friends, was invited to join an expedition up the Nile—an opportunity which he could not bear to miss. He left Seddon, therefore, and set off with a large party of English people in ' 4 boats together ; and 3 more go before, and 5 or 6 follow after.'

The next ten weeks were spent on the river : they visited Assiut, Thebes, Karnak, Philae (where they encamped for some days in one of the great rooms of the Temple), Lear sketching busily all the time and eagerly observing every new variety of flora or fauna.

At the end of April, much improved in health, he returned to England (Seddon and Holman Hunt had by this time gone on to Palestine) : on the way he stayed in Malta with Harry Lushington, his friend Franklin's brother, who was chief Government Secretary there. Arrived in England, he set to work to finish the two pictures which bad health and bad weather had forced him to relinquish in the autumn of

the previous year, Lord Derby's ' Windsor Castle ' and the large ' Bassae,' for which he again visited the rocks of Leicestershire, this time with happier success. His paintings of Marathon and Sparta were hung in the Royal Academy that summer, and he wrote to Holman Hunt, now in Jerusalem : ' The Academy Exhibition is unusually bad. . . . Frith's " Ramsgate Sands " is his best . . . the Queen has bought it. Landseer has a huge canvas full of slosh—melancholy to see when one thinks of what he could do if he liked. Buckner has a pyramid of babies. . . . Altogether the impression of standstillness as to the general run of painters is sad enough.' Academic painting at that time was as mechanical and as dead as it still is to-day, and the efforts of the Pre-Raphaelite Brotherhood to enliven it were met with official opposition and prejudice. There was a storm over the hanging of Millais' picture ' The Rescue,' and Lear wrote again to Holman Hunt : ' Of the mysteries of the hanging committee I shall not be diffuse, as it is an odious task . . . Everything possible was done to prevent P.R.B. paintings being seen : heaps were sent out—Madox Brown all, your drawings, etc., and Millais' wonderful work was hung so as to do the worst for it. But our friend saw it, and the row and hullaballoo he made was stupendous ! He forced the 3 [the hanging committee] to move it, threatening to resign instantly if they didn't. No such scene ever was known. . . . So much general disgust at the three hangers has never been excited. . . . My opinion of his picture is this—*that it is one of the most surprising works of genius in every way.* J.M. has won my heart also, by having no portrait in his study but yours. I have seen much of him at times of late.' Lear himself had sent the ' Bassae,' which was ' really well hung,' also a painting of Monastir, which was ' turned

out neck and crop.' He sold it, nevertheless, for one hundred and fifty guineas : as for the 'Bassae,' it was bought four years later by subscription for the Fitzwilliam Museum, Cambridge.

After a tour in Switzerland in the late summer, he made another attempt to settle down permanently in London. But it was a failure : again, during the winter, he was seriously ill, and his depression and restlessness returned. Always, all through his life, he felt this urgent desire to be on the move, to see new places : on its gratification depended his happiness, and to a great extent his health. It was not for nothing that he had chosen the profession of 'topographical land-scape-painter' : and the ambition of his life—to illustrate the scenery of all the countries of Southern Europe and the Near East, and later of India and Ceylon—served him as an excuse and a justification for his impulse to escape. Escape from what ? Primarily, from the place in which he found himself at the moment, from the monotony of familiar surroundings and the tedium of familiar tasks, from the society of people amongst whom—wherever he might be and however much he might like them personally—he felt himself, fundamentally, isolated. He felt this, at times, even with his most intimate friends. 'I feel woundily like a spectator, all through my life, of what goes on amongst those I know ; very little an actor,' he wrote to Alfred Tennyson at this time, after attending a farewell dinner given by Wilkie Collins for Millais, who was leaving for Scotland. 'If one were but a chimney-pot, or a pipkin, or a mackerel, or anything respectable and consistent, there would be some comfort ; but the years go by without making the use of one's faculties one ought to do, and so I feel disgusted I do.' This perpetual restlessness, this sense of detachment from

ordinary settled life, this feeling that he was different from other
men—were the origins of these to be found in the chronic
nervous disorder that beset him, the ' terrible demon ' of his
epilepsy ? However that may be, it is certain that their
fundamental cause lay, not in material circumstances, however
uncomfortable these may have been : there was some deeper
disquiet, some hidden and unrecognized anxiety which drove
him ceaselessly on and from which he could never escape,
because it was a part of himself.

One of the chief reasons for his attempt to settle in England
at this time had been his desire to be near his friend Frank
Lushington, from whom he had been separated for a long
time by his travels abroad. But this tie was almost immedi-
ately broken, for Lushington was appointed to a legal position
in Corfù and had to leave at once. ' The most intimate
friend I have in the world,' Lear wrote to Holman Hunt,
' is just going to leave England entirely.' Deeply depressed,
unable to make up his mind what to do, where to go, he
attended a farewell party for Lushington at his brother
Edmund's home in Kent. Tennyson himself was staying
with his sister and brother-in-law for the occasion. ' Alfred
Tennyson has just read us his new poem,' Lear told Holman
Hunt ; ' it is called " Maud," and is *most astonishing*. One
part, beginning " O that 'twere possible," is enough to make
you stand on your head.' It is not hard to see why Lear
appreciated some of those lines : they must have made a
poignant appeal to him in the circumstances.

Having said good-bye to his friend, Lear travelled back
to London. But London, now that Lushington was gone,
was more odious than ever to him : he was distracted in his
work ; and, popular as he was, its social life irked and depressed
him.

The shadow flits and fleets
And will not let me be:
And I loathe the squares and streets,
And the faces that one meets,
Hearts with no love for me. . . .

The lines, heard so recently at Park House, haunted him, and it was to their writer that he turned, to him and to his wife, always his angel of consolation. He wrote to Tennyson suggesting that he might come and stay near them in the Isle of Wight. 'Do you think there is a Pharmouse or a Nin somewhere near you, where there would be a big room looking to the North, so that I could paint in it quietly, and come and see you and Mrs. Tennyson promiscuously?' (It was characteristic in him thus to introduce nonsense words and spelling into his letters as a sort of apology for what might seem too bold, or, sometimes, too sententious, or too outspoken—a bridge between, on the one hand, his love of frankness, and, on the other, his easily embarrassed sensitiveness. Terrified of being thought presumptuous or pushing, he found in this nonsense-language a kind of cloak for self-consciousness.)

But this project came to nothing. Harry Lushington, Franklin's brother whom Lear had visited in Malta the year before, had been brought back, seriously ill, to Eastbourne, and Lear, hoping to be of use and comfort to him, spent a dreary summer there. The constant companionship of a dying man, the necessity of outward cheerfulness, the doubts which at the same time assailed him as to whether his presence were really welcome either to Harry Lushington or to his family—all this reduced him to a state of deep melancholy. Mrs. Tennyson, who understood the Lushington character,

tried to reassure him. 'They do understand you,' she wrote, 'and are at heart grateful and sympathizing, though the gift of utterance is except on rare occasions denied them.' So he remained at Eastbourne. Part of his time he employed in looking for a house for the Tennysons, who were thinking of moving to Sussex. After an expedition to see a house at Uckfield he wrote : 'It would no more do for you and A.T. than the moon would. . . . I enjoyed the walk immensely . . . only my feelings were hurt by passing so many flox of geese, who all saluted me and evidently recognized me as a fellow-creature of the same mental calibre as themselves. The Ducks never said a word. And I think it was not kind of the geese to compromise me so openly.'

After Harry Lushington's death, Lear returned to London, and as the autumn advanced fell ill himself with an attack of his old complaints, bronchitis and asthma. 'Pray be better,' wrote Emily Tennyson. 'You will laugh at me if I tell you to make them spread you a plaister of honey and flour (let it be tolerably thick on the cloth) and put it on your chest, but it really does both Ally and me good.' The question arose again as to where he should go to escape the winter in London. Frank Lushington had returned to England for a short time after his brother's death, and it was finally decided that, when he went back to Corfù in November Lear should go with him. The decision brought great relief to his mind, for the plan, promising, as it did, a warm climate, suitable subjects for a landscape-painter, and the company of his dearest friend, seemed to furnish every prospect of happiness.

Before leaving England he and Lushington went for a few days to the Tennysons' at Farringford. Everyone was in good spirits and the visit a great success : at a small

party one evening Lear sang his Tennyson songs with all his usual *verve*, so that his hearers were delighted and deeply moved, and Mrs. Tennyson wrote to him afterwards : ' I am afraid you will not believe me when I tell you what a hero of romance you are at Afton. How Miss Cotton was found all pale after a sleepless night, how her companion came and poured into my ear a mighty river of thanks and praises and admiration of all sorts.' But Lear remained unmoved by his conquest : his feelings had already suffered a reaction, and he answered : ' According to the morbid nature of the animal, I even complain sometimes that such rare flashes of light as such visits are to me, make the path darker after they are over. . . . I really do believe that I enjoy hardly any one thing on earth while it is present : always looking back, or frettingly peering into the dim beyond.'

Late in the autumn they left, travelling through Germany and Austria to Trieste and thence by steamer down the Adriatic. Lear, with his ' dear Franklin Lushington ' all to himself, was in the seventh heaven. ' Nothing can be so kind and thoughtful as my dear friend all the way,' he wrote ; ' making me take food when I did not care to leave the carriage, by buying cakes or bread and bringing them to me, and saving me all the trouble possible, although he, from being my mere travelling-companion in 1848–9, has now risen to one of the very highest places of the land at the age of 33. But he is as wonderfully good and even-tempered as he is learned and wise.' These dangerous heights of feeling, however, brought their inevitable revulsion. No sooner was he settled in lodgings in Corfù, no sooner had the normal, dull routine of life re-established itself, than he was plunged into the depths of depression and loneliness. All the

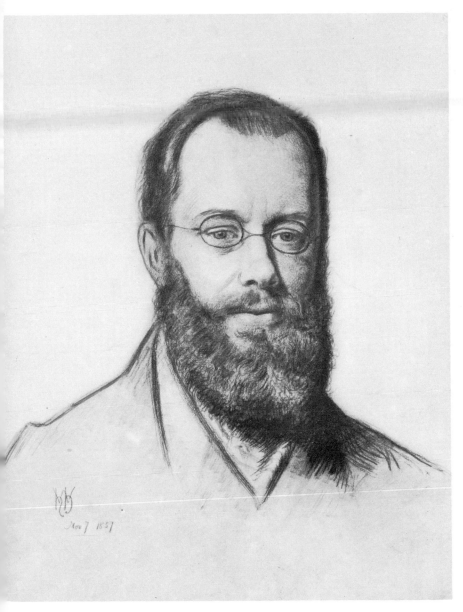

Edward Lear by Holman Hunt, 1857

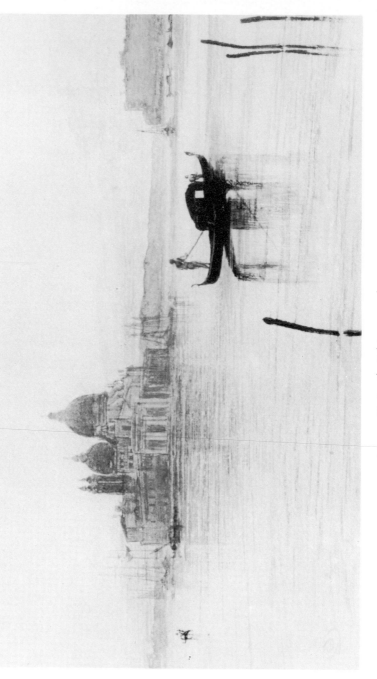

Venice, the Salute, watercolour

beauties of Corfù, its lovely climate, its immense orange trees, still, at this season, hanging with fruit

—like golden lamps in a green night—

all these availed him nothing. Lushington, who was one of the two English judges there, was so busy that Lear hardly ever saw him and bitterly regretted having come at all. ' I have . . . several times wished myself back again,' he wrote to his sister Ann, ' or rather, that I had never come. . . . The greatest sadness I have is that I shall hardly see anything of my friend. Not that his very high position here would make a difference, but it causes him to be wholly occupied. . . . I am wholly alone . . . and sit at home all day, almost unable to paint from very dejection. It is better you should know this, I think, than that I should sham and tell you I am happy. . . . Once or twice, finding I can be of no use to Frank, I have half thought of returning at once, but I think that would be rash and ill judged. If Ellen Lushington [Frank's sister] had come out and they had had a home, my days would have gone by in hopes of having someone to speak to in the evening—and some distant resemblance of better hopes might have been looked at, even though I knew they were shadows and not real. But that was not to be ; so that you see Corfù, present and future, is, and is likely to be, pain. . . . Certainly I have made a great mistake in coming to settle for months. . . . I have hardly known what to do for sheer melancholy sometimes.' But after a few weeks his state of mind improved : his friend was able to see him more often, and Lear, who was passionately devoted to the silent, conscientious young judge, was pathetically grateful for any attention or time that he gave him—though they had an occasional ' foolish misunderstanding.' At Christmas,

Lushington—to make up, perhaps, for past neglect—gave him a 'most exquisite gold watch, with a silver chain ; valuable in itself—but more that the watch has been his own, and the chain Harry's once.'

Things were better ; but still there were moments when he longed to be back in England—as when Mrs. Tennyson, in a letter describing the ' Christmas gambols ' at Farringford, gave an illuminating glimpse of the Poet Laureate, Mr. Jowett, and Mr. Palgrave playing Blind Man's Buff in the evening after the children had been put to bed. He began to know more people in Corfù and to spend more time with his friend ; they rode and walked and dined together, and sometimes Lear, for the sake of being with him, would even endure the odious pleasure of sailing with him in his yacht. After one of these trips Lushington wrote to Mrs. Tennyson : ' Lear is unluckily one of those people who have a natural hatred for being on board a boat of any kind— and though on one or two occasions he has tried with excessive amiability to like it, it is always pain and grief to him.' He began, also, to have a certain success with his paintings : the English colony, led by Lady Young, wife of the Lord High Commissioner, began to take an interest in him, and to buy and commission drawings from him. ' The big room at the Palace is all over " Lear ",' he wrote, ' Lady Young having 3 drawings of her own, and borrows everybody else's to copy—and indeed she copies them very nicely.' But he complained that, as a result of his popularity, the ' Court ' amused itself by coming to watch him sketch, which he did not like at all. He was even offered the director- ship of a School of Art to be established in Corfù, but refused it, feeling that it would destroy his independence. But, as a result of his sales, he was able to move to better rooms,

and also to purchase a 'photographic machine.' 'If I can come to use this mode of working,' he wrote to Ann, 'it will be of great service to me in copying plants, and in many things which distance, limited time, heat, etc. would prevent my getting.' But the machine does not seem to have been a success : it is never mentioned again.

It was at this time that there entered on the scene a figure that was to play an important part throughout almost all the remainder of Lear's life. Giorgio Kokali, whom he now engaged as his personal servant (his brother Spero was in Lushington's service), had been born in Corfù but was a native of Suli in Albania—Suli whose almost inaccessible rock-pinnacle had been obstinately and heroically defended, about half a century before this time, by its five thousand inhabitants against thirty thousand of Ali Pasha's soldiers. The siege had lasted for eighteen years, and had been brought to an end, amid scenes of appalling suffering, only by treachery. Giorgio seems to have inherited some of the qualities of his brave Suliot ancestors : a model of loyalty and quiet patience, for nearly thirty years he gave Lear his complete and unquestioning devotion, which his master rewarded with friendship and absolute confidence. Troubles between them inevitably there were at times—troubles for which, when the storm had blown over, Lear always exonerated Giorgio and blamed his own irritability and unreasonableness ; but on the whole it was a perfectly happy relationship and one which brought Lear a great deal of comfort, both material and spiritual. Lear himself taught Giorgio to read and write, and many years later Giorgio's three sons were all, at different times, in his service. In his diaries and letters there are constant allusions to the faithful Suliot who accompanied him on all his travels and looked after him with such constant care.

Two of Lear's paintings of Philae were in the Academy that summer, though, it seems, badly hung. His friend Holman Hunt (whose ' Scapegoat ' was also there, and sold for £450) praised them as ' excellent—great praise from him.' (Many were the times when Lear longed for Hunt's companionship in Corfù, where, he complained, he felt bitterly the lack of artistic sympathy.) It was in this year also that the Hogarth Club was started—' that afflictive phenomenon ' as Carlyle called it : ' a club not small enough to be friendly and not large enough to be important, a room to which nobody sends things and Friday night meetings to which nobody cares to go. Funerals are performed in the shop below through which one passes.' It held only one exhibition, at which Lear was represented in company with Hunt, Burne-Jones, Leighton, Morris, Watts and others of the Pre-Raphaelite circle.

In August Lear set off with Giorgio on his long-deferred expedition to Mount Athos. Crossing the Greek peninsula by way of Yanina, Larissa and Salonika, he spent nearly two months on the holy mountain. Its scenery he admired, but not its constitution and ethics. ' The worst was the food and the filth, which were uneasy to bear,' he wrote to Fortescue. ' But however wondrous and picturesque the exterior and interior of the monasteries, and however abundantly and exquisitely glorious and stupendous the scenery of the mountain, I would not go again to the "Αγιος "Opos for any money, so gloomy, so shockingly unnatural, so lonely, so lying, so unatonably odious seems to me all the atmosphere of such monkery. That half of our species which it is natural to every man to cherish and love best, ignored, prohibited and abhorred. . . . The name of Christ on every garment and at every tongue's end, but his maxims

trodden underfoot. God's world and will turned upside down, maimed and caricatured. . . . These muttering, miserable, mutton-hating, man-avoiding, misogynic, morose and merriment-marring, monotoning, many-mule-making, mocking, mournful, minced-fish and marmalade masticating Monx. . . .' The remedy he proposed for this sad state of things was drastic but simple. 'As soon as Parliament meets, move that all Sidney Herbert's distressed needlewomen be sent out at once to Mount Athos ! By this dodge all the 5000 Monks young and old will be vanquished : distressed needle-babies will ultimately awake the echoes of ancient Acte, and the whole fabric of monkery, not to say of the Greek church, will fall down crash and for ever. N.B. Let the needlewomen be all landed at once, 4000 at least, on the South-east side of the peninsula and make a rush for the nearest monastery ; that subdued, all the rest will speedily follow.'

His visit to Mount Athos brought him, indeed, little in the way of pleasure—especially as first Giorgio, then he himself, fell seriously ill with fever. But he accomplished his purpose and came back with drawings of all the twenty principal monasteries as well as of the landscape—fifty drawings in all, which, together with his journal, he intended to publish. But this latter part of the plan was never carried out.

Returning by steamer from Salonika, Lear visited the Dardanelles and Troy, and on arrival at Corfù found that his house was 'cracked in 3 places . . . a brutal earthquake having spifflicated my old rooms ' : he therefore stayed with Lushington until he could find new and undamaged quarters. The winter passed fairly happily, in spite of occasional diffi-culties with his friend, caused generally by the latter's taciturnity and lack of responsiveness, which were maddening

to Lear's more unreserved nature. But, to a character such
as his, nervous, excitable, generous, deeply affectionate yet
making great demands on the sympathy of others, always
ready (too ready, some—including perhaps Lushington—
may have thought) to give sympathy where it seemed to be
needed, passing swiftly from the greatest happiness to the
profoundest melancholy—to such a character these clouds
and storms were an inevitable part of intimate friendship.
'We have had one or two sad antagonisms,' he wrote to
Emily Tennyson, ' tho' we are perhaps better friends after-
wards. . . . I feel convinced we are best when not with each
other.' Then he added at the end of the letter, two or three
days later : ' Now what an unjust and beastly Hippopotamus
I am !—to have written what I did of Franky overleaf . . . I
am a beast, and ought to be squashed. . . . I have scratched
out some lines—only morbidisms—and I repent of morbid-
dious feelings. . . . Say or think what one will, he is the
most perfect character I have ever known.'

There were few distractions during the long, monotonous
weeks of winter : but some of the English residents were
agreeable, and some of them, moreover, had children, with
whom many of Lear's happiest hours were passed in making
nonsense rhymes and pictures—a never-failing form of
entertainment for himself as well as for his audience. And
there was a new clergyman whom he liked : ' Gracious ! a
clergyman with large black moustaches and a long black
beard. I never saw such a one before—but there he was,
and moreover he preached a very good sermon. . . . He
was one of the Crimean chaplains . . . and everybody agreed
how manly and how like better times he looked, in contrast
with the nasty effeminate woman-imitating shaved men
who have, since the moral days of Charles II, distorted the

human face out of its natural state.' His own appearance he also described to Ann : 'It is necessary to inform you that my beard is getting quite gray, and all my hair tumbling off ; and when I am quite bald, possibly I may take to painting my head in green and blue stripes as an evening devotion : but I have not decided about this yet.'

He was still restless and depressed, however, and when the spring came he decided he must go back, for a time at any rate, to England. His two excuses for doing so were that he could not finish his large oil-painting of Corfù without advice from Holman Hunt, and that he wished to see about the publication of his drawings of Mount Athos. But the real reason was his desire to escape from his present surroundings, from the loneliness and monotony of his life in Corfù, and from the unsatisfactory state of his friendship with Lushington. 'I can't stay here any longer,' he wrote to Fortescue, 'without seeing friends and having some communion of heart and spirit—with one who should have been this to me, I have none. And I can't bear it.' And to Holman Hunt he wrote : 'I have, alas ! too present a feeling of the want of all kind of sympathy not to find one of your letters most welcome. Perhaps to irritable natures of my temperament, my unsettled early life makes me more susceptible to what devours me here—isolation and loneliness, and sometimes drives me half crazy with vexation. Really, when anyone tells me, as you do, your own inward thoughts and feelings, it flashes across me that after all I *am* a human being, notwithstanding much of the past year and a half has almost made me come to think otherwise.' And, alluding to his picture, he says : 'I believe, *with your aid*, I can still make a fine thing of it. . . . You see, Daddy, you took an awful load of responsibility on yourself when you adopted me as

your son. Meanwhile I am frightfully in debt and *must* sell and get rid of something or other to set me straight. . . . I look forward to meeting you with great interest and hope. You are so solid and distinct in going on constantly in doing what is right ; I am so fluffy and hazy, and never know what is right and what isn't. . . . There are hours when I would rather life were abruptly ended—so as not to add weight to weight as my days but too often do.'

JERUSALEM : ADVENTURES AT PETRA

No sooner had he arrived in London than Lear invited Holman Hunt to come to the studio he had taken in Stratford Place, where he showed him the large picture of Corfù. As usual, the presence of ' Daddy ' Hunt had an effect on him that was both soothing and stimulating, and his advice, given with the calm certainty of one who knew his own mind, restored the self-confidence of the ' fluffy, hazy ' landscape-painter. He was able to finish his picture to such good effect that, before the summer was over, he had sold it to W. Evans, Esq., M.P., for five hundred guineas. His delight was great, but the money, though it eased his financial troubles, did not last long : it ' melted rapidly away in debt-paying, setting out New Zealand and other sisters, etc. etc.' But it was with a lighter heart that he went off, at the end of July, to see his friends in the country. He paid his usual visit to the Tennysons at Farringford, and later went to Ireland with Fortescue, first to the latter's brother Lord Clermont, and then to Ardee, to the house of his aunt Mrs. Ruxton (she left it to Fortescue at her death), where they stayed some weeks. Mrs. Ruxton was an energetic and somewhat tyrannical old lady of eighty-five. ' I never saw such an old lady ! ' Lear told Ann. ' She is 85 but does everything all day long—rises at 6—is walking all over the grounds, seeing to the gardens, etc. at 7 ; goes to her schools after breakfast . . . goes and visits all her poor people by

dozens ; somewhere about 6 comes in and writes for the post . . . at dinner she is full of fun and life ; afterwards listens to and asks for my music.' And, at exactly eleven o'clock, she would call for ' God Save the Queen,' and everybody would have to go to bed.

This was a visit to which Lear always looked back with a particular pleasure. The quiet, busy life of the house appealed to him in contrast with the restless idleness of many country houses, and he found it possible to work there. Moreover it was a delight to be with Fortescue again— Fortescue whose gaiety and charm and communicativeness were a welcome relief from the strain and intensity of his relations with Lushington. There was no need of any attempt to force an intimacy upon Fortescue : with him it was an easy give and take of ideas and jokes and common interests, a relationship that was all the more comfortable because the feelings involved were not so deep.

After leaving Ardee he went to Dublin ; thence to Liverpool, visiting Lord Derby at Knowsley and other old friends in the neighbourhood : then to Manchester to see the Exhibition, in which his large picture of Syracuse was hung. After more visits to friends in Wales, Gloucestershire and Somerset, he returned to London at the beginning of November, but left again almost immediately for Corfù. Crossing from Folkestone in a ' stereopyptic sophisticle steamer . . . the weather being miscelaynious and calm, thanks be to Moses,' he had ' a neasy passage . . . none the less so that there was Lady Somers to talk to and look at :—she is certainly the handsomest living woman.' Lady Somers had been Miss Virginia Pattle, and was one of the most famous beauties of the time. Lear admired her in every way. ' She is a most sweet creature. I think her expression of countenance is

one of the most unmitigated goodness I ever contemplated. I call that a model of a woman.' She also had the distinction of being one of the few women who had ever set foot on Mount Athos. 'It seems that she, S[omers] and Coutts Lindsay,' says Lear, 'really landed at Athos, and lived there 2 months! in tents, various mucilaginous monx coming now and then to see them.' The monks were gallant enough, it seems, to allow their rules to be broken in favour of the 'handsomest living woman.'

Lear continued his journey by Paris, Strasburg and Heidelberg (where he visited the Chevalier Bunsen, who had been ambassador in London a few years before) : thence by Dresden to Vienna, where he stayed with Robert Morier, an attaché at the Embassy (he was later ambassador at St. Petersburg), and passed most of his spare time absorbed in the intricacies of Dürer's draughtsmanship.

On arrival in Corfù, he was met by Giorgio, and immediately all things were ' precisely the same as they all were 6 months ago—the ludicrous sentiment of standstill and stagnation was truly wonderful. Wonderful at first, but gnawing and shocking to me now.' The depression of the winter before descended upon him again—a depression increased by irritation at the noisiness of the house in which he lived and at his consequent inability to work. ' A house . . . where you hear everything from top to bottom—a piano on each side, above and below. . . . Miss Hendon over my head . . . plays jocular jigs continually. You can neither study nor think, nor even swear properly by reason of the proximity of the neighbours.' And one of his greatest comforts of the year before had been removed : the Cortazzis had left. An Italian family with a mother who was one of the Hornbys whom he had known in Lancashire many years before, Lear

had gone frequently to their house, finding in their company some of the culture and intelligence which were so markedly lacking in the majority of the English colony. To one of the daughters, Helena, he had become particularly attached. ' I believe I have found myself wishing sometimes that I was 20 years younger,' he had written to Emily Tennyson, ' and had, I won't say " more," but " any " money.' Helena Cortazzi seems to have been a remarkable young lady. ' She knows every word of " In Memoriam," and indeed all Alfred's poems—and has translated many into Italian, and set many to music . . . her complete knowledge of Italian, French and Greek, her poetry and magnificent music, but withal her simple and retiring quiet.' And now, in his depression and loneliness, he told Fortescue : ' If Helena Cortazzi had been here, it would have been useless to think of avoiding asking her to marry me, even had I never so little trust in the wisdom of such a step.'

Whether, if Helena Cortazzi had still been in Corfù, Lear would have asked her to marry him, is, to say the least, open to doubt. Her ardent lover he was not : but it is certain that he found great pleasure in her companionship, and that her conversation and sympathy stimulated and relieved his mind. But she never absorbed him sufficiently to raise, more than temporarily, his depression, nor to banish his feeling that he was alone in the world, nor yet to take his thoughts off the ever-present problem of his relations with Lushington. There were other reasons, too, why it is unlikely that he would have proposed marriage to her, reasons which all his life prevented him from considering seriously the idea of marriage—the perpetual financial problem to which he so often alludes, and also—more important though seldom mentioned—his epilepsy. And there was another obstacle

also, absurd but no less real, which is described by one who knew Lear for many years. ' He had an ingrained conviction that he was too ugly for any woman to accept him. No doubt he *was* ugly. His impressionistic self-portraiture on the first page of the *Book of Nonsense* as the " Old Derry-down-Derry, Who loved to see little folks merry," is scarcely a caricature : and his plainness of face was made the more emphatic by his nearness of sight, awkward slouch, and a style of dress which can only be called careless by courtesy. He may have thought that dress was no concern of one for whom it could do nothing. But though, as a true humourist, he could make himself his own butt, that perverse conviction of his unquestionably rankled.'[1]

Helena Cortazzi was gone : Frank Lushington remained. There remained also the persistent and apparently insoluble problem of their unequal friendship. To Lushington, admirable and upright man as he was, but with little imagination, no understanding of true intimacy and no desire either to accept or to give it, their friendship was, on the whole, a satisfactory thing. He was genuinely fond of Lear, genuinely anxious to help him, genuine in his admiration of his work and of certain aspects of his character. But the contradictions and subtleties of that character hardly interested him, and no doubt he was often bored with Lear's attempts to achieve his own ideal of unreserved friendship—attempts to which he was incapable of responding. Lear now tried to solve the problem by an effort to hold himself more aloof, to persuade himself that he did not care as much as he really did. ' Nor, though L. is my next door neighbour here,' he wrote to Ann, ' am I likely to see as much of him as formerly ; we dine, and sometimes walk together, but I believe he would

[1] R. E. Francillon. *Mid-Victorian Memories.*

always rather be alone ; and we shall probably by degrees meet much less frequently than heretofore.' Even the occasional dinners sometimes ended badly, for he notes in his diary after one of them : ' Dined at L.'s but wearied myself with talk, and when after dinner, in that cold room, he took a good cigar himself from a box at the other end, but offered me none, and when coffee came $\frac{3}{4}$ of an hour after, I grew black and silent and went away at $9\frac{1}{2}$.'

There were still the English children at Corfù, the ' little Gages and Shakespeares,' and the ' three dear little Reids . . . ducky children as ever were ; ' and Lear records that he finished three nonsense alphabets for them about this time.

But his chief interest during the winter was the planning and preparation of a tour in Palestine for the following spring. This was a tour he had long wanted to take, having been frustrated by illness in 1849 and, ever since, by lack of money. Now, however, having obtained two or three good commissions, he was assured of his expenses, and spent much time reading all the available authorities on the country he was to visit, and also in practical preparations such as buying a tent and equipment and learning to shoot with a

revolver. Here Lushington was able to help him. ' O ! here is a bit of queerness in my life,' he wrote to Fortescue. ' Brought up by women . . . and ill always, I never had any chance of manly improvement and exercise, etc.—and never touched firearms in all my days. But you can't do work at the Dead Sea without them. So Lushington, who is always vy. kind and good, makes me take a 5-barrelled revolver [sic], and I have been practising shooting at a mark (I can hardly write for laughing), and have learned all the occult nature of pistols. Don't grin. My progress is slow —but always (I trust) somewhat. At 103 I may marry possibly. Good-bye dear 40scue.'

He started off with Giorgio in the middle of March, delighted to get away from Corfù and be on the move again. Delayed a few days in Alexandria, he paid a short-visit to Cairo, then returned and caught the Jaffa boat and arrived in Jerusalem about the end of the month. The discomfort of travelling was great, owing to the vast crowds of Easter pilgrims, and the Holy City itself was ' in a most odious state of suffocation and crowding, this one week uniting all sorts of creeds and people in a disagreeable hodge-podge of curiosity and piety.' He was unpleasantly conscious of the atmosphere of bitter conflict and rivalry, so utterly alien to the spirit of Christianity, amongst the numerous Christian churches represented in Jerusalem. It shocked him, as it must shock anyone who regards true religious feeling as more important than differences of form and subtleties of dogma. ' " Almost thou persuadest me *not* to be a Christian ",' he wrote, ' is the inner feeling of the man who goes to the " Holy City " unbiassed towards any " religious " faction. . . . If I wished to prevent a Turk, Hebrew, or Heathen, from turning Christian, I would send him straight

to Jerusalem !' But in spite of his disgust at its religious life, he was enchanted with the beauty, and deeply impressed with the associations, of the place. 'With all this, and in spite of all this, there is enough in Jerusalem to set a man thinking for life, and I am deeply glad I have been there. . . . Let me tell you, physically Jerusalem is the foulest and odiousest place on earth. A bitter doleful soul-ague comes over you in its streets. And your memories of its interior are but horrid dreams of squalor and filth, clamour and uneasiness, hatred and malice and all uncharitableness. But the outside is full of melancholy glory, exquisite beauty and a world of past history of all ages—every point forcing you to think on a vastly dim receding past. . . . The Arab and his sheep are alone the wanderers on the pleasant vallies and breezy hills round Zion : the file of slow camels all that brings to mind the commerce of Tyre. . . . Every path leads you to fresh thought : this takes you to Bethany, lovely now as it ever must have been—quiet, still little nook of valley scenery. There is Rephaïm and you see the Philistines crowding over the green plain—down that ravine you go to Jericho—from that point you see the Jordan and Gilead.'

Weary of the city, he pitched his tent on the Mount of Olives, and found quiet there.

<p style="text-align:center">★ ★ ★ ★ ★</p>

The industrious landscape-painter had determined that, while he was in Palestine, he would make an expedition to Petra and bring back drawings of it to add to his collection. 'Brilliant Petra,' as T. E. Lawrence calls it ; the

> . . . *rose-red city*
> *Half as old as time.* . . .

the ' Sela ' of the Bible, founded by the Edomites, descendants

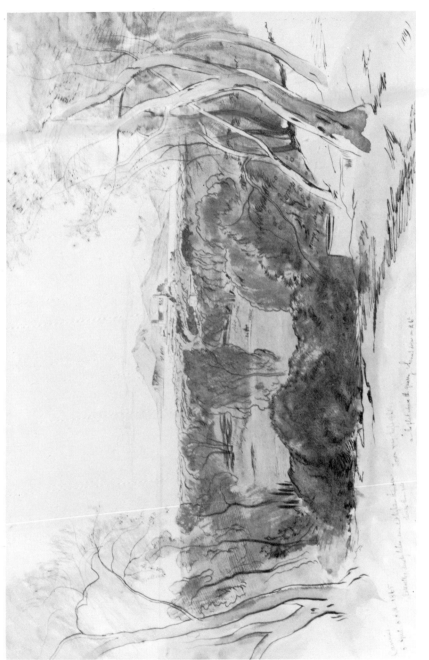

Cannes, watercolour, 1855

Mount Athos, oil painting

of Esau ; capital and treasure-city of the Nabataeans, that
ancient Arab people who rose from a nomad tribe to the
wealth and splendour of a great commercial power with a
culture and architecture influenced by both Greece and Egypt,
unsubdued even by the Romans until the beginning of the
second Christian century ; Petra with its ruined temples
and theatres and palaces carved from the living rock of a
red sandstone valley in the remote mountains of Arabia,
half-way between the Dead Sea and the Gulf of Akaba—
even now it retains some of the romance of ancient and
forgotten places, even to-day, when everyone is a traveller,
it is visited by few. Eighty years ago the journey was some-
thing of an adventure, and was not without danger, as Lear,
glad to escape with his life, discovered.

After a visit to Bethlehem he went to Hebron, which was
to be the starting-point of the journey. He had made
arrangements through his dragoman Abdel with the Sheikh
of the Jehaleen Arabs, who was himself to act as guide with
an escort of fifteen of his own men. The party was to
remain at Petra a week and return by the Dead Sea. But,
by the time they reached Petra, after a journey made trouble-
some by stubborn camels and quarrelling Arabs (one of the
Jehaleen tried to murder his Sheikh and very nearly succeeded),
most of the escort had quietly disappeared. The rest were
incompetent, obviously not to be trusted, and endlessly
squabbling amongst themselves—with the exception of one
Feragh, a negro slave who had joined the party on the way
and who behaved, both on the journey and later, with
courage and sense.

When Lear arrived at Petra, however, all difficulties were
for the moment forgotten in astonishment and wonder. It
was even better than he had expected. ' It is absurd to

attempt to describe this place which is one of the great
marvels of the world. I had expected a great deal, but was
overwhelmed with extra surprise and admiration at the
truly beautiful and astonishing scenes. The whole valley
is a great ruin—temples—foundations—arches—palaces—in
inconceivable quantity and confusion ; and on 2 sides of the
valley are great cliffs, all cut into millions of tombs, magnificent
temples with pillars, theatres, etc., so that the whole place
is like magic ; and when I add that every crevice is full of
oleander and white broom, and alive with doves, gazelles
and partridges, you may suppose my delight was great. All
the cliffs are of a wonderful colour. . . . " O master," said
Giorgio (who is prone to culinary similes) " we have come
into a world where everything is made of chocolate, ham,
curry-powder and salmon "—and the comparison was not
far from an apt one.' But, as a painter, Lear was in despair
of ever being able to convey the true atmosphere of this
enchanted place. 'The singular mixture of architectural
labour with the wildest extravagances of nature—the excessive
and almost terrible feeling of loneliness in the very midst of
scenes so plainly telling of a past glory and a race of days long
gone—the vivid contrast of the countless fragments of ruin,
basement, foundation, wall and scattered stone, with the
bright green of the vegetation and the rainbow hues of rock
and cliff,—the dark openings of the hollow tombs on every
side,—the white river-bed and its clear stream, edged with
superb scarlet-tufted blossoms of oleander alternating with
groups of white-flowered broom,—all these combine to
form a magical condensation of beauty and wonder which the
ablest pen or pencil has no chance of conveying to the eye
or mind. . . . Who could reproduce the dead silence and
strange feeling of solitude . . . ? What art could give the

star-bright flitting of the wild dove and the rock partridge through the oleander gloom, or the sound of the clear river rushing among the ruins of the fallen city ? '[1]

His tents were pitched low down on one of the terraces near the river and he began to explore the valley and make some drawings. The ' far-famed " Khasmé " or rock-fane . . . a rose-coloured temple cut out in the side of the mountain, its lower part half hidden in scarlet blossom and the whole fabric gleaming with intense splendour within the narrow cleft of the dark gorge, from four to seven hundred feet in height and ten or twelve broad,' made a deep impression upon him. But he was not to be left long to drawing and peaceful contemplation. As he came back to the tents late in the evening, Abdel the dragoman pointed out ' 10 black images squatted in a line immediately above the tents.' " He is of the Arab," explained Abdel, " and is for asking from the money."

It had been arranged with the Sheikh of the Jehaleen that the ' gufr,' or tax, for visiting Petra should be paid by him direct, on the traveller's behalf, to the Sheikh of the Haweitât in whose territory the ruined city lay. The Arabs who now began to take up their position near the tents were fellaheen of the neighbouring villages in the hills, who insisted that a separate tax must be paid to them also. Their numbers increased steadily during the night, till by nine o'clock next morning about two hundred of them were closely surrounding the little encampment : the Sheikh of the Haweitât also arrived, but with only ten followers—a hopelessly inadequate number to enforce any kind of order. It was an unpleasant situation, the only thing in Lear's favour being that the fellaheen were not a united force and were quarrelling violently

[1] *Macmillan's Magazine.* April 1897.

amongst themselves—though at the same time becoming
'more importunate and turbulent every minute, snatching
at any object within their reach, and menacing the Jehaleen
with their firearms.' Lear gave orders for everything to be
packed up for immediate departure, and 'meanwhile the
patient Suliot brought me some coffee, bread and eggs,
saying with his usual calmness that we had better eat a little,
for it might be our last breakfast.' After this, while Giorgio
and Abdel were preparing the baggage, Lear managed to
sneak away with Feragh and make a drawing of the theatre
and visit the Khasmé once again. 'Entering the chamber
of the Khasmé, I wrote my name on the wall (the only
place in which I can remember ever to have done so), feeling
that if I should come by the worst in the impending affray,
I might be thus far traced out of the land of the living.'

He came back to the tents to find that the Sheikh of the
Jehaleen was in the act of paying over the money to the
Sheikh of the Haweitât. This was taking place in a cave
near by, round whose mouth the mob of fellaheen surged
in frenzied confusion, shouting and fighting among them-
selves : others were gathered on the paths leading out of
the valley in order to prevent the travellers escaping. 'From
time to time violent outcries burst from the cave, and the
mob without appeared to get more and more excited. Every
minute gave plainer proof that the horde of savages was
quite disunited and uncontrolled by any authority. More
cries from within, and forth rushed 20 or 30 to the camels,
which they dragged away from the helpless Jehaleen, when
in another moment a large number fell on the first party,
and were for the time masters. . . . All the while, too,
parties of the most villainous-looking fellaheen pressed closer
on us, and began to insult and annoy us by twitching and

jostling. So dense was the crowd, and so impossible any movement of escape, that there was literally but one course left to us, that of appearing as far as possible indifferent to the violence one could not resist.'[1]

The division of the money had merely the effect of causing greater discontent among the crowd, and Lear found himself in a very serious situation—a situation which, to one of his peace-loving disposition, must have been doubly odious. Some men's spirits rise at the sight of violence in action : others, more thoughtful, are bored and disgusted. Lear belonged to the second of these types. Though possessed of considerable courage and self-control, he detested every kind of physical violence : had not Holman Hunt said of him that he was 'uncombative as a tender girl,' that he would 'rather be killed than fire a pistol or gun,' that he was terrified of dogs, regarded horses as 'savage griffins,' and revolutionists as 'demons ?' Perhaps it was just as well that he was not called upon to make use, in his present position, of the '5-barrelled revolver' which Lushington had taught him to handle. His decision to maintain an attitude of dignified non-resistance was clearly the right—indeed the only possible —one : but it was hard to bear when he found himself seized and hustled to the entrance of the cave, pushed and dragged this way and that by shrieking Arabs, his ears nipped, his arms pinched and his beard pulled, his clothes torn open and his pockets rifled of everything they contained, 'from dollars and penknives to handkerchiefs and hard-boiled eggs.' Finally they seized Abdel the dragoman, threatening to kill him as well as Lear and Giorgio if he did not hand over money : he was pinioned, his turban torn off, and he was thrown on the ground. Lear determined 'to make a last

[1] *Macmillan's Magazine.* April 1897.

effort to prevent bloodshed if possible.' He still had his pistol, but realized that 'the first pistol-shot would have been the signal for our instant sacrifice, which I believed was probable enough, because the quarrelling among the wretches themselves was becoming so frantic and the whole scene one of such uncontrollable lawlessness. I forced my way into the cave . . . threw myself on the Red Sheikh, who was re-dividing some of the money in the vain hope of appeasing the mob, and uniting to my small amount of Arabic a much larger persuasion by my hands, I pulled him up from his seat and to the door of the tomb, where Abdel was still struggling with his assailants. To these the Sheikh instantly proceeded to deal blows and immense abuse, saying at the same time to us : " You must pay 20 dollars at once to these men of Dibdiba or I can do nothing for you ; after that I will help you on if I can.' Further discussion would have been useless, so I ordered Abdel to pay the money, and immediately that particular body of aggressors wheeled off and left the field, howling and jumping like demoniacs.'[1] The Sheikh and his followers then accompanied the party on their way out of the valley, but not without ' fresh bodies of fellaheen making efforts to prevent him, some of them rushing on him and trying to drag him off his horse ; nor until he had struck one down with his spear and others had been more or less seriously knocked about '[1] were they able to make their way out of the Wady Mousa. Even then, after the Sheikh had turned back, Lear and his party were three times more attacked by large bands of fellaheen : the only possible reply was to hand over what they asked, until the last penny was gone. By sunset the travellers, pressing on with all possible speed, had arrived at the comparative safety

[1] *Macmillan's Magazine. April* 1897.

of the open plain : but even here they did not dare to take the sleep they so much needed ; they remained on guard all night, and started again long before dawn.

The robbing of travellers remained long a profitable concern to the villagers of the neighbourhood of Petra. Several foreigners suffered at their hands, and even Doughty, though he ' came to them in a red cap,' records a similar, though less alarming, experience that happened to him when he visited the place some twenty years later. Petra made an impression upon the writer of *Travels in Arabia Deserta* that was curiously different from Lear's account of it. Apart from the ' Khasna Faraôun ' (the treasure-house of Pharaoh) —the ' Khasmé ' upon whose inner wall Lear had written his name, as he thought, for the last time—' whose sculptured columns and cornices are pure lines of a crystalline beauty without blemish,' Doughty found little to please him in ' that wild abysmal place which is desolate Petra.' His view of it was less romantic than Lear's. ' Strange and horrible as a pit, in an inhuman deadness of nature, is this site of the Nabataeans' metropolis ; the eye recoils from that mountainous close of iron cliffs, in which the ghastly waste monuments of a sumptuous barbaric art are from the first glance an eyesore.'[1]

[1] Doughty. *Travels in Arabia Deserta.*

ROME, THE BROWNINGS, AND THE PRINCE
OF WALES

By the beginning of June Lear was in Corfù again. He was able to feel, looking back upon it, that his recent adventure, unpleasant and dangerous as it had been at the time, had not been wholly in vain. He had at least succeeded in seeing something of Petra, and even in bringing back drawings— only two or three hasty sketches, to be sure, instead of the many he had hoped for, but still enough to paint from them (forgetting his Pre-Raphaelite principles) a large oil-picture of the valley and its cliff-temples, when he got home. And there may also have been a little secret satisfaction, a feeling of pride which he would have been ashamed to express, that he, a mere 'dirty landscape-painter,' hating violence, terrified of firearms, in no sense a 'man of action,' should have emerged so creditably from so tight a corner. At the dinner-tables of Corfù the ladies looked upon him, perhaps, as something of a hero.

On his way back from Petra he had spent a few days by the Dead Sea and in the neighbourhood of Jerusalem, then had caught the boat from Jaffa to Beirut, meeting on his way down to Jaffa 'Lady Ellenborough in a crimson velvet pelisse and green satin riding-habit going up to complicate the absurdities of Jerusalem.' From Beirut he had made an expedition into the Lebanon country (enthusiastically drawing cedars), and had seen Damascus and the ruins of Baalbek.

His plan now was to stay for the summer in Corfù and then return to Jerusalem for the winter—provided that Holman Hunt could go with him. But Hunt wrote that he was unable to do so, and Lear, thrown again into depression and indecision, had to abandon the idea. The few weeks that he spent in Corfù were not cheerful. The heat was unusually intense—too great even for him, who loved heat : he had a sty in his eye ; and Lushington—though it had been a great pleasure to see him again and relate his adventures to him—was preoccupied and depressed by the serious illnesses of his second brother and of one of his nieces. Moreover Lushington was giving up his position in Corfù, and was due to leave in a short time. All this, combined with the feeling of being pent up in a small place with no immediate likelihood of escape, brought back the mood of melancholy from which, for some months, he had been free. ' Oh !—that the blank of life would break into some varied light and shade,' he wrote in his diary at this time. It was not only what he called his ' naturally magnificent capacity for " worry " ' that made him exclaim thus : the ' light and shade ' which he sought could only be brought into his life by some personal contact closer than any he had yet known. He was partially conscious of this. ' I wish sometimes I grew hard and old at heart,' he wrote, ' it would I fancy save a deal of bother.' But that was something he never achieved. Emily Tennyson also was aware of his need, and, with a woman's practical instinct, felt that marriage to a good woman with some money of her own would provide a satisfactory solution. She made another discreet attempt to bring Miss Cotton to his notice—Miss Cotton who had been so deeply moved by his singing of his own Tennyson songs at Farringford three years before—and wrote to him

in July : ' There is a rumour, I scarcely think true, that Miss Cotton is to be married to Mr. James, the new Vicar of Carisbrooke. We like him, that is what we have seen of him. Still I had other dreams for her. I should like one of my own special friends to have so very good a wife as I think she would make. I will say nothing of worldly gear which in her case is I believe considerable.' The rumour of Miss Cotton's marriage was untrue : had Emily Tennyson, perhaps, invented it in order to awaken his attention ? But her efforts met with no success : Lear was not interested in Miss Cotton.

He decided, finally, to return to England with Lushington. The journey home was a gloomy one, for Lushington's ill-fated family had suffered a double blow ; both his brother and his niece were dead, and he was hurrying back to their funerals. The two friends parted at Dover, and Lear, after visits to his sisters Eleanor Newsom and Ann and to various country houses, settled down in London to work at his Palestine commissions. But he did not stay there long. His work not progressing—even ' Daddy ' Hunt's advice seemed ineffective—London unsympathetic (' In spite of efforts I grow more and more isolated '), winter coming on—he felt he must get away as quickly as possible. Where was he to go ? One place seemed as good as another : the very freedom of his choice was discouraging, and turned enthusiasm to dust in the mouth. His indecision became a torment to him. ' Woke to impatience, blindness and misery,' he wrote in his diary in October, ' incapable of deciding whether life can be cured or cursed. I totter giddily, refusing to take any road, yet agonized by staying irresolute. To go to brighton ? To see H.C. ? To take a place at the Isle of Wight—and dismiss Giorgio ? To start at once for Rome with unfinished work ?

To go to Madeira ? To try and complete the five paintings here ? To be involved in more debt ? To attempt the Palestine small drawings ? To write for Fraser's ? To set more songs ? I cannot fix any point but meanwhile groan.' ' H.C.' presumably, was Helena Cortazzi, to whom he had thought of proposing marriage in Corfù, and who was now in England : but this course he rejected, and there is no record that he ever saw her again. Of all the other alternatives he actually accomplished two. The first was the preparation for publication, by Cramer's, of five more of his Tennyson songs, ' put down ' by Dr. Rimbault ;[1] the second, ' to start at once for Rome with unfinished work.'

It was ten years since Lear had been in Rome, and much had happened there since the spring of 1848. Even before that time events had begun to move. Pius IX had been elected Pope in 1846 and had entered on a course of reforms, but, popular as he was at first, he did not progress fast enough for the revolutionary feeling of the times. Garibaldi, returned from exile in South America, had offered him his services but was put off with an ambiguous reply ; and finally, on the Pope's refusal to make war upon the Austrians in order to oust them from Lombardy and Venetia, he lost the popular support. His minister, Count Rossi, was murdered : he himself escaped to Gaeta ; and a republic was proclaimed in Rome in November 1848, supported by Garibaldi, who drove back the French forces sent to assist the Pope. But it was not for long ; a few months later the French, reinforced, attacked again. The defence of the Roman Republic under Mazzini and Garibaldi was conducted with a heroism and

[1] *Come not when I am Dead; When thro' the Land; The time draws near; Home they brought her warrior dead; O let the solid ground* : four others had been published in 1853.

self-sacrifice which placed it for ever among the most
memorable events in the history of the Italian Risorgimento :
and the subsequent occupation of Rome by the French
brought Louis Napoleon little more than a train of ever-
increasing embarrassments which hastened the ultimate
ruin of his cause. The forces of reaction had, for the moment,
conquered. Garibaldi fled : the Papal government was
re-established, and for twenty-one years more, until the
entry into Rome of Victor Emmanuel's army in 1870,
the anachronism of its temporal power subsisted, with
the support of a French garrison.

These important events had, in the meantime, left little
visible trace, and Rome was quiet. But Lear noticed certain
outward changes when he returned. 'The city *is* improved,'
he wrote '—the streets are far cleaner, the shops—many
new and better, the houses also—numbers new or enlarged,
and all brushed up. I wish the people were too ! But they
are the same snail drones as ever, believing Rome to be the
world . . .' Prices, moreover, had risen, and he was shocked
to find that he could get no suitable rooms for less than £80 a
year—and that only after a search so long and discouraging
that he was reduced almost to despair : ' 2 or 3 times I have
nearly resolved on going off straight to America,' he wrote
to Fortescue. At last he found a fourth floor in a new house
in the Via Condotti, which he proceeded to furnish, arranging
one room, ' hung with white,' as his ' gallery,' where paintings
and drawings were placed for exhibition. This was his usual
practice when he settled down for any length of time, and
on two afternoons in the week the ' gallery ' was open to the
public—which, in Rome, consisted mainly of English visitors.
By this means—uncongenial as it was to him, for he hated
crowds of strange and often stupid people, many of whom

125

came out of mere curiosity—he hoped to effect sales ; and on the whole, during this winter, he was fairly successful. But it was some time before he was comfortably established in his new quarters and able to start work, and the delays and procrastinations of the Roman workmen were exasper- ating, especially as the faithful Giorgio had failed to arrive from Corfù. He consoled himself with reading Fanny Burney's memoirs and tried to be patient. Then at last everything was ready : Giorgio arrived ; and he settled down to his usual methodical manner of life. Rising at five-thirty or six, he would write letters and have his hour's Greek lesson before breakfast : then paint all day till about four o'clock, except on his two ' afternoons,' when he would have to receive visitors : then a walk : and then he would either be dining out, or Giorgio would cook his dinner at home and the evening would be spent in ' penning out ' sketches or in reading till bed-time. He tried, as far as possible, not to allow social life—of which there was no lack among the English visitors in Rome—to interfere with his work. ' I am dreadfully bothered by invitations, which I abhor,' he told Fortescue. ' Dinners are natural and proper : but late mixed tea-parties foul and abhorrent to the intelligent mind.'

On his return to Rome Lear had felt sadly the absence of some of his friends of ten years before, who were now dead. But other old friends were still there. Among these was John Gibson, who acquired a certain fame in his own day for his revival of the use of colour in sculpture : also the Knights, who were Lear's own distant relations and close friends (one of the daughters had married the Duke of Sermoneta). And it was during this winter that he made the acquaintance of Edgar Drummond, his banker—an acquaintance which,

nourished by interests in common, grew quickly into a friendship. They saw each other daily during the time that Drummond was in Rome, and in later years Lear stayed often with him at his house near Southampton. Before he met Lear, Drummond had already been an admirer and purchaser of his work, and both he and his brother, Captain Alfred Drummond, continued to be among his best patrons.

The most distinguished of the English residents in Rome at this time were the Brownings. 'Do you know them,' Emily Tennyson asked Lear, 'and those wonderful spirit eyes of hers?' But he found, to his disappointment, that anything beyond the most superficial acquaintance was made impossible by the court of flatterers, snobs and bores which seemed perpetually to surround them. Such had been the outcome of the 'Browning legend.' Having neither unlimited patience nor unlimited leisure, he soon gave up the attempt as hopeless, though still continuing to see them, occasionally, in other people's houses. 'Mrs. Browning *only* receives from 4 to 5,' he answered Mrs. Tennyson, '—an hour which, in the winter time, is my only 60 minutes' chance of any exercise. . . . I went there once, and was extremely prepossessed with Mrs. Browning (he was out) and thought her very nice :—but there were with her people whom I think " far from agreeable," and whom I avoid as much as I can : and I hear from others that she is usually beset with various and sundry people—and so what good does one get of anyone's society when it is merely like a beautiful small rose-tree planted in the midst of 43 sunflowers, 182 marigolds, 96 dahlias and 756 china-asters?' Another visitor to Rome this winter was the poet Aubrey de Vere, who had recently become a Roman Catholic. Lear was not attracted to him. 'Nor do I delight in Aubrey de Vere

particularly, though I make every allowance for the class of mind which can pervert itself and write bosh, supposing it to be poetry.'

But the greatest event of that winter for the English colony in Rome was the visit of the young Prince of Wales, who was travelling in Italy with his tutor, for the improvement of his mind. Even in his extreme youth—and in spite of the strictness of the educational programme mapped out for him by the Prince Consort, which isolated him from all companions of his own age and forbade all frivolous amusements —the future King Edward VII seems to have known how to make himself agreeable to all whom he met. The impression he made in Rome was excellent. ' A pretty youth,' wrote Lear to Ann. ' For the propriety of his behaviour '—this was at the English church, where Lear had seen him—' he might be 76 instead of 16. No novelist could imagine either a better behaved or nicer looking Englishman's son—and that is not saying little.' Then, one day about the end of March, came a note from Colonel Bruce, His Royal Highness's governor, asking Lear if it would be convenient for him to show the Prince his drawings that afternoon. Lear and Giorgio were in a twitter of excitement. ' As the time drew near I made Giorgio put on his best clothes, and open both the doors, and went to meet H.R.H. on the landing-place. Really he is one of the very nicest lads you could ever see—in person, manner, and general conduct towards all around him. I was much pleased to find how much he knew of the places I showed him, and he expressed great pleasure at all he saw, asking many nice questions, and showing how interested he was all through his visit—which lasted just one hour and 5 minutes. He does not purchase or order anything here, but sees a vast deal, and I wonder how he

can remember much of it. Giorgio's remarks on him were—
" He is all so like a half-crown and a shilling "—by which
I found he was much struck by his likeness to the Queen's
portrait on those coins. There is no difference of opinion
about the young Prince of Wales here ; everybody high and
low—speaks well of him . . .' Seventeen years later the
Prince still remembered Lear. He recognized him at a recep-
tion in London given by Lord Northbrook, and came up to
him and ' spoke for some time most amiably.'

In April of 1859 war broke out between France and Austria :
Garibaldi was recalled by Cavour to command the Italian
troops and help drive the Austrians out of Lombardy. The
eyes of all Italy watched eagerly the events in the north, whose
success was to be the signal for the final blow for liberty and
unity. Nobody could tell what would happen in Rome,
and all the English tried to leave in a rush. Lear was left in
a dilemma. He had taken expensive rooms on a three years'
lease and had spent all his money on ' fitting them up as a
winter home ; ' but, even if he stayed, he would have no
patrons if the war continued. In any case he was tired of
Rome, and of the demands of its ' Bath and Brighton ' social
round. 'I grow so tired of new people, and silly people,
and tiresome people, and fanatical people, and robustious
people, and vulgar people, and ugly people, and intriguing
people, and fussy people, and omblomphious people—
and people altogether.' Perhaps he was glad that the war
gave him an excuse to go back to England.

He paid his usual visit to the Tennysons at Farringford that
summer. As always, it was a great pleasure to be with them,
but the rather tense atmosphere that surrounded Tennyson
had a disturbing effect upon him. ' A kind of sensitive excite-
ment here always is not good for such an ass as I am,' he

noted in his diary. And he was deeply distressed at the state of Mrs. Tennyson's health. ' I cannot but be sad,' he wrote to Holman Hunt, ' Mrs. Tennyson's looks compel me to be so—she is so worn, and so weary often. And whether Alfred sees this I cannot tell . . . I so regret there is no communion of society for such a woman as Emily T. There is no family near of like sentiments and feelings—and altogether the atmosphere is full of a certain sadness.—And this (you may wonder at my saying so) does not proceed from my own addiction to low spirits by nature or circumstance—for it so happens that, as far as I know myself, I am just now in better physical and moral condition than usual. But the place *has* a sadness—and I can't help feeling it. . . .' ' E.T. is assuredly a most complete angel, and no mistake—but poor dear— she is ill and weary,' he wrote in his diary. ' " Please God if I live one or two years more ! " she said to me. But what labour for him and how little he seems to regard it ! ' Lear and Tennyson walked on the Downs together, and as they walked the poet ' read out of the Lady of Astolat—another version of the Lady of Shalott ;—most wonderfully beautiful and affecting—so that I cried like beans. The gulls on the cliffs laughed' And another day—' That clear down, with its sheep and furze and the pale Farringford cliffs beyond is lovely. A.T. doddled about a little but has " hay fever " and cold. I am less able now than before to combine with him, he is so odd. . . . The two boys very darling chaps indeed.' Tennyson had recently finished *Idylls of the King.* ' I have read the Guinevere, which is an absolutely perfect poem—and made me blubber, bottlesful,' Lear told Holman Hunt. ' And yesterday, he read me Elaine—which is nearly equally lovely.' The *Idylls* were published shortly afterwards. ' Of course prudes are shocked,' says Lear, ' at Guinevere.'

From Farringford he went on to Romsey to stay with his old friends, the Empsons, where he heard news of Florence Nightingale. William Empson was the vicar of East Wellow, a living in the gift of her father, William Nightingale of Embley Park. Her family was much disturbed that Miss Nightingale had visited her home only twice since her return from the Crimea three years before. The work at her military hospital and her institution for the training of nurses absorbed all her time, and she was living alone at a hotel in London— which was not at all the correct thing for a Victorian spinster, still under forty, to do, even though she had nursed ten thousand sick soldiers at Scutari. 'These things,' commented Lear in his diary, 'appear to lesser minds a mystery, but I cannot but think that they are the natural result of her life.'

In July Lear's sister Harriet died, and he went to her funeral near Aberdeen. There were now only seven left out of the family of twenty-one. After this he took rooms at St. Leonards-on-Sea, where he remained for the next three months, working quietly and steadily for ten or twelve hours a day and doing little else but read eagerly the Italian news in the papers. His industrious mind was shocked at the amount of time he had wasted during the summer, in the 'houses of the rich.' Lushington came over for 'one day and night, and that was a vast pleasure,' and Holman Hunt was staying in the neighbourhood part of the time : otherwise he saw few people. He was comfortable in his lodgings, but the food was sometimes unattractive. 'For a long time,' he told Fortescue, 'I fed on an immense leg of mutton, far, far larger than any leg of mutton I ever saw before or since. But one day I remembered that I had gone to the window to see a Circus Company go by, and attached to that Circus there was an Elephant :—and then the horrid recollection

that the Circus had long since returned (I saw it pass by) but the elephant *never had*. From that moment I felt what that large leg of preposterous mutton really was . . .'

In the autumn, his pictures finished, he returned to London. The state of his finances was unusually bad at this moment, and Fortescue, who had already helped him more than once, offered him a loan. In refusing it, Lear gave his opinions on the subject of borrowing—the opinions of a sensible and generous man with no false pride : for not only a lender, but a borrower, too, may be generous in spirit. 'Fresh borrowing,' he wrote, 'would only distress me more. I am thought wrong by some for want of independence in ever borrowing at all, but I am sure that is not a right view of things, for my whole life from 14 years has been indepen-dentissimo, and on the other hand, the man who will not put himself under obligation of any kind to even the friends who entirely sympathize with his progress—nourishes, in my opinion, a selfish and icicle sort of pride. It is as much a pleasure to me to own that I have been helped by you, J. Cross, J. B. Harford, S. Clowes, W. Neville, and B. H. Hunt, as it is to look back on the fact of my having repaid (in most cases, and to be so in all) what was lent me in money ; I have no wish whatever to shake off the moral acknowledgement of given assistance.' Fortunately his situation was relieved by the sale of some pictures, including the ' Petra,' and he was able not only to pay his debts but to leave for Rome shortly before Christmas, with a little money in hand. He crossed the Channel, by chance, in the company of Thackeray. ' The great man was very amiable and gave me No. 1 of his new magazine, " The Cornhill." '

The war in Italy was over. But the disgraceful terms of the Treaty of Villafranca, in which the French Emperor,

intent only on extricating himself, had ignored his former promises to free Italy from the Austrian yoke, served only to give the strongest possible impetus to Garibaldi's patriotic movement. Unrest began to show itself. The quietest place in Italy was Rome, where the temporal power of the Pope was still maintained by the French garrison. To Lear, when he arrived back in the Via Condotti, it seemed deserted, dead. 'The streets are literally empty . . . a complete constraint and gloom pervades all the city, and inasmuch as I hated it last year, I do so now a thousandfold more for its odious false anti-human reason atmosphere. . . . Most of the Hotels are more or less shut up, and the lodging houses also. The beggars are ravenous and demonstrative to a fearful degree.' There were hardly any English there, 'the Brownings and Mrs. Beecher's Toe[1] being the only lions.' The Brownings he met at the rare dinner-parties given by such English or American residents as still remained. After one of these, given by Miss Charlotte Cushman, a well-known American actress, he wrote in his diary : ' This dinner and evening was most extremely pleasant. Only Miss Stebbins and Miss C. were of the house : besides—R. Browning, C. Newton, Odo Russell. This last I thought as really good a specimen of modern diplomat as possible—so kindly without sham, and so clever without sharpness. Browning was all fun—fun—foaming with spirit ;—his anecdote of Carlyle (which he hesitated ere giving)—how he and C. went to Boulogne, C. for the first time abroad :—when, on seeing the first Crucifix, C. calmly and feelingly said—" Ah ! poor fellow ! I thought we had done with him ! " Great mirth and roaring. Dinner especially good—oysters and peaches from America. Champagne and all things very

[1] Harriet Beecher Stowe, author of *Uncle Tom's Cabin*, etc.

excellent, but all in perfect taste.' But there was little in the way of social diversion now : and little hope of any sales or commissions. He went on quietly working at the pictures he already had in hand—eighteen of them simultaneously. Lack of money to take a journey to Jerusalem, which he had planned, and an unsuccessful attempt to get Tennyson to come out to Rome ('Ally's chief craziness,' Mrs. Tennyson wrote, 'is as you perhaps know for the belt of the earth. You had better come and cross the line with him ') made him, at last, decide to leave Rome altogether and return to England. In giving up his rooms, he sacrificed a year's rent : he was not to blame, but he realized that the plan of making the Via Condotti his winter home had been a mistake.

His visit to the Tennysons that summer was a failure. Frank Lushington was there at the same time, but that did not improve matters. Mrs. Tennyson was still in poor health—'E.T. is very pale and languid, poor dear angel— for she is an angel and no mistake '—and Tennyson himself in his most difficult and exacting mood. Lear vowed he would never go there again. There had been a disastrous walk on the Downs. 'A.T. was most disagreeably queru-lous and irritating and would return, chiefly because he saw people approaching. But F.L. [Franklin Lushington] would not go back, and led zigzagwise towards the sea—A.T. snubby and cross always. After a time he would not go on—but led me back by muddy paths (over our shoes), a shortcut home—hardly, even at last, avoiding his horror— the villagers coming from church. . . . I believe that this is my last visit to Farringford : nor can I wish it otherwise all things considered.' But he repented, as usual, of his hastiness, and noted, a few days later : ' It is always sad to leave Emily T. and indeed all of them—and I was all wrong—not

reflecting on much of A.T.'s miseries. F.L. is certainly one of a million also.'

Lear had still hoped to accomplish his journey to Egypt and Palestine, but to lack of ready money there was now added another impediment—the failing health of his beloved eldest sister Ann. Ann was now almost seventy, and when her brother arrived back from Italy he had already noticed a change in her. When the autumn came, though there was no reason for immediate anxiety, he felt he could not leave England, and so, wishing to work on his picture of the Cedars of Lebanon, took up his abode, for most of the winter, at an hotel at Walton-on-Thames, in the grounds of which he could study cedar trees on the spot. The place suited him : his work progressed, and he was contented and well, in spite of a severe winter. The Oatlands Park Hotel was not too far from London for friends to come and see him, so that he need not be lonely : with regard to his visitors, he tells us, he had 'a Ninstitution . . . their bills themselves they pay—but I give them a bottle of champagne.' One of the friends whom he invited was Sir George Grove— who had begun his career by erecting two cast-iron light-houses in the West Indies, had been then secretary to the Crystal Palace Company and editor of *Macmillan's Magazine* and was afterwards to become celebrated as editor of the *Dictionary of Music and Musicians*. This versatile man had at the moment turned his attention to collecting toadstools, and Lear wrote to him : 'I hasten to inform you that in a wood very near here, there are Toadstools of the loveliest and most surprising colour and form :—orbicular, cubicular and squambigular, and I even thought I perceived the very rare Pongchámbinnibóphilos Kakokreasóphoros among others a few days back. You have therefore nothing better to do

than to come with Penrose and hunt up and down St. George's Hill for the better carrying out of the useful and beastly branch of science you have felt it your duty to follow. Provided also that you bring your own cooking utensils you may dine off your gatherings though I won't partake of the feast, my stomach being delicate. . . .'[1]

At the end of January he returned to London. Ann had been better again during the last few weeks, and he had not allowed himself to believe that she would not recover. Though he had seen her only at long intervals during the last years, he had felt always that she supplied an enduring background of loyalty and love in an existence in which there was so little that was enduring, so little that was solid or settled. She was the one thing he could be sure of as a counterpoise to the personal isolation of which he had so acute a sense. She came to the studio in Stratford Place one day at the beginning of March, 'very fading and poorly,' but it was the last time she ever came to see him. A day or two

[1] Charles L. Graves. *Life and Letters of Sir George Grove.*

136

later she had a relapse, and he realized that there was little hope. During the last few days of her life he was constantly with her, bringing flowers to her and sitting long hours at her bedside, and in the evenings he would go home and pour out all his thoughts and his sorrow into the pages of his diary, together with the exact details of her illness—a record which he turned back to and re-read many times in later life, when the thought of the beloved sister who had been almost his mother was constantly with him. She suffered much, but maintained a cheerfulness and tranquillity that moved him deeply. On March 11th she died.

' If you knew what a more than Mother she has been to me all my life, and how faultless a character she was, you would well believe that her death is the heaviest affliction I can ever have to bear,' he wrote to Drummond. And to Fortescue :
' I am all at sea and do not know my way an hour ahead.

' I shall be so terribly alone.

' Wandering about a little may do some good perhaps.'

CORFÙ AND ENGLAND

LEAR seldom alludes, either in letters or diaries, to what he called his 'nonsenses,' and it is difficult to determine what his own estimate of their importance may have been. Certainly it never occurred to him that it was they, and not his other work, that would bring him immortality, and that fifty years after his death his landscapes would be almost forgotten, while his name would still be known as a nonsense-writer wherever the English language is spoken. His serious work has been more completely forgotten than it deserved to be, more completely forgotten, perhaps, than it would have been if his reputation as a writer of nonsense rhymes had not so unfairly overshadowed it. One or two of his friends have recorded their opinion that in his heart of hearts he was more proud of his nonsense poems than of his paintings : certainly, in later life, they became of increasing importance to him as a vehicle of his deepest feelings ; but in his letters, and in his diary especially, it is the paintings on which he was working at the moment that engrossed him, whereas allusions to the 'nonsenses' are both rare and casual. Of the landscapes, every particular was noted in his diary, every detail of progress, of the hours he had worked each day, of his subjects, frames, prices, exhibitions, and the comments of his friends. Landscape-painting, after all, was his profession. The 'nonsenses,' on the other hand, were jotted down at odd moments for the children of his friends, or for his own

relaxation—sometimes in his moments of deepest depression —and were afterwards collected for publication. He never set himself deliberately to compose a book of nonsense.

The original edition of the first *Book of Nonsense*—which consisted of Limericks only—had been published in 1846, and there had been another edition ten years later. These had not been published under Lear's own name : on the title-page there had simply appeared the rhyme :

> *There was an old Derry down Derry,*
> *Who loved to see little folks merry,*
> *So he made them a Book,*
> *And with laughter they shook,*
> *At the fun of that Derry down Derry.*

But now, in 1861, it was decided to bring out a third edition, with new Limericks and drawings added, and the author was no longer to be known as ' Derry down Derry ' but by his own name of Edward Lear. He offered to sell his publishers the copyright of the book, outright, for one hundred pounds, but they were cautious, and unwilling to take the risk. The edition of two thousand copies, however, was immediately sold. Next year, when the question of a further edition arose, the publishers thought differently, and now asked to be allowed to purchase the copyright. ' But now it is a success they must pay me more than I asked at first,' said Lear, and agreed to sell it to them for £125. It was his idea of a bargain ; and that was all he ever made—apart from his profits on the first two editions, which were not large—out of a book which went into nearly thirty editions even in his own lifetime and of which countless thousands of copies have been sold. But he was delighted with his £125, and immediately went off to put it in the bank. ' I went into the

City to-day,' he wrote to a friend, ' to put the £125 I got for the *Book of Nonsense* into the funds. It is doubtless a very unusual thing for an artist to put by money, for the whole way from Temple Bar to the bank was *crowded* with carriages and people—so immense a sensation did this occurrence make. And all the way back it was the same, which was very gratifying.'

His friends were delighted with the book : the whole Tennyson family, to whom he had sent a copy, was in the highest glee ; and Lear's own simple vanity was pleased with a little incident that occurred one day when he was in a book-shop. Three young men came in and asked for the *Book of Nonsense* and ' went into fits over it,' and ' when I went out,' he wrote, ' I had to turn back . . . and saw all three were being " shown me " by the bookseller, at the door. So vast a thing is fame ! ' He was less pleased, however, at some of the reviews which appeared. The *Saturday Review*, for instance, spoke of the nonsense verses as being ' anonymous, and a reprint of old nursery rhymes,' though giving him credit for a ' persistent absurdity.' ' I wish,' he wrote, ' I could have all the credit due to me, small as that may be.'

After Ann's death one of Lear's most faithful patrons, Lady Waldegrave, seeing that the best thing for him would be to go abroad for a time, gave him a commission to paint her a view of Florence from the Villa Petraja. This was one of the many instances of the thoughtful kindness with which his friends helped him all through his life. He had no false pride about the acceptance of such benefits, and his friends knew that he was not one of those who bear resentment towards those who do them a good turn. And so, after spending some time with the Tennysons, he left England in

May. Stopping at Turin on the way, he found that there was a *festa* in full swing, and had a good view of Victor Emmanuel, who, three months before, had been proclaimed King of all Italy—with the exception only of Venetia, still in Austrian hands, and Rome, where the Pope and his French garrison still ruled the roost.

Lear had not been in Florence since the days of his first enthusiastic visit to Italy twenty-four years before, when he had seen the Grand Duke riding about the streets, and had been so pleased with the ' English Church,' and had described the place as a ' hurly-burly of beauty and wonder.' His reactions now were rather different : Florence, though he appreciated its fascination as a museum full of exquisite *objets d'art*, was a little too much of a good thing. Others have shared this feeling. ' Plum-pudding, treacle, wedding-cake, sugar, barley-sugar, sugar-candy, raisins and peppermint drops,' he wrote to Holman Hunt, adopting one of the ' culinary similes ' of which his servant Giorgio was so fond, ' would not make a more luscious mixture in the culinary world, that Florence and its Val d'Arno does as a landscape. It is well to see it—and draw it : and its associations are marvellous : yet a month of it will be enough for me.' He was in poor health again : the sorrow of Ann's death, and now the news of the death of his sister Mary Boswell, at sea, on her way home from New Zealand, contributed to this. But he set to work on the Petraja picture, making, according to his usual custom (and in spite of Holman Hunt), sketches on the spot, from which to paint when he came home. His journey back to England was leisurely, and he was industriously making drawings all the way—of the spot, at Viareggio, where Byron, Leigh Hunt, and Trelawney had kindled Shelley's funeral pyre, of the marble mountains of

Carrara, the Vaudois valleys, Lausanne, and Ferney, where Voltaire's last years were spent.

He was greeted, on his return, by uncomfortable news from America. Though he can hardly have kept any very strong feelings towards the two brothers who had emigrated there when Jeremiah Lear had been ruined nearly forty years before, when he himself was still a child, his sister Ann had always kept in touch with them. Frederick was an engineer in Springfield, Missouri, Henry a map-maker in New York : neither had found life easy in the New World, and their frequent requests to Ann for help had been answered, often at some cost to themselves, by her and Edward and Eleanor Newsom. Eleanor had now had letters from both brothers, both of whom were in difficulties. The Civil War had just broken out : Frederick's son had joined the Southern Army, Henry's four sons the Northern, and Lear's five nephews were ' actually fighting against each other at Springfield . . . a curious state of unpleasant domestic romance.'

Having dealt with these requests as best he could, and his health suffering from the November fogs in London— ' Foggopolis,' as he called it—he left, as the winter drew on, for the Mediterranean. He had decided to go to Corfù again, which seems strange, considering that it had been the scene of some of the unhappiest times of his life, when he had felt his loneliness most acutely, and when the problem of his relations with Lushington had driven him to despair, so that he had been glad to leave the place and all its associations. But Lushington was no longer there ; Lushington, in fact, was to be married shortly, so that that relationship could never be quite the same again. The friendship continued for the rest of Lear's life, and probably Lushington never noticed any essential difference in its quality : but, as far as

Lear was concerned, all possibility was finally removed of attaining to that degree of unreserved intimacy which he had so ardently desired. 'One would be all,' Emily Tennyson had written to him, years before, 'and, in that one cannot be, here is the loneliness.' He could never have attained to it, because it was not in Lushington's nature to give it : he had made the all too common mistake of trying to form his friend on his own model, instead of accepting him as he was ; and when the struggle had to be abandoned he was forced to resign himself to its final hopelessness. But the relaxing of his efforts, the acceptance of the inevitable, actually brought with them a certain sense of relief.

There had been changes in Corfù in the last few years. The inhabitants of the Ionian Isles, tired of British rule and desiring union with Greece, had begun to show their discontent, with the result that a mission had been sent out under Mr. Gladstone—which failed to achieve its effect because the Corfiotes persisted in regarding him as an apostle of freedom. Their hopes were brought to nothing when a new Lord High Commissioner was appointed to enforce the British rule with greater stringency : yet there remained a general feeling that the desired union with Greece would be effected by time and patience. In the meantime, the new Commissioner, Sir Henry Storks, was considered, both by Lear, when he arrived, and by everyone else, to be a great improvement, both as a man and as a governor, on his predecessor.

Lear had come to Corfù for the beauty of the place and of its climate, and in order to work. The loss of Ann still lay heavy on his mind, and he was in no mood for social diversion. He determined at once to take little or no part in the life of 'this very very very small tittletattle place . . . this little piggywiggy island,' as he called it, and set about his painting

by day and his ' penning out ' by night, interspersed with
lessons in Greek, both ancient and modern, to which
he applied himself with the greatest seriousness and which he
regarded as of extreme importance. ' If I had my way,' he
wrote to Fortescue, ' I would cause it to be understood that
Greek is (or a knowledge of it) the first of virtues : cleanliness
the 2nd, and Godliness—as held up by parsons generally—
the 3rd.' He had found good rooms ' with a perfect north
light '; their only disadvantage was that they were very
noisy. ' People over me gave a ball : people under me had
twin babies : people on the left played on 4 violins and a
cornet : people on the right have coughs and compose
sermons aloud.' But, on the whole, he was fairly contented.

One of his chief comforts during this winter was his regular
correspondence with Fortescue, to whose goodness, both as
a letter-writer and as a companion, his diary pays constant
tribute. ' His society is always, I think invariably, a great
comfort to me,' he had written after seeing him in London,
' and even my boreability and fastidious worry can hardly
ever find any vexation therefrom, which I think I cannot say
of that of any other living man.' And in Corfù he made
another new friend, whose youthful spirits and gaiety and
intelligence did more than the young man himself ever
realized to relieve the monotony and ill-health of Lear's life
at this period. Sir Henry Storks, the new Lord High
Commissioner, had as one of his A.D.C.'s a young officer of
the Royal Artillery, not yet twenty-one, who was immediately
attracted by the whimsical, melancholy, middle-aged painter
with the large spectacles and untidy clothes and the endless
flow of puns and absurdities. His name was Evelyn Baring—
a name which, in twenty or thirty years' time, was to become
famous as that of the ' Maker of Modern Egypt,' and was to

be exalted into the title of Earl of Cromer. Evelyn Baring became one of Lear's dearest friends, in spite of thirty years' difference in age : it was he who, twelve years later, as Private Secretary to his cousin Lord Northbrook, then Viceroy of India, made many of the arrangements for the Indian tour which Lear undertook at Lord Northbrook's invitation.

Lord Cromer's biographer gives the following account of their relations. ' Amongst other visitors to the island was . . . Edward Lear, the artist, with whom Baring struck up a deep and lasting friendship. Lear himself returned in full measure the affection which Evelyn Baring lavished on him, and wrote him letters in strange, incomprehensible phrases culled from his own inimitable vocabulary of nonsense words :

' " THRIPPY PILLIWINX,—Inkly tinky pobblebockle able-squabs ? Flosky ! Beebul trimble flosky ! Okul scratch abibblebongibo, viddle squibble tog-a-tog, ferry moyassity amsky flamsky damsky crocklefether squiggs.

<div style="text-align:right">Flinky wisty pomm
SLUSHYPIPP."</div>

' Lear's was a warm-hearted and lovable personality. He was a great admirer of Tennyson, and Evelyn Baring caught him on one occasion sobbing with emotion over the piano as he played and sang " Tears Idle Tears," which he had put to music. Yet so great was his whimsical sense of the ridiculous that he could not help poking fun even at those whom he admired most. . . .'[1]

So passed the winter in Corfù—or rather, as Lear wrote, there was ' *no* winter : but (*en revanche*) 43 small earthquakes.' In December the Prince Consort died suddenly, and Lear recalled an incident of the time when he was at Osborne

[1] Marquess of Zetland, *Life of Lord Cromer.*

giving the Queen drawing-lessons : ' Prince Albert showed me all the model of the House (then being built only), and particularly a Terrace, saying—" This is what I like to think of—because *when we are old*, we shall hope to walk up and down this Terrace with our children grown up into men and women." ' Another anecdote he told Fortescue at this time, which gives a glimpse both of his own clumsiness and of his ability to poke fun at himself. ' The woes of painters,' he wrote : ' just now I looked out of window at the time the 2nd were marching by—I having a full palate [sic] and brushes in my hand : whereat Col. Bruce saw me and saluted ; and not liking to make a formillier nod in presence of the hole harmy, I put up my hand to salute—and thereby transferred all my colours into my hair and whiskers—which I must now wash in turpentine or shave off.' The poet Aubrey de Vere, whom Lear had met in Rome, had turned up in Corfù to visit his brother, who was a major attached to the English garrison. ' Aubrey de Vere has just arrived—which if I had to see him would be a bore : but isn't. . . . He mooneth about moonily.'

The chief event of Lear's visit to England that summer was the engagement of his friend Chichester Fortescue to Lady Waldegrave. She had for long been a friend of Lear's and had been generous in buying and commissioning pictures from him, and Fortescue had been devoted to her for many years. Her father, John Braham, born of humble Jewish parentage, had been the greatest tenor of his day—' a beast of an actor, but an angel of a singer,' Sir Walter Scott had called him : he had also been a man of considerable originality and force—qualities which seem to have descended to his daughter, who united them with charm, wit and intelligence, and that peculiar talent which goes to make a successful ' hostess.'

Married first to Earl Waldegrave, secondly to George Harcourt of Nuneham Park in Oxfordshire, she was a prominent figure in the social and political world and entertained many of the distinguished people of the day in her various country houses and at Strawberry Hill, Horace Walpole's elaborate Gothic villa at Twickenham, which she restored and made the ' oddest and prettiest thing you ever saw.' George Harcourt, many years older than his wife, died, and Fortescue, in spite of two ducal rivals, was able to obtain his heart's desire.

It was with mixed feelings that Lear congratulated him, rejoicing with him, yet knowing that here again, as in the case of Lushington, a relationship that was of inexpressible value to himself must suffer a change and, inevitably, a diminution. ' Every marriage of people I care about rather seems to leave one on the bleak shore alone—naturally,' he wrote. The friendship would endure, the letters would continue to be written, but the precious sense of companionship must be lost. He wrote to Fortescue some months later, just after the marriage had taken place, saying that he hoped to see him on his return to London shortly, but regretting that their custom of breakfasting together, which had been one of his especial pleasures, must now be abandoned :

> But never more, O ! never we
> Shall meet to eggs and toast and T !

' Never mind. I don't grumble at the less I see of friends— so they gain by it.'

Before leaving for Corfù he saw the Tennysons, who were staying at this time in a house at Putney Heath lent to them by Mrs. Cameron, their neighbour in the Isle of Wight. Julia Margaret Cameron was a sister of the lovely Lady Somers, and the only one of the seven daughters of James Pattle, of the

Bengal Civil Service, who had inherited no share of beauty. But what she lacked in looks she made up in a high-handed eccentricity of character and an unconventionality that were often alarming, making amends for her own plainness of appearance in a passionate cult of beauty in her surroundings. Photography was then in its early days, and her genuinely creative talent found expression in the series of remarkable portraits and groups of her friends and relations. Draped in cloaks and rugs, with flowing hair and beards, the literary and artistic lions of the Victorian age—Browning, Tennyson, Carlyle, Watts, Darwin, Jowett—were forced to submit to the ordeal of her camera : or her housemaids and the village girls would be posed as Sappho and the Virgin Mary, her children as angels with swans' wings, fishermen as King Arthur, and Mrs. Watts and her sisters as the 'Rosebud Garden of Girls.' Many of her friends loved her dearly : others found her formidable vitality a little exhausting. Among the latter class was Lear. He had met her several times at Farringford : she had had her grand piano carried up there one evening specially for him to sing his Tennyson songs, because the Tennysons' was out of tune ; she had sent him one of her many photographs of the Poet Laureate ; but still they did not make friends. At last she was tactful enough, in spite of her imperious ways, to see this. 'Mrs. Cameron only came in once—with feminine perception, not delighting in your humble servant,' Lear wrote to Holman Hunt after a visit to the Tennysons ; 'we jarred and sparred—and she came no more.'

During one of the visits to the Tennysons at Putney Heath the Poet read Lear his poem of *The Dying Farmer* (or *The Northern Farmer*). Lear—not surprisingly—did not like or admire it. 'A. T. read his *Dying Farmer*, which, however

remarkable as a curiously accurate portraiture of a queer subject, is by no means a pleasing poem to me. That men play the fool in the face of death and a Creator is no new fact—that I doubt its being a more agreeable one for poetry. However, perhaps I am over fastidious.'

Lear's financial affairs, that summer and autumn, were undergoing one of their frequent crises ; but once again he was saved, at the last moment before he went abroad, by a stroke of luck. Through the offices of Lady Waldegrave, his picture of ' Philæ at Sunset ' was purchased by one of the exiled princes of the House of Orléans, who was then living at Twickenham—the Duc d'Aumale, fourth son of Louis-Philippe. (It was he who had inherited the Château of Chantilly and a vast fortune from the old Prince de Condé—a fortune round which had centred one of the darkest scandals of the early nineteenth century, when the English adventuress, Sophie Dawes, who had risen from the position of servant-girl in a London brothel to that of the old Prince's mistress and confidante, had bargained with Louis-Philippe, in return for the privilege of being received at court, the Condé inheritance for his son. She completely dominated the feeble old man, bullied him, plundered him unmercifully and, almost certainly, murdered him, but was never brought to justice owing to the royal protection). Lear's picture of Philae still hangs in the gallery at Chantilly.

He had a certain success again next spring in Corfù, where he held his usual ' eggzibission ' in his rooms. Evelyn Baring was still there, and he also made the acquaintance of Sir Percy Florence Shelley, the only surviving son of the poet, who came with his wife and his little daughter in a yacht. ' The people whose acquaintance has most delighted me are the Shelleys,' he wrote to Lady Waldegrave. ' Think of my

music to "O world, O life, O time !"—Shelley's words—being
put down in notes by Shelley's own son !' He was much
amused, also, at this time, to discover in Corfù an eccentric
and drunken old sailor, a 'seafaring man who has formerly
been in the Balearic Isles,' who had taken a kind of 'mono-
maniac fancy' to the *Book of Nonsense*, and who declared that
he '*knew personally* the Aunt of the Girl of Majorca !! I
hear it is more than humanity can bear to hear him point
out how exactly like she is—and how she used to jump the
walls in Majorca with flying leaps ! ! !'

> *There was a young girl of Majorca,*
> *Whose aunt was a very fast walker,*
> *She walked seventy miles,*
> *And leaped fifteen stiles,*
> *Which astonished that girl of Majorca.*

In the spring Lear went off for an eight weeks' tour of the
Ionian Isles, before returning to England. He was never so
happy and well as when moving about and seeing new places,
and he enjoyed this tour greatly, returning well-pleased with

the large portfolio of sketches that he had made, a selection of which he intended to lithograph and publish as a book. He was delayed in his journey to England by a severe sunstroke with which he was smitten at Ancona, where the Papal Customs examination was performed ' in the middle of the road ' : he managed to get as far as Turin, where he collapsed and lay seriously ill. ' I did not think I should live,' he wrote . . . ' I often thank God that although he has given me a nature easily worried by small matters, yet in cases such as this I go on day after day quite calmly, only thankful that I do not suffer more. It is an odd full stop to my triumphant 8 weeks' success in the Island tour. . . .' When he finally reached London he started work on the Ionian Isles book, first completing the twenty lithographs and then setting about the laborious task of writing three hundred letters : it was with great difficulty that he collected an adequate number of subscribers, with even greater difficulty their subscriptions. ' You will be happy to hear that I have put by £300, and therefore am entitled annually to £9 all my life,' he told Fortescue. ' I would not go through what I have again for £9000 a year. But having seen fit to begin a work, I went through with it.' *Views in the Seven Ionian Islands* was published in December 1863 : apart from brief descriptive notes, it has no letterpress, but the lithographs achieve their purpose of faithful representation. It was dedicated to the Lord High Commissioner, Sir Henry Storks, who gratified Lear by taking ten copies. Otherwise it had no great success.

The next winter was to be Lear's last in Corfù. Prince George of Denmark had been proclaimed King of Greece some months before. (Lear had written to Fortescue : ' I want you to write to Lord Palmerston to ask him to ask the Queen to ask the King of Greece to give me a " place " . . .

I wish the place to be created a-purpose for me, and the title to be ὁ Ἀρχάνοησιαφλυαρίαποιὸς [Lord High bosh-and-nonsense-maker], with permission to wear a fool's cap (or mitre)—3 pounds of butter yearly and a little pig, and a small donkey to ride on. Please don't forget all this, as I have set my heart on it.') And now the treaty ceding the Ionian Isles to Greece was on the point of being signed. Corfù was in an unsettled and uncomfortable state owing to the approaching departure of the English—who, whatever else they had done, had brought prosperity to a large section of the population. By no means everyone was glad they

were going, but there was a considerable measure of anti-English feeling, further irritated by the seemingly unnecessary decree that the English forts were to be blown up.

Lear found the atmosphere of the place unfavourable to work, depressing to the spirits, and in March he prepared to leave. ' All things have suffered change,' he wrote. ' All is packed. All is empty. All is odious. All is anger. All is sorrow. All is bother. I have given up Corfù, and go on

Monday . . . to Athens, and thence to Crete, the faithful Suliot George accompanying me. . . . I never in all my life passed a sadder and uglier time than the last six weeks. . . . Everyone either miserable for going away—or miserable at being left : while angry passions and suppressed violence were abundant.' In spite of all that had happened there, Lear had loved Corfù : and he was bitterly sorry to leave it. At the beginning of April he sailed for Greece with Evelyn Baring. ' Once more,' he wrote in his diary, ' I left the loveliest place in the world—with a pang—tho' less this time thro' not being alone. Dinner—and afterwards B. and I walked, talked, smoked and sat till 8—when there was tea—and then I sate star-gazing till 9—when we went to bed.'

WINTERS AT NICE AND MALTA ; ENGLAND
AND THOUGHTS OF MARRIAGE

WITH its memories of one of the most ancient of European civilizations and its little-explored beauty of mountain and coast, Crete, ' island of a hundred cities,' was a place that Lear had long wished to see. Now, after his visit to Athens with Evelyn Baring, he went on there for a few weeks before returning to England. This visit, also, was a great success : he returned with two hundred sketches, but never fulfilled his intention of publishing a book of Cretan views, discouraged, no doubt, by the laboriousness of the task and the comparatively poor success of the Ionian Isles volume.

He had been thinking, for some time, of giving up his yearly visits to England and making permanent headquarters somewhere in the warmer climate of the Mediterranean. Italy was the obvious place, but Italy was still in an unsettled state. Corfù was now impossible. He thought of Athens ; but Athens, again, was too far away from England and his friends. The plan would have been an economy, saving him the rent of his rooms in London and heavy travelling expenses : it would also have benefited his health : but, for the moment, indecision and his chronic dislike of establishing himself anywhere overcame him, and it was not till some years later that he put it into effect. Since Ann's death, he had few ties in England. London he had come to dislike, not only on

account of its climate, but of the social demands which distracted him from his work and claimed so much of his time. Even the dinner-parties, that important feature of Victorian life, which he had used to enjoy, had become a burden : ' I object to this continued circle of dinners,' he told Mrs. Tennyson ; ' I have no life to do as I like with.' The most exasperating thing of all was that his work was liable to continued interruptions, which his financial difficulties forced him to endure, for fear of losing a sale. (In later years, more arbitrary, he took to barricading his doors.) After one of these incursions of fashionable ladies into his studio he worked off some of his irritation by scribbling a little ' scene from studio life,' which he sent to Holman Hunt. It has the ring of truth, and Hunt was able to sympathize.

(*4 ladies, having staid 2 hours—rise to go.*)

' *1st Lady.* " What a treat, my dear Mr. Lear ! but how wrong it is of you to stay so much indoors ! You should take more care of your health—work is all very well, but if your health fails you know you will not be able to work at all, and what could you do then ! Now pray go out, and only see your friends before 12 or 1, in the morning."

' *2nd Lady.* " But how dreadful these interruptions must be ! I cannot think how you ever do anything !—*Why* do you allow people to break in on you so ? It quite shocks me to think we have taken up so much time."

' *3rd Lady.* " Yes, indeed : these are the best hours of the day. You should never see anyone after 2 o'clock."

' *4th Lady.* " You should walk early, and then you could see your friends all the rest of the day. Interruptions must be so dreadful ! "

(*Enter* 4 *more ladies. The first* 4 *rush to them.*)

' *All* 8 *Ladies.* " How charming ! how fortunate ! dear Mary ! dear Jane ! dear Emily ! dear Sophia ! *etc.*"

' 5*th Lady.* " How wrong of you dear Mr. Lear to be indoors this fine day ! "

' 6*th Lady.* " How *you can ever* work I *cannot* think ! You really should not admit visitors at all hours ! "

' 7*th Lady.* " But do let us only sit and look at these beautiful sketches ! "

' 8*th Lady.* " O how charming ! and we will not go to Lady O's."

' *The other* 4 *Ladies.* " O then we also will all sit down again—it is *so* delightful.

' *Chorus of* 8 *Ladies.* " What a charming life an artist's is ! "

' *Artist.* " ———— D———n ! " '

All that summer he was unable to throw off the mood of alternate melancholy and irritation which possessed him—the mood which had caused him to exclaim : ' I am less and less interested in myself—having come to regard the remainder of life as so much time to be used up to the best of my power —and then the end.' He felt that he was growing old—he was now fifty-two—without any solid achievement, even that of a regular income, and that his life was drifting aimlessly and without anchor. Even his work often failed to interest him, and became more and more of an effort. He who, if circumstances had been different, might have been the most domesticated of men, wandered restlessly from place to place, seeking always, beyond every horizon, some vague and indefinable peace. There were certain people, certain places that could give him a taste of what he sought—the Tennysons, for instance, though Farringford could hardly be

described as a cheerful household. 'Altogether this is one of the places I am really happy in (and few they are)—though the pleasure is mingled with melancholy,' he wrote in his diary when he went there in October. But 'Emily T. is I think sadder than formerly. . . . Alfred is more expansive and offensive than usual.'

His unquiet state of mind had affected even his relations with Fortescue, which, since Ann's death, had been the most stable thing in his life. But partly this change was due to Lear's inevitable feeling that, now Fortescue was married—much as he liked and admired his wife ; but that did not affect the question—their friendship could no longer be on the old intimate footing. Fortescue reproved him for what he termed a 'stern and stiff' letter, and Lear answered : 'Every year—especially in London—makes me less able to write as formerly. . . . You must make up your mind never again—except by chance or fits of irregular elasticity, to find in me the descriptive or merry flow of chronic correspondence I used to be able to indulge in. As we grow older, and life changes around us and within us, we ourselves must show some sign of change—unless we are fools, or vegetables, or philosophers to a greater degree than I am or can be. Your letter makes me almost think that it is better to write scarcely at all rather than that which is unsatisfactory. . . .'

That winter he decided to spend at Nice. Nice had been ceded by Italy to France four years before, and had to a great extent taken the place of Rome as the fashionable winter resort of wealthy English people—though it could not supply the 'artistic' tone on which smart Anglo-Roman society of twenty years before had prided itself. To Lear it appealed, not at all as a place, but on account of its extreme dryness, and as a hopeful market for his pictures. 'A queer place,' he

called it : ' Brighton and Belgravia and Baden by the Mediter-
ranean : odious to me in all respects but its magnificent winter
climate.' He took furnished lodgings on the Promenade des
Anglais, and proceeded to set up his ' gallery.' ' The carpet
and papers here are so extremely damnable that they resemble
large flights of red and blue and green parrots with roses and
mustard-pots interspersed—so that I had to buy 4£ of brown
Holland to cover them up or I should have gone blind or
mad.' There were plenty of friends at Nice, at Cannes, at
Mentone, who flocked to see his exhibition : even the Empress
of Russia expressed a desire to come. Lear at first agreed to
this visit ; then, next day, characteristically, changed his mind.
' It would be better,' he wrote in his diary, ' to sell no more
drawings here, than to involve oneself in endless risk of loss
of time and temper by contact with Royalty.' Then he
changed his mind again, and decided ' to let things take their
course.' But the visit never took place, for the young
Tsarevitch, the Empress's eldest son, fell ill of cerebro-spinal
meningitis and died shortly afterwards.

In December Lear took a walking and sketching tour along
the Riviera to Genoa and back, and, as a result of so much
unaccustomed exercise, returned ' in better health than before
—also less abdomen ' and with ' 144 drawings great and small.'
Again he had ideas of publishing a book of lithographs, but,
as in the case of the book of Cretan views, the project came to
nothing. He was busy also in making drawings in the
country round Nice, Antibes and Cannes, but this had its
difficulties, for, he told Holman Hunt, ' if you want to be
quiet anywhere for miles round Nice, and sit down to draw—
lo ! presently, 30 parties of smart young ladies on donkies
immediately surround you—and in a twinkling the ground is
white with tablecloths, and liveried servants are opening

champagne bottles.' But, with its many disadvantages, Nice had repaid him ; he had sold a large number of ' £5 drawings,' and left for England satisfied that he would be able to ' shuffle on till autumn.'

On his return he set up his exhibition in his studio at Stratford Place, and, on the advice of a friend, sent out a thousand circulars in the hope of thus inducing people to come and buy. There came, among many others, the Prince of Wales, who chose ten sketches ; so that the effort had not been in vain, though the method, he complained to Emily Tennyson, ' was so harassing and odious—seeing the vapid nature of swells, and the great amount of writing, and the close confinement to the house—that I loathe London by the time I have been here a month. . . . I should like to know,' he added, ' how Alfred likes a Pome or Tragedy by one Mr. Swinburne—*Atalanta in Caledon* [sic] : I take to it extremely.'

There occurred during the autumn of that year, in the world of which, up till then, Lear had been undisputed king— the world of Nonsense—an event of the utmost importance, the publication of Lewis Carroll's *Alice in Wonderland*. From Lear's complete silence on the matter it might be thought that he had never heard either of the book or of the distinguished Oxford mathematician, its author : yet this is hardly possible. He was in London when it came out ; and the book had an instant success and was everywhere talked of—and nowhere more than in the very circles Lear himself frequented, for Dodgson knew the Rossettis, Holman Hunt and Millais well, and was on terms of the closest friendship with the Tennysons and their circle. His *Index to " In Memoriam "* had been published three years before, and he was a constant visitor to Farringford. It seems almost impossible that the two never met—or, even if they never met, that they were not aware of

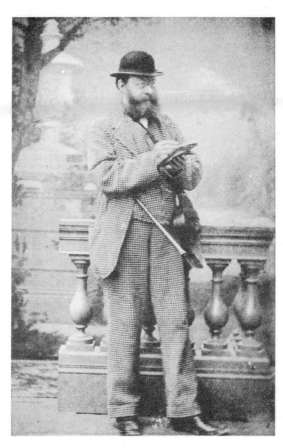

*Edward Lear from a photograph
taken in Nice, c. 1865*

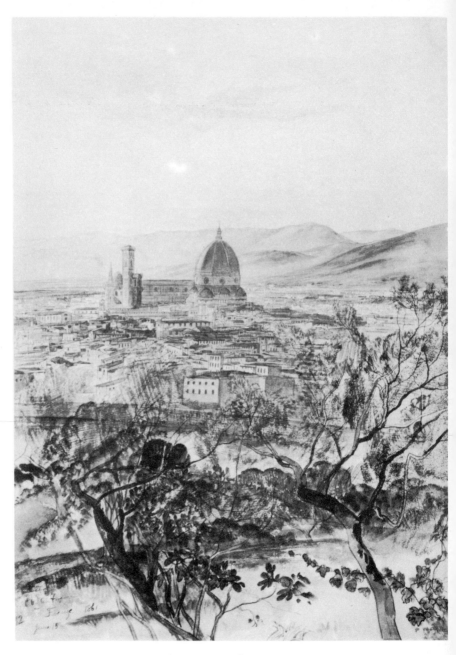

Florence, watercolour, 1867

each other's existence : yet there is no mention of Dodgson or of *Alice* in Lear's letters or diaries, nor does Dodgson's biographer allude to Lear. The Tennyson family were rejoicing in *Alice*, as they had rejoiced in the *Book of Nonsense* : yet Mrs. Tennyson, though she wrote constantly to Lear, never speaks of it. One is tempted to believe that this silence was deliberate, that Lear, perhaps, was conscious of Dodgson as a rival, resenting the incursion of the younger man into his own peculiar realm and showing his pique by ignoring him. Yet this may be an injustice to Lear, who, for all his vagaries of mood, was never ungenerous : the evidence is purely negative. And in any case there was no real rivalry, for Dodgson's nonsense and Lear's are as different—not as chalk from cheese, for both are varieties of the same genus, but as, let us say, Gorgonzola from Camembert. Some like one ; some like the other ; some like both. But it would have been interesting to know what they thought of one another— the mathematician and the landscape-painter, who have both become immortal, their own mundane occupations forgotten, in the aery world of nonsense.

Lady Waldegrave had given Lear another commission, this time for a picture of Venice, and he started off there in November on his way to Malta, where he proposed spending the winter. He had been to Venice some years before with Lushington on their way back from Corfù and had taken a strong dislike to the place. ' I don't care a bit for it,' he had told Ann, ' and never wish to see it again.' Probably Lushington had influenced his feeling, for Venice is hardly the place that would have made a strong appeal to that un-imaginative and rather prosaic man—nor is it a place to visit with an unsympathetic companion. But now Lear felt quite differently about it. ' This city of palaces, pigeons, poodles

and pumpkins (I am sorry to say also of innumerable pimps—
to keep up the alliteration) is a wonder and a pleasure,' he
wrote to Drummond. It was while he was there that he heard
of Fortescue's appointment as Secretary of State for Ireland,
and, in a letter to Lady Waldegrave, he gave the following
account of his own behaviour on reading the news in *The
Times* at breakfast in his hotel. 'Being of an undiplomatic
and demonstrative nature in matters that give me pleasure, I
threw the paper up into the air and jumped aloft myself—
ending by taking a small fried whiting out of the plate before
me and waving it round my foolish head triumphantly till
the tail came off and the body and head flew bounce over to
the other side of the *table d'hôte* room. Then only did I
perceive that I was not alone, but that a party was at breakfast
in a recess. Happily for me they were not English, and when
I made an apology saying I had suddenly seen some good
news of a friend of mine, these amiable Italians said—" Bravis-
simo signore ! We rejoice with you ! And if only we had
some little fish we would throw them about the room too,
in sympathy with you ! "—so we ended by all screaming
with laughter.'

In Malta he was not so happy. He had hoped to find Sir
Henry Storks and Evelyn Baring there, but, to his great
disappointment, they had been transferred to Jamaica and
had just left. He had, consequently, few friends, and did not
care for the ordinary naval and military social life. He had
no great opinion of the ' Anglo-Maltese intelligence ' : fifty
people and 'no end of dogs' came to see his pictures, but
there had been no sales, only foolish and irritating conver-
sations. 'Were I to ask a Military cove if this climate, on
account of its dryness, required him always to pour water
down his gun before firing it, or a Naval one if he weighed

anchor before he sailed or a week afterwards, I should be laughed at as a fool ; yet many not much less silly questions are asked me. . . . To many people, however,' he went on, ' Malta ought to be a charming winter residence : for there is every variety of luxury, animal, mineral and vegetable—a Bishop and daughter, pease and artichokes, works in marble and fillagree, red mullet, an Archdeacon, Mandarin oranges, Admirals and Generals, Marsala wine 10d. a bottle, religious processions, poodles, geraniums, balls, bacon, baboons, books and what not.' He became more and more depressed and lonely.

In March, having worked endlessly at ' Venetian sunsets ' and ' drawn all Malta,' he paid a visit to the neighbouring island of Gozo and ' drew every bit ' of that. Its scenery, he wrote, ' may truly be called pomskizillious and gromphib- berous, being as no words can describe its magnificence.' After this he could bear Malta no longer. It had been what he called ' a squashed winter,' and he decided to leave at once and exhibit the Malta and Gozo drawings in London. He wrote in a final burst of indignation to Drummond : ' Of Admirals and Generals, Captains, Colonels, Majors military and nautical with the wives and daughters thereof—no less than 83 of all sorts have been to see my " beautiful drawings " and not a single creature has asked for one. I am perfectly ashamed of all Malta. Brutes. Porchi. Apes. Owls. You may imagine I shan't come back here.'

He arrived in London in the late spring—' back to the evil days of English life.' All that summer his mind, for the second time, was deeply occupied with what he called the ' marriage phantasy,' which now absorbed him and would not let him be, ' yet seemed an intangible myth.' But this was a more serious attachment than ever his feeling for Helena

Cortazzi had been : that, to a great extent, was a result of his loneliness and depression in Corfù and of his unsatisfactory relationship with Frank Lushington ; it had been formed as a kind of compensation for his troubles, and when circumstances changed, it also vanished, without undue heartburnings, leaving little more than the memory of an agreeable companionship. His feeling for Augusta Bethell was of a deeper nature. At the age of fifty-four a man, if he is wise, does not attempt the role of the passionate young lover, even if the lady is many years younger than himself ; and it was not passion that he felt for her. It was rather a profound affection and respect, a delight in her society, a feeling that she alone could help him to solve the tangled problems of his nature and that if she would marry him life would somehow be renewed. There was something of desperation in it, but he was wholly sincere : if he had been less so, if he had been bent upon marriage merely as a drowning man clutching at a straw, it is much more probable that he would have brought himself to ask her.

It was no new or sudden attachment. Her father, Lord Westbury, an ex-Lord Chancellor, was one of Lear's oldest friends, with whom he had frequently stayed and who had bought more than one of his pictures. They had had many friendly arguments, especially on the subject of Tennyson, whom Lord Westbury persisted in regarding as a 'small poet' ; and once, on Lear's introducing one of his foolish puns into the conversation, the Lord Chancellor had reproved him with an assumption of his most grandiloquent legal manner—'Lear,' said his Lordship, 'I abominate the forcible introduction of ridiculous images calculated to distract the mind from what it is contemplating.' And it was while staying with him in the country that Lear had produced one

of the very few 'nonsenses' that he ever wrote in prose—
'The Story of the Four Little Children who went round the
World,' published later in *Nonsense Songs and Stories*. It was
written for the entertainment of Lord Westbury's four little
grand-children, who were the characters in the story—Violet,
Slingsby, Guy and Lionel. Lear had thus had many years in
which to cultivate the friendship of Lord Westbury's daughter
—'Gussie,' as he called her—but it was only recently that the
idea of marriage had come into his mind. He started the
summer in high hopes. Soon after his return to London he
dined at Lord Westbury's : ' in various ways,' he wrote to
Fortescue next day, ' *there is much that gives me satisfaction.* I
am to dine there again on Friday.' She came frequently to
see him at his studio, and all through the summer Lear spent
much time in her company, which brought him a happiness
and a tranquillity he had seldom felt. But the situation
became embarrassing for them both : reluctantly he was
forced to the always painful process of making up his mind.

It was a difficult problem he had to face. As a man well
past middle age, suffering from a chronic nervous infirmity
and other complaints that made his health a perpetual anxiety,
not very successful in his profession, with no settled income,
no home, endless financial worries, and no sure prospects—
and his ugliness : he must not forget how important that was
with the female sex, though at fifty-four it mattered less,
perhaps, than at twenty-four—as such, was he justified in
proposing marriage to a woman many years younger than
himself, daughter of a distinguished and wealthy family—
even if, as he supposed, she was rather fond of him ? The
uncertainty of what he ought to do worried him into succes-
sive moods of hope and despondency, deep melancholy and a
kind of stupor in which he could neither think nor act. He

consulted Fortescue and his wife, who were in his confidence on the subject of the proposed marriage, and decided, in his indecision, to be influenced by their advice. They were frank, but not encouraging, though naturally unwilling to take responsibility in so important a matter : his financial position, they told him, was too precarious, and they could not wholly approve the idea of his getting married.

His hopes were dashed—but at least it was a relief to have come to a decision. What would Gussie Bethell's answer have been ? We cannot know ; but, not very long afterwards she married, in order to take care of him, a man who was a far more hopeless invalid than Lear, a Mr. Parker who was completely paralysed. Lear resolved to give up all idea of matrimony. That he did not do so is clear from many confessions in his diary and letters : both before she was married, and after she was widowed a few years later, whenever they met—which they did fairly frequently and always with great pleasure on both sides—he was still thinking of it. The idea of marriage with her pursued him almost as long as life lasted ; but he never spoke of it to her.

EGYPT AND NUBIA : CANNES : CORSICA

THE farthest southward point of Lear's Egyptian tour in 1854 had been Philae : now, when he left for Egypt in the autumn, he made up his mind to press on farther south, and to make drawings of the Upper Nile and Nubia, as far as the Second Cataract. After that he intended to visit Palestine again, and to go northwards to Lebanon and Palmyra, before returning to England.

All the way up the Nile he was busy sketching, making new drawings of Philae and Denderah and other places that he had visited thirteen years ago ; but it was the new country above the First Cataract that now interested him more. 'Nubia delighted me,' he wrote ; 'it isn't a bit like Egypt, except that there's a river in both. Sad, stern, uncompromising landscape, dark ashy purple lines of hills, piles of granite rocks, fringes of palm, and ever and anon astonishing ruins of oldest temples.' The crowning moment of all was the sight of the Temple of Rameses the Great at 'wonderful Abou Simbel, which took my breath away . . . the great Abou Simbel—which last, unless a man or woman has seen, he or she might as well have been born blind—because all other visible things in this world seem to me to be as chips, or potato-parings, or any nonsense in comparison.' Part of the journey had been somewhat spoiled by the presence of 'an " American " or Montreal cousin,' one Robert Jones, whom he had come across at Luxor and who had insisted on travelling

with him. (Robert Jones was really Lear's great-nephew, one of the daughters of his elder brother Henry having married a ' Robert Jones, senator, of Montreal,' and this being their son. A daughter, Fanny, had married a Mr. Boomer, of Niagara, and had visited Lear in Corfù some years before). ' He was a fearful bore,' says Lear ; ' of whom it is only necessary to say that he whistled all day aloud, and that he was " disappointed " in Abou Simbel.' At Luxor, Lear had also seen the beautiful Lady Duff-Gordon, friend of Tennyson, Meredith and Kinglake, and author of the not wholly forgotten *Letters from the Cape* and *Letters from Egypt*. Already dying of consumption, she lived but two years longer.

He was back in Cairo in March, and, after a few days spent in drawing at Memphis, left for Jerusalem, travelling by land over the ' Short Desert ' (where now the railway runs) and stopping on his way at Gaza, Askalon and Ashdod. With Jerusalem—apart from its external beauty—he was as disgusted as he had been nine years before. ' The city itself is as filthy and odious as ever,' he wrote to Edgar Drummond, ' and its different religious sects as opposite as ever to the real spirit of Christianity. Forms and ceremonies, dogmas and doctrines— all held up to veneration. Charity and tolerance and brotherly love at zero.' He had not been there long before he fell ill with a bad throat and threatenings of fever. Sadly disappointed, he was forced to change his plans ; it would have been foolish to attempt a long journey which might have involved many discomforts and hardships. Galilee and Nazareth (of which a picture had been commissioned from him by the poet Richard Monckton Milnes, Lord Houghton), Tyre and Sidon, Lebanon, Palmyra—all these must be deferred to a later occasion. This was one of many plans that he made which were never to be carried out. He returned, as soon as

he was well enough to travel, to Alexandria, and so to Brindisi and London, bringing with him the harvest of his winter's work, one thousand new drawings.

It was now some years since Lear had undertaken the long round of country-house visits that had formerly occupied most of his summers in England. He had decided, not unreasonably, that it was a waste of time and an unsatisfactory way of seeing friends, for in ' the houses of the rich ' it was impossible either to work or to enjoy the society of those whom he went to see. He now stayed most of the time in London, working hard, and had reduced his visits to a very small number, among them being his sister, Mrs. Newsom, at Leatherhead, Fortescue and Lady Waldegrave at Strawberry Hill, Lord Northbrook, and the Tennysons. The latter were staying, this summer, in a farmhouse near Hindhead : they had just bought a piece of land in that neighbourhood, on which their new house, Aldworth, was to be built. Lear went to see them there, and for a time thought seriously of going to live near them. ' Mr. Lear came from Liphook,' Mrs. Tennyson wrote in her journal : ' he liked our neighbourhood so much that he said we were to look out for some land for him hereabouts. . . . He told an excellent story,' she went on, ' about a misquotation of a passage in *You ask me, why*. A friend of his remarked to him : " It is a well-known fact that Tennyson hates travelling." " Nonsense," answered Lear, " he loves it." " On the contrary," the friend retorted, " he hates it, and he says so himself somewhere :

> *And I will* die *before I see*
> *The palms and temples of the south.*" [1]

(It should, of course, be ' I will see before I die.' But one suspects that it may have been Lear who had invented this

[1] *Tennyson : a Memoir. By his Son.*

169

little story). Lear had been delighted, on this visit, to find his dear Emily Tennyson, instead of 'being altered and aged,' as he had expected, 'appearing younger, and handsomer and diviner than ever. The affection of the boys to her was beyond all idea. Also the Poet was more genial than of old, though of course he had his growl about his publishers after dinner. . . . Perhaps,' he added, 'the happiest evening I have passed for a time and times, such is the fascination of this lot of intellectual coves.'

He decided, that autumn, that he would make his winter headquarters 'permanently' (which, in this case, was to mean for three years) at Cannes. As a place, he much preferred it to its neighbour, Nice : it was smaller, quieter, its climate was equally beneficial, and it was patronized by the right type of wealthy and distinguished English visitors. Both Lady Waldegrave and Mrs. Tennyson encouraged him in his idea. 'I do think it a good thing to have a home somewhere certainly,' the latter wrote. 'There is a dearness in the old room and the old chair that is something worth.' Cannes, as a fashionable resort, was then almost in its infancy. 'Every bit of ground near the place seems to be for sale at great prices,' Lear wrote. 'But so scattered and detached are the villas and hotels, and so dirty are the roads, that very few people see much of others, unless they keep carriages. . . . Cannes is a place literally with *no* amusements : people who come must live . . . absolutely to themselves in a country life.' Nevertheless there were two thousand English there and he began to have some success with his drawings : among others who bought was Dr. Montagu Butler, then headmaster of Harrow. He had also been delighted to hear from London that his picture of 'The Cedars' had at last been sold, for £200, to Lady Ashburton.

Lear's most congenial neighbours during this winter at Cannes were the writer and scholar John Addington Symonds and his wife and their little daughter Janet. ' A more charming and good fellow I never met,' Lear wrote, ' besides so full of knowledge and learning.' He saw them almost every day, but Symonds, though only twenty-seven, was already seriously affected by the consumption which made his life a struggle against ill-health and sent him eventually to live at Davos, where many of his books were written. To him, with ' broken nerves and diseased lungs,' the sojourn at Cannes was a kind of nightmare—' that infernal experience of the Riviera,' he called it in his autobiography. Lear was one of the few whose company he could tolerate : his gift of unobtrusive sympathy, his honest friendliness, his humour, made him a visitor whose society required no effort. And Lear could forget himself and his own troubles in the company of little Janet, then two and a half years old, whom he entertained with his ' nonsenses.' ' Janet is very well,' Symonds wrote to a friend at this time. . . . ' Mr. Lear, author of the book of Nonsense, a great friend of ours, is here. He makes rhymes for her and illustrates them ; one about " the owl and the pussy-cat," who " went to sea in a beautiful pea-green boat " is notable, and his pictures of " Sing a song of sixpence " would greatly edify you.'[1] Symonds and Lear enjoyed many jokes together, culminating in a kind of competition in grumbling, which took shape in the *Growling Eclogue* which Lear wrote at this time, in which the ' Interlocutors ' are Mr. and Mrs. Symonds and himself. (This was published later in *Nonsense Songs and Stories*) :

' *Edwardus.* " What makes you look so black, so glum, so cross ?

[1] Horatio F. Brown, *John Addington Symonds* : a biography.

> Is is neuralgia, headache, or remorse ? "
> '*Johannes.* " What makes you look so cross, or even more
> so ?
> Less like a man than is a broken Torso ? "
> '*E.* " What if my life is odious, should I grin ?
> If you are savage, need I care a pin ? "
> '*J.* " And if I suffer, am I then an owl ?
> May I not frown and grind my teeth and
> growl ?

★ ★ ★ ★ ★

> " See Catherine comes ! to her, to her,
> Let each his several miseries refer ;
> She shall decide whose woes are least or
> worst. . . ." '

Another neighbour was the French novelist and historian, Prosper Mérimée, who, also ill and melancholy, was spending the last few years of his life at Cannes. He came one day to see Lear's drawings, and they struck up an acquaintance. ' He speaks English well,' wrote Lear, ' which is a comfort to me who hate speaking French.' Lear, who was thinking of going to Corsica in the spring and had read Mérimée's *Colomba*, took the opportunity of questioning the author of that gory tale of Corsican vendetta, who had an intimate knowledge of the island and its people. Lear could not have chosen a better adviser. Mérimée was able to give him, not only a vast amount of the kind of information which is not to be found in guide-books, but also many letters of introduction which were to prove very useful.

Lear crossed to Corsica at the beginning of April, taking with him ' a brace of strong saddle-bags ' containing clothing for all occasions, a quantity of drawing materials, a small

camp bed and 'an indian-rubber bath' : Giorgio was with him. They sailed from Nice, and on board also were the Symondses and Janet, going to stay with an English doctor at Ajaccio. Lear, too, stayed for some days at Ajaccio, which was to be his base of operations; and there he made the acquaintance of one of the most remarkable of its inhabitants. Miss Campbell belonged to that class of slightly eccentric middle-aged Englishwomen of independent means of which a representative is to be found in all the obscurer Mediterranean ports—descendants, however inglorious, of the illustrious tradition of Lady Hester Stanhope. ' A vast and man-like maiden who roars and raves about Corsica ' ; so Lear described her. Fearless, enthusiastic, pioneering, in a small carriage accompanied only by her maid, she had roamed the bandit-ridden lonely roads of the interior : her knowledge of the island, though differently expressed, almost equalled that of Mérimée himself. Gladly she poured forth information, which Lear, diffidently but politely, received.

His first journey was to the extreme southerly point of the island, the surprising, cliff-perched town of Bonifacio that looks across the narrow straits to Sardinia ; then northwards up the east coast. To M. Quenza, the mayor of the little town of Porto Vecchio, he had a letter from Mérimée ; and M. Quenza had the distinction of being the nephew of Mérimée's heroine, the celebrated leader in the vendetta-wars at Fozzano—Colomba herself, who had died only four years before. M. Quenza had many tales to tell of his blood-thirsty aunt. ' Among his anecdotes of that surprising female,' Lear relates, ' he recounts that at one time the family who were in vendetta with her own . . . wished to build a tower, which would have commanded that of their antagonists. Colomba, therefore, improvised a party of her own people,

173

who sate down to play at cards on the ground opposite the tower, and when they were settled she went out and joined them, as if observing the game, always dancing and dandling her baby at the same time. But in the dress of the child she had concealed a loaded pistol, and, watching her opportunity, suddenly shot one of the masons on the tower, replacing the pistol in the child's girdle under a shawl. The wildest confusion ensued ; but the card-players had their hands full of cards, and their guns all lying by their sides, while Mme. Colomba, with both hands, was pacifying the screaming child, so that the party seemed guiltless. . . . This feat Colomba is said to have performed on two more of the builders, till the raising of the tower was deferred *sine die*.'

Lear went up the coast as far as Aleria, then back again and westwards over the mountains through the Forest of Bavella, the enormous trees of which he admired immensely. 'And yet,' he said, 'though the last two days have considerably altered my opinion about pine-forest scenery, I would rather live among palms than pines.' During this tour he was received everywhere—to his surprise—as a person of great importance. His coachman at last explained the reason. ' " At these villages," he said, " I am very often asked who you are, and I always say you are the Ministro delle Finanze— the Finance Minister of England." " But why," said I, " do you say such a thing ? " " Oh, partly because you wear spectacles, and have an air of extreme wisdom—and partly because one must say something or other." ' This same coachman, in spite of Lear's continued protests, persisted in ill-treating his horses in an extravagantly brutal manner that brought with it, eventually, its own revenge—in which, fortunately, Lear and Giorgio were not involved except as horrified spectators. ' The last day of twenty on my return

here,' he wrote to Fortescue from Ajaccio, 'a vile little disgusting driver of the carriage I had hired, took a fit of cursing as he was wont to do at times, and of beating his poor horses on the head. In this instance, as they backed towards the precipice and the coachman continued to beat, the result was hideous to see, for carriage and horses and driver all went over into the ravine—a ghastly sight I can't get rid of. The carriage was broken to bits ; one horse killed ; the little beast of a driver not so badly hurt as he ought to have been. It took a day or two to fish up the ruins, and this . . . has rather disgusted me with Corsican carriage-drives and drivers.'

He was not discouraged for long, however. After a few days' rest at Ajaccio, he hired a new carriage and a less excitable driver, and set off again. This time he went northward up the west coast, through the Greek settlement of Carghésé to Piana and Porto, with their vast theatrical red rocks like the scenery of some fabulous grand opera. Thence up to Evisa and back through the great forests of Aitone and Valdoniello to Vico and Ajaccio. The third, and longest, tour took him to the northerly part of the island. Going from Ajaccio to Corte he passed through the Vizzavona forest and through the highest mountains of all Corsica. Lear was by no means one of those who are carried away with enthusiasm at the mere sight of a very large mountain—those who think that any mountain, because it is a mountain and because it is large, is therefore beautiful. 'To me these Corsican Alps,' he wrote, 'like their Swiss brethren, seem generally more awful than lovely.' With the discrimination of an artist, he felt that a mountain, to be beautiful, must have some quality above that of size, however stupendous : it must have sculptural beauty of form. Lear, during his lifetime, drew an immense number

of mountains ; and this sense of form in their representation is one of the finest qualities of his landscape drawing.

From Corte he went on to Bastia and Cap Corse ; then westwards along the coast to Île Rousse and Calvi, whose ancient rock-set citadel, with its vast walls, towers above a wide sandy bay. And so back to Ajaccio and Miss Campbell and the Symondses. In two months he had traversed the whole island ; had visited its chief towns and many less important ; had seen its rugged mountains, its romantic cliffs and the mighty trees of its forests ; and had found time, not only to see, but to make over three hundred drawings for the book he intended to publish.

The next two years were spent between London and Cannes, where he now had something that resembled a home of his own, having had a certain quantity of his books and furniture sent there from the rooms in Stratford Place, which he had now given up. He was working at this time on his Cretan and Egyptian journals, which were never published : also on his Corsican book, which did eventually appear, though not at all in the form he wished. He was anxious to have it illustrated with lithographs as his earlier travel-books had been, but the various publishers he approached with this idea decided that it would be far too expensive. After three or four attempts he was forced to submit to having his sketches reproduced as wood engravings, and for this purpose stopped for a month in Paris on his way back to England in 1869. By that time he had arrived at a state of mind in which, sick to death of the whole affair, he was yet obstinately determined to see it through. 'I found the only way to shake off this dreadful book was to do all the wood drawings myself here,' he wrote to Holman Hunt, 'where I get them cut for 6£ each instead of 13. . . . Of course the cuts will be coarse and

Domas, watercolour, 1867

Capo Sant'Angelo, Amalfi. Projected illustration to Tennyson's poem,
The Palace of Art: 'One showed an iron coast, One heard an angry wave.'

queer, and the book will not have the shadow of a pretension to merit quâ art, but it will give a good notion of the scenery of an island little known. . . . To get these wood drawings done I work daily from 4 A.M. to 8 A.M. ! !—barring one hour for breakfast.' The only ray of comfort during this dreary month was that, when he visited Lord Lyons at the British Embassy, he found that two of his pictures were adorning its largest room.

In London again he was overworked and depressed. Things did not go smoothly, and he calculated that his plan of finding three thousand subscribers for the book would pay its expenses but would still produce no profit. He was writing ' often over one hundred notes in the day ' till, his task at last completed, he went away, overtired and worried, for some country visits. He stayed with the Tennysons in their ' new big palace ' at Aldworth ; but ' Alfred was too much cumbered with many things, and talks of ruin. . . .' His other visits brought a kind of melancholy pleasure. ' Nor does looking at places I knew so well, and shall shortly cease to see, bring much regret : as I grow older, I as it were prohibit regrets of all sorts, for they only do harm to the present and thereby to the future. By degrees one is coming to look on the whole of life past as a dream, and one of no very great importance either if one is not in a position to affect the lives of others particularly.' He could not help feeling a certain bitterness at his own lack of success, considering himself, not unjustly, to be—if not a painter of the first order, for he had no illusions about that—at any rate a painter of greater interest, and much higher integrity, than many of those Academicians whose work the public bought for hundreds, sometimes thousands, of pounds. ' I can't help laughing at my " position " at fifty-seven ! ' he wrote to Fortescue. ' And considering how

N 177

the Corfù, Florence, Petra, etc. etc. etc., are seen by thousands, and not one commission coming from that fact, how plainly is it visible that the wise public only give commissions for pictures through the Press that tell the sheep to leap where others leap ! . . . Rest there is none,' he wrote. . . . ' Perhaps in the next eggzistens you and I and My Lady may be able to sit for placid hours under a lotus tree a-eating of ice creams and pelican pie, with our feet in a hazure coloured stream and with the birds and beasts of Paradise a-sporting around us.'

Journal of a Landscape Painter in Corsica was published during the winter of 1870, while Lear was at Cannes. It was dedicated to his friend Lushington, and had been produced, the author explained, with the same practical object as his previous travel-books—' to be aids to the knowledge of scenery which I have visited and delineated.' The text of the journal is as readable and informative as before, but in its illustrations it falls sadly short of *Albania* and *Calabria*. The eighty wood engravings, all except a few of which had been drawn on wood by Lear himself from his sketches and cut in Paris the year before—the work was done too cheaply and hastily to do justice to the originals—are indeed as he himself had said, ' coarse and queer.' They have the harsh, dreary, mechanical look of illustrations in any commonplace guide-book of the period : one place looks very much like another. Lear's admirable sensitiveness of line, his power of expressing atmosphere and space and of reproducing the true character of a scene, which gave charm and distinction to the Albanian and Calabrian drawings—these qualities have disappeared entirely. He himself was by no means satisfied, but the struggle of getting the book published had been so painful that he no longer cared very much. In one way it gave him more pleasure than he had expected, for he found that he had been wrong

in his financial calculations, and that, after all expenses had been paid there was a sum of one hundred and forty-three pounds due to him. ' And M. Mérimée,' he wrote, ' seems greatly pleased with it.'

LEAR AS PAINTER AND POET

LEAR's decision, at the age of twenty-three, to become a landscape-painter, had been an almost entirely professional one. He had, it is true, a sincere, if conventional, feeling for the beauty and the ' picturesqueness ' of landscape : he had already proved himself, in his drawings of animals and birds, to have a strong feeling for ' line ' and a gift for accurate drawing. But it was his health, his eyesight, and the absolute necessity of making a living that made him turn to landscape, rather than any great love of painting for its own sake. Oil-painting was to him always a labour, an effort, from which he derived no intrinsic enjoyment : the true painter's love of his medium was unknown to him. ' Yes : I certainly *do* hate the act of painting,' he exclaimed to Fortescue : ' and although day after day I go steadily on, it is like grinding my nose off.' ' Always painful and disagreeable work,' he called it : and this sentiment is repeated again and again, throughout his life, joined with the frequently expressed sense of his own ineptitude—' It is true I don't *expect* to improve, because I am aware of my peculiar incapacities for art, mental and physical. . . . The great secret of my constant hard work is, to prevent my going back, or at best standing quite still.'

It was to his oil-painting that he was referring ; and the results of such feelings could not but be apparent, for his heart was not truly in his work, and the paintings lack the

gusto that would have brought them to life. He persevered
with untiring industry : his pictures grew larger and larger,
more and more ambitious : their technical accomplishment
increased, but they still remained little more than exceedingly
accurate and well-constructed illustrations of well-chosen
views. Sir Roderick Murchison, great expert as he was,
used to say that he could always tell the geology of the
country from Lear's paintings, and Professor Grundy, on
account of their faithful portrayal of scenes in the neighbour-
hood of Thermopylæ, used many of them to illustrate his
history of the Great Persian War. Lear at all events achieved
his object of accurate representation. A 'topographical
landscape-painter,' he called himself : the exact and naturalistic
representation of nature was his aim. Beyond that he did
not attempt to go. That a painter should make his own
personal interpretation of nature, should put something of his
own feeling into his picture, did not occur to him—still less
that the medium, the paint itself, should play any part. And
he was quite frankly bored by the oil-painting of the past.
On a visit to Venice in 1857 we find him writing to his sister
Ann (with whom he had no need to keep up any Pre-
Raphaelite pose) : ' Well—this morning I suppose I must so
far sacrifice to propriety as to go and see some " pictures."
Very few I intend to see. All the best I know by copies : and
looking into the guide-book I see, " This is one of the best
specimens of Tintoretto's corrupter style—or his blue style—
or Bassano's green style—or somebody else's hoshy boshy
lovely beautiful style "—all looked on and treated as so many
artificialities, and not the least as more or less representing
nature. The presentation of Christ in the Temple—with
Venetian Doges' and Senators' dresses—and Italian palaces in
the background !—fibs is fibs—wrapped up in pretty colour

or not. And besides—looking at pictures wearies me always. It is quite hard work enough to try and make them.' Yet, when he visited Vienna later in the same year, his reaction to another Old Master was very different, and he spent many blissful hours poring over ' folio after folio ' of Dürer's drawings in the Archduke Charles's collection.

Lear's whole artistic interest, in fact, was absorbed by draughtsmanship, and it was here that his own gifts lay. Indeed, it can even be said that the best of his oil-paintings are those which most closely resemble his water-colour drawings. His oil-paintings were a purely professional matter, by means of which he contrived to make a moderate, though very irregular, income. They were bought largely by his own friends, and largely, one suspects, out of friendship : and to-day such as have survived are, most of them, hidden away in the attics of country houses or the cellars of the public galleries to which those friends had presented them. Their minute descriptiveness, their qualities of hardness and tightness, do not appeal to a generation which looks in painting for vitality and rhythm and subtlety of colour rather than imitation of nature. His violent admiration of Holman Hunt and his consequent desire to identify himself with the Pre-Raphaelites did not help him much : Hunt was able to teach him some of his own technical methods, and to advise and criticize, but Lear, in spite of his admiration and liking of him as a man, was not really in sympathy with the movement except in some of its incidental aspects. But Hunt's friendship had undoubtedly provided a stimulus at a moment when it was much needed.

Lear's drawings and water-colours, on the other hand, are of far greater importance. Here Hunt and the Pre-Raphaelites hardly touched him : here he could be himself ; and if it

183

had not happened that the name of Edward Lear had become synonymous to all the world with Nonsense, it is probable that he would here have been granted a greater measure of the fame he deserves. There have been, even during the present century, exhibitions of his water-colours which have been highly praised by critics : he is represented in many of the museums and public galleries of London and the provinces ; yet to the general public the nonsense-writer is unknown as a water-colourist. His water-colours, like his 'nonsenses,' have an essentially English character and quality about them. He does not rank with Girtin and De Wint, with Turner and Cox, among the greatest of the English Water-Colour School ; yet he is worthy of a place there—and a higher place than has so far been accorded to him—as a contributor to one of the most specifically English branches of our national artistic heritage.

Lear's water-colour landscapes—which may be described, without prejudice, as coloured drawings, for draughtsmanship is their main preoccupation, colour of secondary importance—may be considered, for the sake of convenience, in three groups. The first of these dates from the time when he first went to Italy and includes the sketches and lithographs made for his earlier travel-books. It shows a young artist working under the influence of the best tradition of the early nineteenth century (a tradition which, no doubt, he had studied in the Knowsley collection), but with an already developed style of his own. Though the construction of the pictures is somewhat conventional, their delicacy of line, their sense of space, their feeling for the 'bones' of a landscape, are all entirely individual. He loved a wide horizon, a far-off mountain-range, and one of his most admirable qualities was the skill with which he could create the illusion of receding

space and at the same time indicate the sculptural solidity of distant mountains. The second, and artistically least important group, belongs to the time when he was most closely associated with Holman Hunt and Pre-Raphaelite ideas. Here he is frankly ' topographical,' wholly preoccupied with exact and literal description : no detail is eliminated, every leaf, every pebble is portrayed, the sky is a blue back-cloth, and there is nothing of atmosphere, very little of the artist's personal feeling.

But Lear was too genuine an artist to be long contented with such emotional sterility. His feeling for linear expressiveness reasserted itself, and the third group, which comprises most of the work of his later life, includes his best work. Here he was most completely himself. He had by this time evolved a mature, personal style which gave him complete freedom to express himself. His line is more supple, more sweeping than before, apprehending essential forms and not distracted by detail. His colour, too, has improved : though still playing a secondary part in the picture, it has become subtler and is planned pictorially rather than copied direct from nature. Turner was his idol : he never mentions Constable, and it is doubtful if he had ever heard of Cézanne or knew what was going on in Paris ; yet many of his later water-colours might well have been painted almost half a century later, when new ideas and new influences had come to be widely felt. He was creating, not copying : the ' topographical landscape-painter '—in spite of himself, and perhaps without knowing it—had been defeated, to his own salvation, by the artist. To his own ultimate and posthumous salvation : yet during his lifetime it was essentially the professional point of view that had the upper hand. His ceaseless, almost automatic industry, his rising at half-past four in the

morning to work all day and then spend the evening, after the light was gone, diligently ' penning out ' the sketches he had made (thus often destroying their spontaneity)—these became a matter of almost mechanical programme : while his feverish desire to produce what the public wanted and would pay for—so that he would often make two or three copies of a picture that had proved popular ; his absence of self-criticism and lack of discrimination with regard to his own work, which led him into exhibiting much that was not worth exhibiting and into accumulating vast masses of unselected sketches that had better have been destroyed (Lushington inherited over ten thousand water-colours at Lear's death)—these hindered his recognition as an artist and helped to keep him, in popular estimation, on the level of ' topographical landscape-painter ' that he modestly claimed for himself. ' O dear dear dear ! ' he wrote to Holman Hunt, ' the more I see of nature the more sure I am that one Edward Lear should never have attempted to represent her—unless as a painter of bees, black beetles, and butterflies. Yet I cannot but know that there is a vein of poetry within me that *ought to have* come out—though I begin to doubt if it ever will.' Joined with his technical skill, it was that ' vein of poetry '—which, whatever Lear himself may have thought, did succeed in expressing itself—that saved him from sinking in the slough of the commonplace and assured his survival as a not unworthy descendant of the English Water-Colour School.

There remains the question of Lear's comic drawings. It was in these, as in his nonsense poems, that he showed his greatest, his supreme, originality, for here he invented something that had never been done before. (Lear has had imitators, but none of them have equalled him. Only one— who is in no sense an imitator, but who may be said to belong,

even if unconsciously, to the ' school of Lear '—that sym-
pathetic American humourist, Mr. James Thurber—possesses a
talent for comic draughtsmanship which can be placed on a
level with Lear's. Mr. Thurber's drawings have the same
subtlety concealed under an apparent naïveté, the same
expressiveness achieved by extreme economy of line, but they
are, of course, infinitely more sophisticated. The whole
difference of the nineteenth and twentieth centuries—and
the American twentieth century at that—lies between them.)
Some of Lear's contemporaries, even if they thought his
nonsense drawings funny, considered them to be so merely
because they were childish and ' out of drawing,' and would
not allow their children and grandchildren to look at them
for fear that the precious infants' ' sense of the beautiful '
might be damaged. There are still people like that : just as
there is another class of people who find no difficulty in
approaching Lear's comic drawings—because they are comic
—in the way that all drawings should be approached, not
realistically, but for their expressiveness of line. The same
people are quite incapable of approaching a non-comic
drawing in the same spirit, and profess to be horrified at
so-called ' modern ' drawings which depend on exactly the
same fundamental qualities.

But the tender melancholy of the Young Lady in White,
the beatific smile of the Old Man in a Tree as he abandons his
whiskers to the birds, the flowery grace of the Guittara
Pensilis and the Jinglia Tinkettlia, the sharply differentiated
characters of the Scroobious Bird and the Runcible Bird—
these diverse qualities, so simple but so clearly expressed, are
not apparent merely because of an assumed childishness, a
wilful or incompetent distortion. Children's drawings, it is
true, sometimes have the same kind of expressiveness, because

187

children, before they are taught, can often draw with astonishing imaginative directness. With Lear it goes much farther. The imaginative directness, the inventive fantasy are there, but they have at their service a pen which is a master of line, a hand which can control the pen and make it do things which are surprising, whimsical, but always deliberate. Lear, when he made these drawings, was playing with his own skill, quietly amusing himself, just as he amused the children who watched him and greeted each new drawing and rhyme with cries of delight. Sitting thus, pen in hand, surrounded by intent faces of children, completely at ease, completely absorbed, he spent some of the happiest hours of his life.

I sing a song of Sixpence, a Bag full of Rye,
Four & twenty blackbirds baked in a pie:

hen the pie was opened the Birds began to sing

d wasn't that a dainty dish to set before the King?

High diddle diddle
The Cat, & the fiddle.

The Cow jumped over the moon.

The little dog laughed to see such sport.

And the dish ran away with the spoon.

The King was in his counting house, Counting out his money

The Queen was in the parlour, eating bread & hunney,

Maid was in the garden
anging out the clothes

hen down came a blackbird & pecked
off her nose.

And, shortly after that, there came a little wre
As she sat upon a chair, & put it on again.

Yet in Lear's nonsense-world it is not his drawings, but his poems, which take first place. Here again—with the exception, as we have already seen, of the limericks—he invented something entirely new. In his poems, pure and absolute nonsense as they are, he yet found a vehicle for the expression of his deepest feelings, paradoxical though this may seem : and this is the often unsuspected secret of their peculiar power to move others. It is not only that Lear had an 'extraordinary mastery of rhythm,' as Mr. Maurice Baring calls it. 'It is quite different,' he points out, 'from the neat clashing rhymes of most writers of humorous poetry. Poems like " The Owl and the Pussy-Cat " have an *organic* rhythm. That is to say, the whole poem (and not merely the separate lines and stanzas) forms a piece of architectonic music. . . .'[1] Behind this sense of rhythm—which makes itself felt, too, in the best of his water-colours—there lies the emotional force that is an essential quality of all true poetry, a force that is derived from life itself. Even in some of the limericks, light-hearted as they are, there is, if one chooses to think of it, a foundation of human experience. Is not the story of the *Old Man of Thermopylae, who never did anything properly* :

> *But they said, " If you choose to boil Eggs in your Shoes,*
> *You shall never remain in Thermopylae "*

—sadly true to life ? And equally so, that of his harmless brother eccentric, the *Old Man of Whitehaven, who danced a quadrille with a Raven* :

> *But they said, " It's absurd to encourage this Bird ! "*
> *So they smashed that old man of Whitehaven.*

[1] Maurice Baring, *Punch and Judy* and other Essays.

What a world of implication there is in Lear's ' they ! ' ' They ' are the force of public opinion, the dreary voice of human mediocrity : ' they ' are perpetually interfering with the liberty of the individual : ' they ' gossip, ' they ' condemn, ' they ' are inquisitive and conventional and almost always uncharitable. The only people ' they ' really approve of are people like the *Old Man of Hong Kong, who never did anything wrong:*

> *He lay on his back: with his head in a sack,*
> *That innocuous old man of Hong Kong—*

Or the *Old Person of Shoreham, whose habits were marked by decorum,*

> *He bought an umbrella, and sate in the Cellar,*
> *Which pleased all the people of Shoreham.*

And ' they ' can be icily chilling in their cruelty :

There was an Old Person of Bow, whom nobody happened to know,
So they gave him some Soap, and said coldly, " We hope
> *You will go back directly to Bow ! "*

But it is, of course, in some of the later and longer poems that the moving, personal quality of Lear's emotional force can be most strongly felt. Though his method of expressing his own deepest feelings was to make fun of them, the emotion is none the less real : it is perhaps the more poignant. Who is the Yonghy-Bonghy-Bò but Lear himself, living poor and solitary on the Mediterranean shore ?

> *On the coast of Coromandel*
> *Where the early pumpkins blow,*
> *In the middle of the woods*
> *Lived the Yonghy-Bonghy-Bò.*
> *Two old chairs, and half a candle,*
> *One old jug without a handle—*

These were all his worldly goods :
In the middle of the woods,
These were all the worldly goods
Of the Yonghy-Bonghy-Bò
Of the Yonghy-Bonghy-Bò.

And the Lady Jingly Jones, sitting on her little heap of stones with her milk-white Dorking fowls about her, if she is not Gussie Bethell herself, does she not symbolize the wife whom Lear never found ?

Keep, oh ! keep your chairs and candle,
And your jug without a handle,
I can merely be your friend !

' My Aged Uncle Arly,' too, the last and saddest of all the poems, written during one of the illnesses that darkened the last two years of his life, is filled with the forlorn sense of desolation and failure that possessed him. Many of these longer poems were written in his moments of most hopeless despondency ; and almost all of them have an echo of deep sadness that sounds beneath the gaiety of their surface. Whimsical humour is closely allied with tears : and Lear is yet another instance of this, of the classic pathos of the clown, the tragi-comedy of Punch.

It is a strange world that he created, a world in which fire-irons and nutcrackers, tables and chairs, owls, kangaroos,

pelicans, and such unlikely creatures as the Dong with the Luminous Nose, Mr. and Mrs. Discobbolos, the Pobble and the Jumblies, are all endowed with human life and feelings and weaknesses, and so convincingly portrayed that their adventures and characters seem a perfectly natural part of their own extraordinary ambience. Lear's great gift is that he can transport his reader into this world and make him accept its values, and it is in the incongruity of taking such values seriously that much of the humour lies. Yet ' pure ' nonsense such as Lear's is more than a mere absence of sense : it has an absolute value of its own ; it enriches life with a new kind of wisdom ; it is a true child of the imagination, and its native realm is poetry. In this respect Lear is greater than Carroll—not so much because he invented something new, from which the younger man learned much, but because he was a greater poet.

Not only had Lear that ' extraordinary mastery of rhythm,' of which we have already spoken ; he had an ear that was exquisitely sensitive to verbal music. Many of his lines— quite irrespective of their content—have a great beauty of sound, which, if Lear had been a serious, instead of a ' nonsense,' poet, might have attracted more attention. Many examples might be quoted ; for this quality is to be found running all through the *Nonsense Songs.* There are the Pelicans, who stand—

> *On long bare islands of yellow sand.*
> *And when the sun sinks slowly down*
> *And the great rock walls grow dark and brown,*
> *Where the purple river rolls fast and dim*
> *And the ivory ibis starlike skim,*
> *Wing to wing we dance around*
> *Stamping our feet with a flumpy sound. . . .*

(Obviously Lear had the Upper Nile in mind when he wrote this.) There is the refrain of ' The Jumblies,' haunting and mysterious :

> *Far and few, far and few,*
> *Are the lands where the Jumblies live ;*
> *Their heads are green, and their hands are blue,*
> *And they went to sea in a sieve. . . .*

And the superbly thrilling opening of ' The Dong with the Luminous Nose ' :

> *When awful darkness and silence reign*
> *Over the great Gromboolian plain,*
> *Through the long, long winter nights ;—*
> *When the angry breakers roar*
> *As they beat on the rocky shore ;—*
> *When Storm-clouds brood on the towering heights*
> *Of the hills of the Chankly Bore :—*
>
> *Then, through the vast and gloomy dark,*
> *There moves what seems a fiery spark. . . .*

(Lear was a master of the art of inventing words. What could be more expressive than ' stamping our feet with a *flumpy* sound ' ? ' The great Gromboolian plain ' has all the mystery and melancholy of the limitless steppe : and when he speaks of scenery as ' pomskizillious and gromphibberous,' of people as ' omblomphious,' of a hat, or a cat, or a spoon, as ' runcible,' of a bird as ' scroobious,' these epithets, even if they have no precise meaning, give a vivid colour, a marked character, to the nouns which follow them. These are words created for the quality of their *sound*. It amused him also, in his letters, to invent new and absurd spellings for real words.

But when he writes 'troppicle seen,' 'Polly Titian,' 'egg-zibission,' 'spongetaneous,' or 'phiggs,' it is for the comic quality of their *visual* appearance on the written page.)

Lear, clearly, was much influenced by Tennyson—more than merely to the extent of using his metres (the 'Yonghy-Bonghy-Bò,' for instance, is in the metre of 'Row us out from Desenzano'; 'My Aged Uncle Arly' in that of 'The Lady of Shalott;' 'Calico Pie' in that of 'Sweet and Low,' etc.). But he did not burlesque him: his poetry, rather, is in the nature of a burlesque of bad romantic poetry of the popular kind. While good poetry confines the reader to the poet's own point of view at the moment, bad poetry, by the use of vague images, allows the reader to interpret it in his own way and in accordance with his own associations. Lear suggests very often the kind of effect attained by this use of vague images: yet his own images are always perfectly clear and conscious. His poetry might be called the 'reductio ad absurdum' of Romanticism. It is here that he has some slight resemblance to the Surrealists, who have claimed him as one of themselves—together with Dante, Shakespeare ('dans ses meilleurs jours'), Hugo, Poe, Baudelaire, and other distinguished writers of the past. The 'automatic writing' of Surrealism, indeed, with its 'absence of all control exercised by reason and all aesthetic or moral preoccupation'[1] is a 'reductio ad absurdum' of the Romantic theory of Inspiration: but Lear's writing is intended to be absurd, whereas that of the Surrealists is not. Lear's effects are deliberate, carefully thought out, selective: there is about him none of the conscious, and self-conscious, irresponsibility that is one of the principal dogmas of the Surrealists. Lear might well have been parodying them in

[1] André Breton, *Manifeste du Surréalisme*.

anticipation when he wrote 'Mrs. Jaypher' and added the direction that the poem 'is to be read sententiously and with grave importance':

> *Mrs. Jaypher found a wafer*
> *Which she stuck upon a note;*
> *This she took and gave the cook.*
> *Then she went and bought a boat*
> *Which she paddled down the stream*
> *Shouting: " Ice produces cream,*
> *Beer when churned produces butter!*
> *Henceforth all the words I utter*
> *Distant ages thus shall note—*
> *From the Jaypher Wisdom-Boat."*

Mrs. Jaypher was, evidently, to be a kind of Delphic Priestess of Nonsense; but the poem about her was, alas! never completed. Like the Sibylline Books, her utterances are lost to posterity: only one other of her oracular remarks has been preserved:

> *Mrs. Jaypher said it's safer*
> *If you've lemons in your head*
> *First to eat a pound of meat*
> *And then to go at once to bed.*

But, even without Mrs. Jaypher, posterity has already many causes of gratitude to the 'dirty landscape-painter' who produced not only a number of excellent landscapes (which posterity has already well-nigh forgotten) but created a whole new and fantastic world for the delight of all ages of humanity. For, though made for children, it is not only to children

that Lear's world is open. Children are more readily at
home in a world of pure imagination : in a grown-up,
perhaps, the entry to it demands an act of faith such as that
made by Alice when she tried to go and meet the Red Queen
—of starting in the opposite direction. It is an act of faith
worth making, and generously rewarded.

1

The Owl & the Pussey=cat went to sea
 In a beautiful peagreen boat.
They took some Honey, & plenty of money,
 Wrapped up in a Five pound note.

2

And the Owl looked up to the moon above,
 And sang to a small guitar,
"O lovely Pussey! O Pussey my love!
 What a beautiful Pussey you are!"

203

3.

Pussy said to the Owl, "You elegant Fowl!
 How charmingly sweet you sing!
For long we have tarried, O! let us be married!
 But what shall we do for a ring?"

4

So they sailed away, for a year & a day,
 To the land where the Palm tree grows,
And there in the wood, a Piggywig stood
With a ring in the end of his nose.

$\overline{5}$

"Dear Pig, are you willing, to sell for a shilling
your ring?" — Said the Piggy "I will".

So they took it away, & were married next day,
By the turkey that lives on the
In a beautiful house on a hill.

$\overline{6}$

They dined on mince, with slices of quince,
Which they ate with a silver spoon,
And hand in hand, on the golden sand
They danced by the light of the moon

LIVING AT SAN REMO

DURING the winter of 1870–71 Lear at last decided that the time had come for him to have a home of his own—a home that should be something more than the dull half-furnished lodgings he had so long endured. He was a man who, though sensitive to his surroundings, had singularly little love of possessions : his life, so far, had been always that of someone on a journey, to whom no stopping-place had been more than temporary, no habitation—whether inn, tent or lodging-house—more than a stage on the road to somewhere else. But now he was fifty-eight : he felt he could not live long : he had saved three thousand pounds ; and he began to look about for a place in which to live and work quietly till he died. Yet, characteristically, at the same moment he was thinking that ' after all, it is perhaps the best plan to run about continually like an Ant, and die simultaneous some day or other ' ; and suddenly had a notion that he would like to go and join his sister Sarah in New Zealand, who, ' at seventy-six, thrives as usual, and rows her two great-grandchildren about in a boat.' He decided against this, however, because ' on the whole they are too fussy and noisy and religious in those colonial places.'

As he happened to be at Cannes, it was there that he first started his search. He found a ' queer little orange garden for £1000,' but that would not do, because somebody would be sure to come and build opposite it. Everything else at

Cannes was far too expensive or quite unsuitable—for, now that he was to have a house of his own, it must be exactly according to an ideal he had formed in his mind. Above all, it must have a very large studio with a north light, and no houses opposite. He decided to give up Cannes. In any case he was already tired of it, and of its ' beastly aristocratic idiots ; ' he had ' only got £30 from the rich Cannes public ' during the winter. ' A haunt of rich or Aristocratic people,' he wrote to Holman Hunt a few months later—' all perhaps good, but all *absolutely* idle. All smiles and goodness if they could take up the whole of an artist's time—" We shall be so delighted if you will let us come and sit in your studio while you work ! " said one of many gt. ladies to me. " We will stay all the day ! we should never be tired ! "—but on the Artist showing a little notion of independence and self-assertion, he was quite thrown by, and other painters—awful daubers !—taken up, or art altogether ignored. . . . One person has sedulously represented me as a sort of impostor, *copying* views out of books (!) and selling them for fabulous prices tho' I did them in 10 minutes ! My most charitable explanation of that conduct is that ——— was paid to talk as he did by other artists—a queer solution, but kinder than to suppose injury done purposely. . . . In the end therefore I gave up Cannes, and resolved to leave the clique of great folk to what are their natural functions, driving about to leave cards, sitting to M—— for busts—pigeon-shooting—and going to church any number of times daily.' (Never, since the ' uniform apathetic tone assumed by lofty society ' at Knowsley nearly forty years before, had Lear had any great opinion of the aristocracy—though some of them, as he was the first to admit, had been exceedingly generous to him as patrons. But he had made up his mind that ' of all things

most to be remarked' in London society, 'this is a fact :—
the middle classes, professional or otherwise, are by far the
best fun for pleasure and knowledge as to converse. The
big folk are in most cases a norful bore.')

Having ranged all up and down the Riviera, both French
and Italian, his choice finally fell upon San Remo. In March
a piece of land was bought, a deed was signed, and building
operations were at once put in hand. The house was to be
called Villa Emily—named, according to some accounts, after
Emily Tennyson, but more probably after his great-niece
Emily in New Zealand (grand-daughter of his sister Sarah
Street), now twenty-two years of age and married to Robert
Gillies, with already two children, and more to follow. It
was she whom he always intended to make his heiress (though
he had never seen her), and in the design of the house the
children were taken into consideration, one room being
intended for a nursery and another for 'The King,' as he called
the youngest boy. (Later he changed his dispositions :
Emily was left a young widow with eight children, and as
it was unlikely that she would ever wish to come to Europe
and settle at San Remo, he left her a sum of money instead.)

In the meantime, having completed his arrangements at
San Remo, Lear went off for the summer to an hotel in the
mountains south of Turin—La Certosa del Pesio, formerly a
Carthusian monastery. Here he busied himself with writing
up his Egyptian journals of 1854 and 1867 with a view to
publication (they were never published, however) and with
the preparation of a new nonsense book, which appeared
next year under the title of *Nonsense Songs, Stories, Botany and
Alphabets*. It was the summer of the Franco-Prussian War,
but Lear, in his remote Italian retreat, was only affected by
it inasmuch as it interfered with the regular arrival of his

P 209

letters and papers. He led 'the queerest solitary life . . . in company of seventy people' whom, though some of them were agreeable, he avoided as much as possible. Some of them, however, had children, and them he did not avoid. There was a little American girl upon whom he made a deep impression, and who never forgot him. Sixty years later she wrote her memoirs, and gave an account of the kind, funny old gentleman whom she and her brother had adopted as their uncle. 'One day there appeared at luncheon sitting opposite to us a rosy, grey-bearded, bald-headed, gold-spectacled little old gentleman who captivated my attention. My mother must have met him before, for they greeted each other as friendly acquaintances. Something seemed to bubble and sparkle in his talk and his eyes twinkled benignly behind the shining glasses. I had heard of uncles ; mine were in America and I had never seen them. I whispered to my mother that I should like to have that gentleman opposite for an uncle. She smiled and did not keep my secret. The delighted old gentleman, who was no other than Edward Lear, glowed, bubbled and twinkled more than ever ; he seemed bathed in kindly effulgence. The adoption took place there and then ; he became my sworn relative and devoted friend. He took me for walks in the chestnut forests ; we kicked the chestnut burrs before us, the " yonghy bonghy bos," as we called them ; he sang to me " The Owl and the Pussycat " to a funny little crooning tune of his own composition ; he drew pictures for me.

'I still have a complete nonsense alphabet, beautifully drawn in pen and ink and delicately tinted in water colours, done on odd scraps of paper, backs of letters and discarded manuscript. Every day Arthur and I found a letter of it on our plate at luncheon, and finally a title-page for the collec-

tion, with a dedication and a portrait of himself, with his smile and his spectacles, as the " Adopty Duncle ".[1] (Lear made a number of these Alphabets for different children of his acquaintance, seven of which are included in his *Nonsense Botany and Nonsense Alphabets*. They gave rise to some of his most charming humour, such as the ' Judicious Jubilant Jay, who did up her Back Hair every morning with a wreath of Roses, Three Feathers, and a Gold Pin,' and—the perfect ' non sequitur ' :

> *G was Papa's new gun,*
> *He put it in a box ;*
> *And then he went and bought a Bun,*
> *And walked about the Docks.*)

In the autumn he went back to San Remo, where he found the Villa Emily progressing rapidly. But expenses were alarming, and he was worried about money. He had been comforted by the sale of one of his pictures in the Academy that summer, but that did not suffice, and he wrote to Lord Derby, naïvely asking whether, for sentimental reasons, he might paint one last picture for Knowsley. ' I had some strong and particular reasons for making the request,' he told Fortescue, ' and to no one else could I have made it.' Lord Derby—the ' little boy in black velvet of 1833—1835,' one of the children for whom he had made the first rhymes of the *Book of Nonsense*—answered at once, in the kindest and friendliest manner possible, giving him a commission for a ' £100 Corfù.' Lear was touched and delighted. ' So I begin my San Remo life,' he wrote, ' with the same Knowsley patronage I began life with at eighteen years of age.' He was also making plans for a wider public exhibition of his

[1] Mrs. Winthrop Chanler, *Roman Spring.*

work. He saw that the private patronage on which he had mainly depended ' must end in the natural course of things, but eating and drinking and clothing go on disagreeably continually,' and that, as he was now likely to go less often to England, it was all the more important that his work should be visible there for those who wanted to see it at any time. Accordingly, not long after this, he made arrangements with a gallery in Wardour Street to act as his permanent agents. He also made the experiment of sending to exhibitions organized by various art societies.

He continued, nevertheless, to exist mainly on private patronage. Never did a man have kinder friends than Lear— which speaks well for his character as well as for theirs. And there must have been times when some of those friends— Lord Derby, Fortescue and Lady Waldegrave, Edgar Drummond, Lord Northbrook, Lushington—grew a trifle bored at the sense of continued obligation to buy pictures that perhaps they did not always want. For Lear, pressed by necessity, became an untiring ' salesman ' of his own work : during his London exhibitions he would write imploring his friends to come and see his pictures—obviously with an eye to sales—in a way that seems almost shameless in a man who, in other respects, was apt to be over-sensitive. But the very ingenuousness of his appeals was disarming : and he had a fixed idea (perhaps quite rightly) that one of the duties of the rich is to buy works of art.

And now, at this moment, just as he was building his new house and money was so badly needed, there arrived most opportunely an order for two drawings at £25 each from Lushington, two at £12 from Drummond, and the news that Sir Francis Goldsmid had bought a Corsica painting for £100 and that F. W. Gibbs, the Prince of Wales's tutor, wanted

a drawing as a wedding-present for Princess Louise. Lear
was overjoyed at his sudden good fortune : did it ever occur
to him that the timely demand for his pictures amongst his
friends might not have been quite so spontaneous as it appeared?

At last the time arrived when the Villa Emily stood com-
plete. Two ' damsels ' were found to cut out and sew curtains
and carpets : books and furniture arrived from Cannes and
from London, and more furniture was bought in San Remo ;
and towards the end of March, three days short of a year

from the time when he had purchased the site, the artist
moved into his new home. Giorgio was with him, and
soon he was able to say : ' thanks to the excellent arrangement
and care of my good old servant . . . I have since then
been living as comfortably as if I had been here 20 years.
Only I never before had such a painting room—32 feet by
20—with a light I can work by at all hours, and a clear view
south over the sea. Below it is a room of the same size,
which I now use as a gallery, and am " at home " in once a
week.' Giorgio had already, before the house was habitable,
begun work in the garden, helping with the fences and the

planting of cypresses and beans. Lear had never before had a garden, and, if the house was a delight, the garden was a novelty which soon became once of the chief interests of his life. ' Tho' I like flowers and a garden,' he said at first, ' I don't like working in it.' But the fascination grew : soon, as far as his health would allow, he was helping Giorgio and the garden-boy, and finding the ' picking off of caterpillars and the tying up of creepers no end of distraction.' The simple joy of making things grow became for him, as it has for many a troubled soul, a consolation and a deep satisfaction.

But his time was not wholly spent in his garden. He was working hard at Lord Derby's ' Corfù,' preparing a book ' on the whole of the Riviera coast,' and had also returned to the plan, first proposed to Emily Tennyson twenty years before, of carrying out his landscape illustrations to Tennyson's poems. It had never been wholly forgotten : many of the scenes that he had painted in the intervening years, in many different countries, had been chosen for that ultimate purpose ; and, now that at last he had a prospect of uninterrupted quiet, he returned to the task with enthusiasm. There were to be one hundred and twelve illustrations. ' Don't laugh ! ' he wrote to Fortescue : ' not that I'm such a fool as to suppose that I can ever live to finish them (seven more years at farthest I think will conclude this child), but I believe it wiser to create and go on with new objects of interest as the course of nature washes and sweeps the old ones away.' In his heart of hearts, however, he believed that he would finish them. They became the chief occupation of his old age, when constant ill-health made work a labour ; and as more obstacles arose in the way, as negotiations with publishers, printers, lithographers, became more and more exasperating, so he became more determined that his task should be completed.

Enthusiasm gave way to irritation ; irritation to obstinacy ; obstinacy to a still-struggling despair ; and it was only with his last illness that the hope of seeing the dearest wish of his heart fulfilled was finally abandoned.

In the meantime, however, he enjoyed some of the happiest months of his life. The new house, the progress of the garden, the possibility of uninterrupted work—all these brought their own satisfactions and soothed his restless spirit. ' What delights me here is the utter *quiet*,' he told Fortescue : ' twittery birds alone break the silence, as I now sit, in my library, writing. . . .' It was a joy to have escaped from the social stupidities of Cannes. ' I can hardly realize,' he wrote to a friend there, ' that I am so near Cannes, and yet in so superior a climate, not to speak of the quiet and comfort of the place, and the absence of all the vulgarity and fuss of Flunkeyville-cum-Snobtown. There has only been one footman here all the winter, and that a very small and bad one. . . .' However he was not left entirely alone : he would not have liked that. Even San Remo had its winter visitors, who came, on Wednesday afternoons from one to four, to see his gallery (at other times the bell was not answered) : but it was not often that any of them went so far as to buy a picture. And there was one neighbour, Walter Congreve, who was a ' vast blessing ' to him. Congreve had been a pupil of Dr. Arnold's at Rugby and had returned there as a master : he was a brother of Dr. Richard Congreve, the Comtist, who created a certain stir by resigning his fellowship at Wadham College, Oxford, on account of his positivist opinions. Walter, owing to his own and his wife's ill-health, had retired and come to live at San Remo some years before. ' You may suppose,' Lear wrote, ' the comfort it is to me to have my next neighbour a scholar and such a man to boot as Walter

215

Congreve.' Lear saw him almost every day, and one of his chief diversions was the instruction of his two boys in drawing. 'They are the nicest little coves possible,' he noted in his diary. One of these boys, Hubert, had considerable aptitude. He wrote, many years later, that 'these lessons were some of the most delightful experiences of my young days, as they were accompanied with running comments on art, drawing, scenery, and his travels, mixed up with directions for our work.'[1] A relation grew up between the solitary, elderly painter and the intelligent little boy which the latter described later as 'almost paternal' : he was frequently with Lear in his studio, watching him at work (a much more sympathetic spectator than the smart ladies of Cannes), and they would go for sketching expeditions together, 'Lear plodding slowly along, old George following behind, laden with lunch and drawing materials. When we came to a good subject, Lear would sit down, and taking his block from George, would lift his spectacles and gaze for several minutes at the scene through a monocular glass he always carried ; then, laying down the glass, and adjusting his spectacles, he would put on paper the view before us, mountain range, villages and foreground, with a rapidity and accuracy that inspired me with awestruck admiration.'[2] Lear was bitterly disappointed, and could with difficulty forgive him, when, some years later, he decided to take up, not painting, but engineering, as his profession. But the friendship—in spite of this, for a time, serious disagreement—continued till Lear's death ; for nineteen years—from the moment when, as a small boy, he had first been put at ease by Lear's ' wonderful charm of manner and voice ' and his ' genial, yet quizzical

[1] Preface to *Later Letters of Edward Lear* : ed. Lady Strachey.
[2] Ibid.

smile,' Hubert Congreve regarded him as his 'dearest and best friend of the older generation.'

To Lear's household, which consisted of himself, Giorgio, and the 'bandy-legged gardener' Giuseppe, there was now made an important addition—the tom-cat Foss—'my cat who has no end of a tail,' says Lear, 'because it has been cut off.' Foss, Lear's constant companion for many years, achieved a celebrity denied to most cats, not only through the many allusions to him in Lear's letters, but through the series of lively but unflattering pictures of him in 'The Heraldic Blazon of Foss the Cat'—'Foss Couchant,' 'Foss Rampant,' etc.—published in the later editions of *Nonsense Songs and Stories*. This distinguished animal attained the great age of seventeen years, and was buried, beneath a tombstone and an Italian inscription, in the garden of the Villa Tennyson, the house to which Lear moved some years later.

In the summer Lear gave Giorgio six weeks' holiday, so that he might go to Corfù to see his family, and himself set off for a short tour in Italy. He went to Rome, then to Frascati, where he stayed with his old friends the Duke and Duchess of Sermoneta : then made a tour by Bologna and Padua and 'all through the Belluno province.' Everywhere he went he was struck by the great changes and improvements that had resulted from the final success of the patriotic movement. The last step had been the withdrawal, just a year before, of the French garrison from Rome, and the consequent end of the Pope's temporal power : Victor Emmanuel had at last entered the city, and the emancipation of Italy was complete. 'Two things are difficult to realize,' Lear wrote : ' the immense progress Italy has made—the Emilian and Naples provinces are actually metamorphosed : and secondly, the intense and ever-increasing hatred of the people to the priest class. *Even I* have more than once tried to moderate

the horror expressed by Italians. . . . The whole people, barring the women, seem to have become aware of the absurdity of their priests' pretensions. . . .'

He returned to San Remo, and shortly afterwards had the great delight of welcoming his 'most partickler' friend Franklin Lushington as his first guest in the new house. Since Lushington's marriage Lear had seen him but seldom : the responsibilities of family life and of his new position as magistrate at the Thames Police Court gave him little time for visiting his old friends, especially if they lived abroad. Now he had escaped for a short holiday, and he and Lear were able to re-establish something of the old companionship of the days of Greece and Corfù. His presence brought Lear a quieter, mellower pleasure than in former years. The old strain and exasperation were gone, and if most of the old enchantment and intensity of feeling that Lear had felt in their early friendship had vanished with them, there remained something more solid, more lasting, more entirely secure. He felt, and was justified in feeling, that, in spite of changed conditions, of marriage, of children, of career, Lushington's sober affection would last, unchanging, as long as he was there to need it.

When Lushington left for England, Lear went with him as far as Genoa. The Villa Emily, when he returned alone to Giorgio and Foss, seemed very empty and isolated from the world ; but, however melancholy he felt, he at least could know that his restless spirit had an anchorage, that he was no longer a wanderer on the earth. So the autumn passed. A little before Christmas *More Nonsense* was published in London, and was instantly successful. 'It is queer,' Lear wrote to Fortescue, ' (and you would say so if you saw me) that I am the man as is making some three or four thousand people laugh in England all at one time. . . .'

la Erving . 9. Octr. 1891 The Landscape painter Catches a
severe cold by going into his garden
at 6. A.M, (in very slight costume.
& no stocking.)
to tie up his
flowers

Chapter XV

TOUR IN INDIA AND CEYLON

THIS newly acquired peace was not to remain long undisturbed. Early in 1872 Lear's friend Lord Northbrook, who had just been appointed Viceroy of India, wrote offering to take Lear out to India with him, give him a year's sightseeing and send him back free of expense. Lear would repay his debt by painting one or two pictures of Indian scenes for the Viceroy. It was a splendid offer, for he had always longed to see India and Ceylon ; and it seemed madness to refuse such an opportunity. But there were considerations on the other side too : ' I have a new house, and to flee away from it as soon as it is well finished seems a kind of giddiness which it rather humiliates me to think of practising.' There was also the question of his health. He was now sixty : and apart from the infirmities against which he had struggled all his life, he had been told two years before that he was suffering from the same form of heart trouble that had caused his father's sudden death. ' I have had advice about it,' he had written, ' and they say I may live *any* time if I don't run suddenly, or go quickly upstairs : but that if I do I am pretty sure to drop *morto.*'

The problem agitated him so disturbingly that he almost wished Lord Northbrook had not been so kind. He could not resolve to leave so hurriedly as would have been necessary, and moreover, much as he liked Lord Northbrook and his young private secretary Evelyn Baring, his friend of Corfù

days, he could not bear the notion of travelling with the Viceregal suite. 'There is something antagonistic to my nature to travelling as part of a suite,' he told Fortescue ; 'and indeed, though I am not in the strongest sense of the word Bohemian, I have just so much of that nature as it is perhaps impossible the artistic and poetic beast can be born without. Always accustomed from a boy to go my own ways un-controlled, I cannot help fearing that I should run rusty and sulky by reason of retinues and routines. This impression it is which keeps me turning over and over in what I please to call my mind what I had best do.' . . . Lord Northbrook came to Cannes on his way to India, and Lear saw him there. The invitation was renewed : Lear was to come out to India, if he decided to accept it, at any time that suited him.

In the summer, still undecided, he went to England, but by the time he returned to San Remo his mind was made up, and at the end of October he and Giorgio set out for the East. But they went only as far as Suez. 'I got as far as Suez, but the landscape-painter does not purSuez eastern journey farther. . . . Every hole and corner of the outward steamers was crammed,' and after waiting a week at Suez in the hopes of finding a berth he finally took one on a French boat, but missed that, at the last moment, 'by a singular chance of ill luck.' Moreover he had had a blow on the head some weeks previously, which pained him whenever he went into strong sunshine, and had affected his right eye. He came back, discouraged but resigned, to San Remo, and consoled himself, during the winter months, with reading the nine volumes of Horace Walpole's *Letters* and the eight volumes of Tom Moore's *Memoirs*. He was also occupied in looking through, and mostly destroying, 'three large chestfuls or chestsfull' of old letters to himself from his friends, keeping some specimens

' of each writer more or less interesting—four hundred and forty-four individuals in all.' ' Either all my friends must be fools or mad,' he wrote ; ' or, on the contrary, if they are not so, there must be more good qualities about this child than he ever gives or has given himself credit for possessing—else so vast and long continued a mass of kindness in all sorts of shapes could never have happened to him. Seriously, it is one of the greatest puzzles to me, who am sure I am one of the most selfish and cantankerous brutes ever born, that heaps and heaps of letters—and these letters only the visible signs of endless acts of kindness—from such varieties of persons could have ever been written to me ! ' He also entertained himself with writing ' The Akond of Swat '—' of whom one has read in the papers,' said Lear, ' and someone wrote to me to ask, " Who or what is he ? "—to which I sent this reply—

> *Why, or when, or which, or what*
> *Or who, or where, is the Akond of Swat,—oh WHAT*
> *Is the Akond of Swat*'

The poem—one of his funniest but not of his most subtle—was afterwards published in *Nonsense Songs and Stories.* He was amused at this time, and his vanity not a little flattered, at mention being made of him in a speech in the House of Commons by Vernon Harcourt, who had said (as Lear noted in his diary) : ' " A friend of his, an admirable artist, had published a *Book of Nonsense.* But Parliament published every year a much more celebrated Book of Nonsense, called the Statute Book " (laughter). Fancy being really in a speech by " Willie " . . . re parks and addresses debate. Sich is phame.'

In the autumn he decided to make another attempt upon India. Sending on Giorgio (who was to go with him) for

a holiday to Corfù, Lear 'shut and sealed and screwed up' the Villa Emily; then 'doddled about the Portofino coast' till the 25th of October, when he sailed from Genoa in the *India* for Bombay, picking up Giorgio at Naples on the way. He had been given a number of commissions, apart from Lord Northbrook's, for Indian landscapes. The voyage from Genoa to Bombay took twenty-seven days, so that Lear had ample leisure to become acquainted with his fellow-passengers, whom he disliked almost without exception. One day he was accosted, he relates, by a 'German Pessimist':

'G.P. You vear spegtacles alvays?
E.L. Yes.
G.P. They vill all grack in India; von pair no use.
E.L. But I have many pairs.
G.P. How many?
E.L. Twenty or thirty.
G.P. No good. They vill all grack. You should have got of silver.
E.L. But I have several of silver.
G.P. Dat is no use; they vill rust; you might got gold.
E.L. But I have some of gold.
G.P. Dat is more vorse; gold is alvays stealing.'

Lear never could bear Germans. He had written shortly before that there had been an influx of them into San Remo: 'the ground is all bescattered,' he complained, 'with horrid Germen, Gerwomen, and Gerchildren.'

Towards the end of November he arrived at Bombay. His excitement and curiosity were almost too much for him. 'Violent and amazing delight,' he wrote in his journal, 'at the wonderful varieties of life and dress here. . . . O fruits!

O flowers ! O queer vegetables ! ... These hours are worth what you will.' Then there began fourteen months of incessant travelling by every imaginable kind of conveyance—trains, elephants, horseback, carriages, carts, boats—many of them, on the interminable journeys from end to end of India, of a discomfort almost unbearable . nights spent in noisy hotels, dâk bungalows, viceregal palaces, tents, railway carriages : food strange and often uneatable : extremes of heat and cold : ill-health, depression, nervous exasperation and consequent quarrels with Giorgio, weariness, and a general hatred of ' all Indian ways and Indian life.' And all the time, at every available moment, he was drawing, drawing feverishly, drawing as though for dear life. This incessant exertion, under such trying conditions, might have exhausted a stronger man than Lear : his endurance and courage were truly remarkable, seeing how delicate his health was, that he was now over sixty, that he had been forbidden all violent effort on account of a weakness of the heart, and that he was having constant epileptic attacks (the sinister little crosses in the journal are very frequent during his Indian tour). It was only his extraordinary enthusiasm, his passion for work, his admiration for much that he saw, his insatiable curiosity, that drove him onwards and kept him going.

From Bombay he went to Cawnpore, where he joined the Viceregal party and went on with them to Lucknow. There, riding on an elephant, he took part in a Viceregal procession—' more or less miserable, being chilly and without proper clothes ' (his luggage had been lost). ' I believe " Viceregal " life will bore me to death,' he wrote. Evelyn Baring had made all possible arrangements for his comfort, but the atmosphere of official formality was chilling. ' Can't tell what to do, in all this miserable hullabaloo, and luggageless-

Q 225

ness.' He escaped by himself to make drawings of the ruined Residency—for the Mutiny, only sixteen years before, was still fresh in English minds. When he returned his luggage had been found, and he was able to dress for a State dinner-party of fifty-six people, where he ' grew dreadfully tired of the lights and fuss.' Benares, however, gave him more pleasure : he described it as ' one of the most abundantly

buoyant and startling radiant places, of infinite bustle and movement. Constantinople and Naples are simply dull and quiet in comparison.' But he was still miserable, regretting San Remo and the quiet of his Villa Emily. ' I am half wild,' he wrote, ' when I think of my folly in coming to India at all. The only thing now is to make the best of a miserable mistake.' His moods succeeded each other with surprising rapidity, for at Dinapore, where he went next, he spent a few very happy, quiet days, staying with the son of an old friend, who was established there as a doctor. His host was charming, the bungalow comfortable and the food good, and there was a baby elephant which he enjoyed drawing. It was one of the few placid intervals that helped him to endure the rush and hurry of those fourteen weary months.

He joined Lord Northbrook again at Calcutta, but life at

Government House was not at all to his taste. His rooms were 'preposterously magnificent, not to say awful': there were too many servants, too many distractions, too much necessity of being polite to bores. He was unwell, depressed: 'a hateful fussy life; no rest in Hustlefussabad,' he sighed. Lord Northbrook and Evelyn Baring were as kind as possible, but they were constantly occupied and there was little opportunity for the quiet friendly intercourse that Lear valued above all things. He was only happy when he could steal away by himself and explore the city or the country near by, finding peace as he drew an ancient temple or a quiet scene at a water-tank in the very early morning, the beauty of which he observed with a painter's eye. 'The beauty of white sheets, both in light and shadow—also black bodies and white waist-cloths;—also extreme featheriness of cocoanut palms; depths of brown-grey shale; brilliancy of Bananas and general misty greyness, more like English even than Nile scenes at early morning, owing to the profusion of vegetation. . . . General tone, a deep beautiful dark grey, relieved with vividly bright bits of light;—a *green* tone throughout; even the Mosque domes are rather greeny brown. The palms, if in shadow, have hardly any colour.' But one of these sketching expeditions ended in a disaster which kept him to his bed for several days: 'very ill,' he wrote, 'along of the new sketching-stool having broken down under me, and hurt my behind very badly.'

As soon as he was well, thankful to leave 'Hustlefussabad,' he set off to Darjeeling. A week of uncomfortable travelling by road and on foot, and nights spent in the primitive simplicity of dâk bungalows, reminded him of journeys long ago in Albania. Lord Northbrook had commissioned a picture of Kinchinjunga from Darjeeling, and of this ambitious

227

subject (whenever the fog lifted) he was making drawings, rising every morning at five. He found it a difficult task. 'Kinchinjunga is not—so it seems to me—a sympathetic mountain ; it is so far off, so very God-like and stupendous, and all that great world of dark opal vallies full of misty, hardly-to-be-imagined forms—besides the all but impossibility of expressing the whole as a scene—make up a rather distracting and repelling whole.' The Himalayas, altogether, were a disappointment to him. He refused to be impressed merely by their size, and in shape, it seemed to him, they fell short of many far lesser mountains that he had seen and drawn in Greece and elsewhere. He went later to Simla, where the Viceroy lent him a house and servants for a fortnight. There it was the rhododendrons, not the Himalayas, that astonished him. The view of the mountains compared unfavourably with the view from Darjeeling. 'Methinks these Himalayas —always barring Darjeeling—are mighty uninteresting !' But at Agra his reactions were quite in the orthodox Victorian manner : the Taj Mahal, he wrote, is 'the most beautiful of all earthly buildings.'

It would be tedious to give a catalogue of all the places that Lear visited during his Indian tour—but it is certain that few, either before or since, have made so complete a survey, in so short a time, of that vast and heterogeneous land. Most of the time he was tired, ill and depressed : very often he thought of giving up altogether and returning to the repose of the Villa Emily. 'Weary !—oh, how weary I am of this most miserable Indian journey !' he exclaimed—and pressed on to Allahabad, where news of his sister Sarah's death in New Zealand added to his unhappiness. Yet there was much that he found to admire and to enjoy, many sights that surprised and amused him—as, for instance, at a Hindoo festival at

Hurdwur, when he saw two hundred thousand pilgrims 'flumping simultaneous into the Holy Gunga at sunrise on April 11—squash.' All the time, apart from his endless sketching, he kept his journal with the most meticulous care : nowhere is his curious love of often gratuitous detail more clearly displayed. In a man so intensely occupied every moment of the day, so incompetent in business and financial matters, in many ways so 'fluffy and hazy,' this is an un-expected quality. But he can never leave an hotel nor eat a meal without stating precisely the amount of the bill : if he travels by railway he notes the price of the ticket, as well as the time of the departure and arrival of the train, and the time of its stopping at every intermediate station ; and every action is timed, not only by the day, but by the hour. Of his food, too, he gives always the exact *menu*—of the enormous meat meals, especially the immense quantities of roast mutton, that English people were accustomed to eat in India at that time, even in the hot weather : two meat courses always for ' breakfast ' (at about 10 a.m.), and a similar, or larger, amount of meat again at dinner in the evening. (Had this extravagant carnivorousness, perhaps, something to do with the ' prickly heat' from which Lear and his English friends constantly suffered ?) Another solace, besides his journal, was letter-writing, when he had time to spare, for he could always find a little comfort in this imaginative contact with his friends. These letters are full of foolish puns and nonsense— and the more depressed he was, the more nonsensical the letters. At Delhi, where he thought ' now more than ever most seriously of going away from India altogether,' he stayed ten days ' a making Delhineations of the Delhicate architecture as is all impressed on my mind as inDelhibly as the Delhiterious quality of the water in that city.' To Lord Northbrook he

229

wrote with strong disapproval of Indian laundry methods. 'Does your Excellency know that in various places in your Empire the Dobies fill shirts, drawers, socks, etc. with stones, and then, tying up the necks, bang them furiously on rocks at the water's edge until they are supposed to be washed? Surely, no country can prosper where such irregularities prevail.'

In June, when the monsoons began, he found himself at Poona, and had to remain there several weeks, as travelling was impossible during the rainy season. He had already completed ' 560 drawings, large and small, besides 9 small sketchbooks and 4 of journals,' and for these he had tin boxes made and sent them off to Bombay to await his final departure from India. At Poona it was not the rush and discomfort of travelling, but the enforced inaction, that irked him. He was unwell, and he hated the continual bickerings, the 'incessant bear-garden and dog-kennel feeling' amongst the Anglo-Indians in the hotel, where he felt like a fish out of water. 'What to do? I cannot tell,' he wrote. . . . 'Penned out a good deal, but ever getting worried and puzzled and sad beyond much more endurance.' Even such diversions as an elephant that smoked a hookah, and a 'big musickle phunktion in the gardens,' and being attacked by a mad fanatic in the bazaar, quite failed to relieve his melancholy. The only remedy for it lay in composing 'nonsenses.' It was during this time that he wrote 'The Cummerbund: an Indian Poem':

> She sat upon her Dobie,
> To watch the Evening Star,
> And all the Punkahs as they passed
> Cried, ' My ! how fair you are ! '—

which appeared, with great success, in the *Bombay Times* during July, and was later published in *Nonsense Songs*.

Lear was gratified, and somewhat surprised, to discover how popular his nonsense books were in India—' even in spite of Madame de Bunsen saying that she would never allow her grandchildren to look at my books, inasmuch as their distorted figures would injure the children's sense of the beautiful ; and in spite of the admonitions of other sagacious persons as to my perversion of young folks' perceptions of spelling and correct grammar.' He was deeply touched by an incident that occurred one evening at an hotel where he was staying— one of those Anglo-Indian hotels that he grew to detest more and more. Before dinner he was engaged in drawing birds for the landlord's little daughter, when, as he was drawing a picture of an owl, another little girl, who was watching, said : " O please draw a Pussy-cat too !—because you know they went to sea in a boat, with plenty of honey and money wrapped up in a £5 note ! " ' On enquiry I found that she and all the school she went to had been taught that remarkable poem ! ! ' At such moments he felt, perhaps, that his life, after all, had not been quite in vain.

His impatience would not let him wait till the end of the rainy season : he set off for Hyderabad, saw Bellary, whose temples he found 'involvular beyond all possibility of execution' ; but was prevented by the rains from visiting Anagoonda and its Hindoo ruins, and by the same cause from going to Mysore, Coorg and (till later) the Malabar Coast. So he crossed eastwards to Madras, whence he visited the Seven Pagodas of Mahabalipur and the temples of Conjeveram. The heat in this region was intolerable : his irritability and fatigue burst out upon the patient Giorgio and they had a violent quarrel in which Lear actually dismissed him for ever

from his service. Giorgio, knowing his master, probably did not take it very seriously : and next day Lear was repentant and took all the blame upon himself. ' George,' he said, ' though he very seldom speaks, speaks sense when he speaks at all.' Many times, during these journeys, did he pay tribute to his old servant's invaluable help and constant good temper under trying conditions, recognizing that without him he could never have accomplished so much. For he had no patience with Indian servants : there were always too many of them, and they tried to do too much and succeeded in doing nothing, and were fussy, incompetent and stupid. Or they quarrelled amongst themselves ; and Lear began to be a little doubtful of the benefits brought to India by English missionaries when one servant, complaining of another, said to him (the remark has a satirical point almost worthy of Voltaire) : ' I Christian : he miserable heathen—go to hell and burn.'

From Madras he made his way steadily southwards towards Ceylon, going first to Bangalore, then Trichinopoly and Tanjore, then across to the Nilgiri Hills : Coonoor he found to be ' not unlike Bournemouth . . . with different foliage.' Thence to Calicut and the Malabar coast, whose superb scenery and tropical vegetation delighted him. But the heat, again, was almost unendurable : ' Good evans ! ' he exclaimed, ' if any of my old friends could know how much Beer and Brandy and Sherry this child conshumes, would they recognize me ? '

Ceylon, on the other hand, was a disappointment. By this time he was not only unwell and exhausted physically, but his mind was sated with new impressions and stale with over-work, and was hardly in a fit state to appreciate anything, however admirable. Lord Northbrook's two children were

staying at Galle, and he went on from Colombo to see them before going inland. But the hotels were noisy and uncomfortable, the damp heat intolerable, and the natives, whenever he tried to draw, so inquisitive (far more so, it seems, than those of India) that he gave up in despair. Ceylon had been one of the places that he had longed all his life to see, and his disillusionment was the harder to bear. 'Verily!' he exclaimed, 'Ceylon the long looked-for is a bore of the first quality—and as disgusting a place—at least in the phase I see of it—as I have known in any part of my travels.' Its scenery was inferior, he considered, to that of Malabar, 'nor did I find any interest in the place as compared with India.' He went on to Kandy, where the greatest of all his Indian disasters overtook him. Giorgio fell very seriously ill with dysentery— so seriously that there seemed, for a time, little hope of his recovery. Lear, ill himself with a bad throat, worried almost out of his senses, miserably depressed, gave up everything, without hesitation, to the exacting and unpleasant task of nursing him. After days and nights of acute anxiety, he was able to move Giorgio, still very weak, down to Colombo, and soon afterwards they took the steamer back to Calicut. Giorgio was well again, and now it was Lear's turn for misfortune. During a tour from Calicut down the coast to Cochin and Alleppey he strained his back and side severely as he was getting into a boat : to his other ailments and the discomfort of the great heat was added an acute attack of lumbago.

It was the end : he felt he could do no more. India was too vast, too overwhelming, too merciless. Many more places he had planned to see—Mangalore, Goa, Elephanta— but all these he had to abandon (characteristically, he began almost at once to plan another Indian tour in two or three

years' time). He went straight back, by sea, to Bombay, and thence, after a short stay, sailed for Brindisi. On board he worked out a scheme of fifty subjects, chosen from the fifteen hundred drawings he brought back with him—'if ever I publish *Indian Landscape*.'

235

Chapter XVI

SAN REMO ; LAST VISIT TO ENGLAND

THE next few years of Lear's life were spent mostly at San Remo. But if the Villa Emily provided him with a haven of quiet such as he had often longed for—more than ever during the restless, exhausting months of his Indian tour—it could not protect him from external disasters and sorrows. He had looked forward with the greatest delight, during the long voyage, to the moment of seeing his house and his beloved garden—where he would plant the rare Indian seeds he had brought with him, among them the ' Ipomaca Learii,' called after another Lear, a botanist, who had visited India forty years before—and to the prospect of a long period of undisturbed work in the studio he had made for himself. Above all, after his restless wandering, he longed to remain fixed in one place, where there would be no more packing, no more travelling, no more hotel food nor irritating Oriental servants. But, on his arrival, all pleasure was immediately spoilt by his discovery that the villa had been broken into by burglars. His state of mind magnified this misfortune into a disaster much greater than the reality. The place was in confusion ; cupboards had been ransacked and all his belongings scattered ; but it seems, from Hubert Congreve's account of it, that little, if anything, had been stolen. But an outrage had been committed upon his precious villa, an outrage which he, mildest of men, had done nothing to deserve, and which he could never forget nor forgive. For many years it rankled.

It was not, however, wholly without compensation : for if anything that was wanted could not immediately be found, its loss could always be blamed upon the burglars.

' I suppose it was to be expected that life would be more and more disagreeable towards its close, but that don't make the fact any nicer,' he wrote at this time. Worse things were happening than the burglary. His little god-daughter, one of Lushington's four children, died : the health of that ' nearly-angel woman Emily Tennyson ' was increasingly precarious ; and his sister Eleanor Newsom had become almost totally blind. She was the last remaining of his sisters, and her letters, which now ceased to arrive, had been his only remaining link with his family—apart from those of his nephew and niece in New Zealand. ' Every few months,' he wrote to Fortescue (now Lord Carlingford), ' bring tidings of illness and death. I do not know what your views of future states or material-annihilation may be—but probably similar to mine—hating dogma about what we really *know* nothing about, yet willing to hope dimly.' Lady Augusta Stanley was one of the old friends whose loss he mourned at this time. Lear, recalling the days of their Irish tour, forty years before, wrote his sympathy to Arthur Stanley, with whom—though he saw him but seldom—he had kept up a correspondence. ' I have now crossed the summit of my life,' the Dean replied. ' All that remains can be a long or short descent, cheered by the memories of the past.' Lear could not help feeling, a little bitterly, that Dean Stanley, however great his loss, was lucky to have such memories to cheer him.

But the misfortune that affected Lear most closely was the steady decline in health of his ' dear good servant and friend ' Giorgio. Ever since his attack of dysentery in Ceylon Giorgio had been growing weaker and more depressed :

on his return from India he had received the news of the
almost simultaneous deaths of his wife, mother and brothers
in Corfù, a blow which, Lear wrote, 'seemed to paralyse
and change him'; and although Lear sent for Giorgio's
second son to come from Corfù to look after his father, his
health failed more and more. Finally he told Lear that he
could work no longer, and that he would like to go to Corfù
to see his other two children before he died.

Lear, deeply distressed both at Giorgio's state and at the
prospect of losing him, gave his consent at once, but decided
that Giorgio was too ill to travel alone. So, one day towards
the end of February, a party of four set off—Giorgio and his
son, Lear, and young Hubert Congreve whom Lear had
invited to come with him to help him on the journey. As
they started Lear thrust a bundle of notes into Congreve's
hand without counting them, all money transactions being, he
said, 'a nabbomination to this child.' The journey was
long and dreary, the weather bitterly cold, and Lear became
more and more despondent. All night and all day, as they
travelled, a snowstorm was raging : Brindisi they found two
feet deep in snow, with a gale blowing ; and all thought of
an immediate crossing to Corfù had to be abandoned. The
primitive discomfort of the hotel in which they stayed was
extreme, and Lear, exhausted and nervous, lay all night tossing
and moaning in a bed with only a single thin blanket, with
the snow drifting in through the crevices of the ill-fitting
windows. Congreve now became seriously alarmed for
Lear's health. The possibility of being stranded in a cheap
hotel in Brindisi with two elderly invalids on his hands was
disquieting, and, as Giorgio had his son to look after him and
there was still no prospect of being able to cross to Corfù,
he managed, at last, to persuade Lear to give up this last part

of the journey and return, by way of Naples and Rome, to
San Remo. Lear was desolate at the thought of leaving,
probably for ever, the old servant who for twenty-two years
had so faithfully looked after him, nursing him in sickness,
accompanying him in his travels, bearing patiently with his
attacks of ill-humour and depression, and whom he looked
upon more as a friend than a servant. Giorgio, too, was
deeply moved : " My master," he said as Lear left him, " My
master, so good to me and mine for so many years, I must
tell you this—I shall never, never see you more. I know
that death is near—and ever nearer."

These forebodings, however, were not realized. Lear was
in England that summer, and on his return to San Remo in
the early autumn he set off again almost immediately to
Corfù to see Giorgio, whom he found still very ill, but less
depressed. Then, after a new treatment had been employed,
he began to make a surprising recovery, and the doctor
recommended a sea voyage and a change of air. In June of
the next summer Lear went to meet him at Genoa : still ' a
mere skeleton and unable to walk,' he took him at once to
Monte Generoso above Lake Como, where ' he grew better
in a fabulous way, and in six weeks was able to sleep, eat and
walk as he had not done for three years.' Before they left
in September he was walking about Como, carrying Lear's
folios and drawing materials as he had been accustomed to
do for years. On their return to San Remo Lear sent him
off to Corfù to fetch his second son, Lambi, who was to be
trained to take his father's place : then they all settled down
again—Lear, Giorgio, Lambi and Foss the cat—to a quiet life
at the Villa Emily.

For a time everything went well : Lear's health was good,
and he sat on his terrace in the sun, delighting in his garden

and finding that, after all, life still had something to give.
' I have lovely broad beans,' he wrote, ' and the Lushingtons
come and stay with me, so that altogether I should be rather
surprised if I am happier in Paradise than I am now. . . .' It
was this contented and genial mood that produced, about
this time, the self-portrait in verse which is given at the
beginning of the present volume : ' How pleasant to know
Mr. Lear ! ' It was written for a young lady of his acquain-
tance who had quoted to him the words of another young
lady, not of his acquaintance, which provide the first and last
lines of the poem. It is a surprising example, in the truthful-
ness of the impression it gives, of Lear's ability to convey
sense through nonsense.

It was about this time, too, that he produced, for the amuse-
ment of his god-daughter Gertrude Lushington, the song of
' The Pobble who had no Toes.' The poem, as published in
Nonsense Songs, contains six stanzas ; but there is a hitherto
unpublished version which, in place of the fourth, fifth and
sixth stanzas, has the following :

The Pobble went gaily on,
To a rock by the edge of the water,
And there, a-eating of crumbs and cream,
Sat King Jampoodle's daughter.
Her cap was a root of Beetroot red
With a hole cut out to insert her head ;
Her gloves were yellow ; her shoes were pink ;
Her frock was green ; and her name was Bink.

Said the Pobble—" O Princess Bink,
A-eating of crumbs and cream !
Your beautiful face has filled my heart
With the most profound esteem !

R 241

And my Aunt Jobiska says, Man's life
Ain't worth a penny without a wife,
Whereby it will give me the greatest pleasure
If you'll marry me now, or when you've leisure ! "

Said the Princess Bink—" O ! Yes !
I will certainly cross the Channel
And marry you then if you'll give me now
That lovely scarlet flannel !
And besides that flannel about your nose
I trust you will give me all your toes,
To place in my Pa's Museum collection,
As proofs of your deep genteel affection ! "

The Pobble unwrapped his nose,
And gave her the flannel so red,
Which, throwing her beetroot cap away,
She wreathed around her head.
And one by one he unscrewed his toes,
Which were made of the beautiful wood that grows
In his Aunt Jobiska's roorial park,
When the days are short and the nights are dark.

Said the Princess—" O Pobble ! my Pobble !
I'm yours for ever and ever !
I never will leave you my Pobble ! my Pobble !
Never, and never, and never ! "
Said the Pobble—" My Binky ! O bless your heart !—
—But say—would you like at once to start
Without taking leave of your dumpetty Father
Jampoodle the King ? "—Said the Princess—" Rather ! "

*They crossed the Channel at once
And when boats and ships came near them,
They winkelty-binkelty-tinkled their bell
So that all the world could hear them.
And all the Sailors and Admirals cried
When they saw them swim to the farther side—
" There are no more fish for his Aunt Jobiska's
Runcible cat with crimson whiskers ! "*

*They danced about all day,
All over the hills and dales ;
They danced in every village and town
In the North and the South of Wales.
And their Aunt Jobiska made them a dish
Of Mice and Buttercups fried with fish,
For she said—" The World in general knows
Pobbles are happier without their toes ! "*

Keeping to his principle of ' Always have ten years' work mapped out before you, if you wish to be happy,' Lear had planned a vast programme—in his work, at any rate, a determined optimist—that would take many more years to complete than he expected to live. He was busy with the ' penning out ' of his Indian sketches ; he had the large picture of Kinchinjunga to paint for Lord Northbrook ; plans for an even larger ' Enoch Arden,' and for the finishing of a ' big Athos ' and a ' Bavella ' ; and, above all, he had returned to his work on the Tennyson illustrations. During the remaining ten years of his life this last project absorbed him more and more : the more his strength and his eyesight failed (he had already lost, almost completely, the sight of one eye), the more obstinately he clung to a labour which brought him

little satisfaction and which he knew he could never finish. His dealings with publishers, printers and lithographers exhausted and exasperated him : he spent far more money than he could afford on experiments in reproduction, none of which satisfied him ; and so the dream of his life, his tribute of admiration and love to his friend Tennyson, gradually turned into a nightmare that served only to hasten him into his grave. But in the meantime everything seemed to be going satisfactorily. A few of the drawings were completed, and had been entrusted to a certain Frederick Underhill, a talented but impecunious young artist with a large family, whom Lear knew to be a skilful lithographer—whom, also, he liked and was anxious to help. And his other work, his large Indian landscapes, were also progressing well.

Then, suddenly, without warning, calamity descended upon him. His retirement was to be invaded, his peace shattered, by the building of a large new hotel at the end of his garden, which would completely shut out all view of the sea and cut off the light from his studio, destroying the privacy of his house and the seclusion of his garden. Like the burglary—but much more grievous—it was an outrage upon his beloved villa, which he resented bitterly and unforgivingly, for many years, as a personal injury to himself. ' Certainly a more devilish injury was never inflicted by 2 English people and a Gerwoman on any unoffending artist,' he wrote to Hallam Tennyson. Work began at once on the ' diametrical damnable blazing 5 Story Hotel.' ' At present,' he wrote, ' owing to the incessant clamour of stone-carters, and the terrible annoyance of mines sprung (to make cisterns in the rock) just below me, I can neither work, read nor write— a sort of misery which in 10 or 12 months of course will come to an end :—but what will it give place to ? an immense

building (like the Langham) completely shutting out all sea and distance, and also, from quite intercepting the sun from the lower part of the garden, making half my small property useless.' All peace of mind was gone : the one thing certain was that he could no longer remain at the Villa Emily. But what could he do ? Where could he go ? The thought of creating a new home for himself, of starting life afresh in some new place at nearly seventy, with his precarious health, when all he wanted was to be left in peace for his short remaining span of life, was infinitely distasteful. The effort seemed to him too great to be worth making, feeling as he did that he had so short a time to live. It was his indignation and resentment that contributed most to the resolve that at all costs he must leave : if he stayed, the ' 2 English people and a Gerwoman ' would be having too easy a triumph, he would be accepting defeat in too poor-spirited a fashion.

There seemed, finally, to be two alternatives. Either he must find another site, in San Remo or elsewhere, and build another house, selling the Villa Emily (but the value of the property was now much depreciated ; and who, anyhow, would want to buy a villa that was overshadowed by a hateful and monstrous hotel ? And if he could not sell it, where was the money to come from to build a new house ?) —or he would break away completely from Europe and his old life, from his friends and all that connected him with England, and go to join his nephew and niece in New Zealand. He was less reluctant now to leave San Remo, since his friends and neighbours the Congreves—the only permanent inhabitants of the place in whom he had any real interest— had left. Still undecided, and his depression and irritation further increased by the news that the Academy had rejected

the large Indian landscape painted for Lord Northbrook, he left, with Giorgio, to spend the summer at Monte Generoso.

It was on his way there that he saw in a newspaper a report of the death of Fortescue's wife, Lady Waldegrave, after a short and sudden illness. It was a loss that he felt very deeply, both on his own account and on that of his friend. He knew —better, perhaps, than anyone—what she had been to Fortescue, how devotedly he had loved her for nearly thirty years, how utterly he had depended upon her since their marriage—for she was, in general, of a more positive character than he ; and the letters he wrote to Fortescue at this time were filled with the sympathy of true understanding and friendship. He knew how severe the blow, intensified by its suddenness, would be, and was almost alarmed at the thought of what might become of his friend. His concern for him even eclipsed his own great personal grief at her death. He had had a great admiration and respect for that woman of brilliant vitality and intelligence, whose preoccupation with social affairs had never had the effect of dulling her charity and humanity. ' No person who has occupied so high a social position as Lady Waldegrave ever had so many real friends and so few enemies,' someone wrote after her death. To Lear she had been a loyal friend, a trusted counsellor, a generous patron. With the exception of Lady Tennyson, she had been the greatest of his women friends—who held a very special and important place in his life.

To one of Lear's temperament—who had singularly little interest of a sensual kind in the opposite sex—the friendship of women was of inestimable value, and, for that same reason, more attainable and more sympathetic than to the average man. He had the greatest respect—almost veneration—for

the finest and most characteristic feminine qualities : friendship, to him, was the most important thing in life, and his friendships with women acquired a quality which placed them on a different plane (neither higher nor lower, nor yet comparable) from his friendships with men. And—at a period when sex-distinctions were very clearly defined—there is no doubt that women were conscious, in him, of some quality that made him approachable in a more direct way, with less of *arrière-pensée*, less of reserve, than was generally to be felt with their masculine acquaintances. He realized this, and appreciated it. One of the favourite books of his old age was the *Spectator*, and in it he marked emphatically the following passage : ' I take it for a peculiar happiness that I have always had an easy and familiar admittance to the fair sex. If I never praised or flattered, I never belied or contradicted them. . . .'

(His cheap edition of Addison was often in his hands during these last years : he used it also as a kind of note-book, and on its yellow end-papers are to be found rough drafts of ' My Aged Uncle Arly ' and of the unfinished fragment of a sequel to ' The Owl and the Pussy-Cat ' :

THE CHILDREN OF THE OWL AND THE PUSSY-CAT

Our mother was the Pussy-Cat, our father was the Owl,
And so we're partly little beasts and partly little fowl,
The brothers of our family have feathers and they hoot,
While all the sisters dress in fur and have long tails to boot.
We all believe that little mice,
For food are singularly nice.

Our mother died long years ago. She was a lovely cat
Her tail was 5 feet long, and grey with stripes, but what of that ?
In Sila forest on the East of far Calabria's shore
She tumbled from a lofty tree—none ever saw her more.
Our owly father long was ill from sorrow and surprise,
But with the feathers of his tail he wiped his weeping eyes.
And in the hollow of a tree in Sila's inmost maze
We made a happy home and there we pass our obvious days.

From Reggian Cosenza many owls about us flit
And bring us worldly news for which we do not care a bit.
We watch the sun each morning rise, beyond Tarento's strait ;
We go out —————————— before it gets too late ;
And when the evening shades begin to lengthen from the trees
—————————— as sure as bees is bees.
We wander up and down the shore ———————
Or tumble over head and heels, but never, never more
Can see the far Gromboolian plains————
Or weep as we could once have wept o'er many a vanished scene :
This is the way our father moans—he is so very green.

Our father still preserves his voice, and when he sees a star
He often sings ——— to that original guitar.
————————————————
————————————————

The pot in which our parents took the honey in their boat,
But all the money has been spent, beside the £5 note.
The owls who come and bring us news are often——
Because we take no interest in poltix of the day.)

Some months after his wife's death Fortescue came out to
San Remo to visit Lear. He had been to Cannes for the

wedding of Lady Waldegrave's niece and adopted daughter (who later edited the two volumes of Lear's Letters) to Sir Edward Strachey's eldest son : on arrival at San Remo he took a room at an hotel near the Villa Emily, for Lear had been having domestic difficulties and could not take him into the house. (Lear and Giorgio, on their return from Monte Generoso in the previous autumn, had found that Giorgio's son Lambi had ' gone completely to the bad ' ; there was nothing to be done but pay his debts and send him back to Corfù. It was the beginning of many troubles and anxieties that Lear suffered from Giorgio's three sons : with endless patience, for their father's sake, he employed them in his house, helped them when in trouble, and nursed them in sickness ; and had little reward for his pains.) Fortescue's visit was a great joy to Lear—a joy necessarily tempered by the sorrow of the recent loss which both of them still felt acutely. They saw much of each other, taking walks and sitting together in the sun, and each found comfort and benefit in the other's company. Lear was able to pour out his grief and resentment at the building of the new hotel, and Fortescue, seeing how it was preying upon his mind, helped him to come to the decision of buying another piece of land at San Remo and building a new villa. It was to be called the Villa Tennyson, and was to be an exact replica of the Villa Emily : otherwise, Lear explained, Foss would not like it. Lear, his mind at last made up, immediately set about raising money, and again his friends rallied to his assistance. Lord Northbrook lent him £2000 till the Villa Emily should be sold, other friends—Lord Derby, Lord Somers, and Fortescue himself—smaller sums. The site was bought. ' My new land,' he wrote to Lady Tennyson, ' has only the road and the railway between it and the sea, so unless the

Fishes begin to build, or Noah's Ark comes to an anchor below the site, the new villa . . . cannot be spoiled.' This done, and all arrangements made for the building of the house, he left for England.

Lushington's London house was his headquarters that summer. The breakfast-room at Norfolk Square was turned into a 'gallery'; five or six hundred 'tickets' were sent out, and Lear's exhibition had a fair success. But this was counterbalanced by the bankruptcy of Bush, his publisher, in whose hands were the *Corsican Journal* and some of the Nonsense Books, from which Lear, not unjustifiably, had hoped to derive some profit. The money that Bush owed him was lost; nothing could be done, and he was much discouraged. His country visits, too, made him tired and restless. 'Country visiting in English "summers",' he wrote to Drummond, 'is well enough for the rich and strong, but ill suited to Landscapepainters in debt and sneezing.' The only days he fully enjoyed were those spent at the Tennysons' new house at Haslemere, where he found his 'angelic dear Emily T.' much improved in health. Visits to Eleanor Newsom, his last remaining sister, had become a more and more painful duty. She was over eighty, blind and nearly deaf and full of infirmities, and to see her was both trying and depressing. 'Gussie Parker and her poor husband' he went to see at Wimbledon : 'she certainly is an admirable creature,' he wrote, 'I admire her more than ever.' There was a slight note of regret that he himself was not in the 'poor husband's' place. At Brighton he occupied himself with making a copy of one of his Viareggio drawings for the two old Miss Shelleys, who were staying near by. 'Two sisters, older than the poet, died,' he noted in his diary ; 'but these 2 sisters were younger, and are about 80 and 84. . . .

They are both extremely clever, and would be delighted at any drawing or music connected with their brother's memory, so I am to make a drawing of the Viareggio coast, and am to have a letter to the 2 ladies at Chertsey, where they have taken a house.' In London there was the usual round of dinner-parties—and though, as always, he protested against such a wearisome waste of time, he was not above deriving some satisfaction from finding himself still, to a certain extent, a social ' lion '—even if not of the first order. And it always delighted his essentially innocent vanity to be confronted with one of his own pictures hanging in a grand drawing-room. ' Yesterday at Lady Ashburton's [at Kent House, Knightsbridge] I saw my " Crag that fronts the even "—let into the wall in a vast black frame all the room being gilt leather ! Never saw anything so fine of my own doing before—and walked ever afterwards with a nelevated and superb deportment and a sweet smile on everybody I met.'

Life still held its sweeter moments, after all. But they were rare : its prevailing tone was one of weariness, of loneliness, of depression. He felt he had little to live for, that, when all was said and done, there was nobody who cared very much whether he went on living at all. Of his two great friends he could see but little—Lushington, tied to a post in London and a wife and family, Fortescue wedded to the memory of a dead wife and again engrossed, greatly to the benefit of his own mind, in his political career. Neither of them, fond as they were of him, had ever given him an affection comparable to the love he had felt for them : neither had furnished an opportunity for him to give true expression to that love. He was one of those to whose nature love— not love of humanity, but love of individuals—was more

251

important than anything in life. But he had failed to find any single object on whom this feeling could be concentrated, and herein lay the chief cause of his melancholy, of his painful sense of isolation and frustration. If he could have married and had a settled home of his own—he who, in spite of his wandering existence, loved a quiet, industrious life; if he could have had children of his own—he who loved and understood children so well . . . yet such speculations are vain, for it was something in his own nature which forbade the possibility of their realization. It was the very acuteness of his feeling for others which led him to his greatest distress. He tried to persuade himself that he did not care. 'Is it better, I wonder, as A.T. says, "to have loved and lost, than never to have loved at all" ? ' he wrote to Emily Tennyson. 'I don't know. I think, as I can't help being alone, it is perhaps best to be altogether jellyfish fashion, caring for nobody.' He failed completely to put this principle into practice, and the brief glimpses of his old friends in England now brought him more pain than pleasure. 'A weary scramble it was,' he wrote afterwards, describing the succession of short country visits he had made. 'I was really tired out —body and mind : the constant leave-taking of old friends having made me quite miserable—82, 84, 85, and 92 being ages at which I can hardly hope to see their possessors again in this life—even if I myself come to England again.' There were many old friends he never saw again ; for it was his last visit to England.

Edward Lear.
æt 73.½

His cat Foss,
æt 16.

Chapter XVII

'THE new House he go on like one Tortoise,' Giorgio, practising his English, had written to Lear while he was in England; and when he returned in the autumn to his ravaged Villa Emily it was evident to Lear that he would have to control his impatience at least through another winter. Finally it was not until June of the next year, 1881, that he was able to move into the Villa Tennyson. He was greeted on his arrival there, to his great pleasure, by a letter of good wishes from the whole of the Tennyson family, with all their signatures, in order of seniority, at the end of the page. But he found it hard to settle down in his new quarters; he could never quite forget his grievance at being driven from his other beloved house and the garden which he had created there; and the new house never quite took the place of the old. Much of his time was occupied in the making of a new garden, but even here his pleasure and interest were marred by the sudden death of the young gardener who had been with him for five years, 'merry little Giuseppe,' only twenty-one years old, to whom Lear and his household were much attached.

The last few years of life that remained brought little happiness. His health was slowly declining, enfeebled by a series of illnesses, sometimes so serious that he himself gave up all hope. But again and again he rallied, his remarkable vitality re-asserting itself over threatenings of paralysis

255

and acute rheumatism, as well as his usual infirmities. Every summer he would spend the hottest months in the mountains of northern Italy, at Monte Generoso or Barzano near Lake Como—a change of air which never failed to do him good.

He was working less now, reading more, and his thoughts turned, sometimes, to religion, which meant, for him, not the conventional, church-going religion of his earlier life, but a belief in the essential spirit of Christianity such as he had always held sincerely, and which, as he grew older, seemed to him to have less and less to do with the Church, its dogmas and its clergy. During the last years he had hardly ever gone to church : it had become his ' bête noire ' ; and when he did go, he returned bored and disgusted. As his dislike of organized religion had increased, his sense of a genuine, personal religion deepened, and, at times of bitter depression and loneliness, when he felt, often, that his end was near, it brought him consolation. One summer at Barzano he was reading, as he often did, the *Spectator*, and marked the following passage : ' I know but one way of fortifying my soul against these gloomy presages and terrors of mind, and that is, by securing to myself the friendship and protection of that Being who disposes of events, and governs futurity. . . . Amidst all the evils that threaten me, I will look up to him for help, and question not but he will either avert them, or turn them to my advantage. Though I know neither the time nor the manner of the death I am to die, I am not at all solicitous about it ; because I am sure that he knows them both, and that he will not fail to comfort and support me under them.'

It was at Monte Generoso, in 1883, that Giorgio, Lear's faithful servant of twenty-seven years, died. For a year

before this Lear had been anxious about him : his health
had been bad again, and there had been an occasion when
he had had a complete breakdown and lost his memory,
and when, wandering away from San Remo, he had
disappeared entirely for three weeks, to be found eventually
by his son Nicola, sitting on a hill above Toulon, almost
starving, his clothes in rags. Nicola had brought him back
in a half-conscious, half-crazed state, and Lear, worried out
of his wits, did everything that was possible to restore him
to health. But he never fully recovered, and Lear's grief
at losing him was softened by the knowledge that Giorgio
could never regain his old activity and usefulness, and that
life had become a burden to him. He was buried at Mendrisio,
and later Lear had a tablet raised in his memory at San Remo,
beside the spot which he had chosen for his own grave.
Writing to Emily Tennyson at this time, he spoke of Giorgio's
' constant fidelity, activity, humility, goodness of disposition,
endless cheerfulness, honesty, patience, and untold other
virtues. . . . When I wrote as I did just now—" humility "
—I recall that sometimes I have found dear old Giorgio
blacking my or others' boots, and when I have said—" Why
don't you let the gardener's boy do that—or at least one of
your sons ? "—he would reply—" No, Master : lavoro come
questo impedisce orgoglio, e poi, è industria "—" work of
this sort prevents pride, and besides, is a sort of industry ".'
Giorgio's two sons continued with Lear, but were a constant
worry to him, Nicola because of his health—he died two
years later, of consumption—and Demetrio because of his
character : to Lear, who had taken an almost fatherly interest
in the boy and who had himself taught him to read and
write, it was a bitter disappointment when he was found
to be a hypocrite, untrustworthy, and, like the other son

s 257

Lambi, to have ' gone utterly to the bad ' ; Lear was forced to dismiss him, sending him back to Corfù.

There were other worries too, and other sorrows. Again and again, during these last years, he was saddened by the loss of old friends, losses which he felt very deeply, and to whose inevitability—considering the advancing age both of his friends and himself—he could never be resigned. ' I am greatly grieved,' he wrote to Edgar Drummond, ' at the death of one of my oldest and kindest friends, Earl Somers . . . and now one more, that of Lady Strachey : so that the days of cheerfulness seem gone for ever.' Dean Stanley, whom Lear had known for nearly fifty years, had not long survived his wife : and another friend—though not an intimate one—who died at this time, at the age of eighty-nine, was Edward Trelawney, the friend of Byron and Shelley. By the death of Eleanor Newsom, the last of the Lear sisters (she and Lear had written regularly to each other every fortnight before she became blind), ' a sort of continuity of relationship seems now to be all at once mysteriously dissolved : ' and a greater shock, because entirely unexpected, was the loss of his New Zealand nephew, Charles Street. And he was bitterly distressed, on Emily Tennyson's account, at the news of young Lionel Tennyson's death in India.

Lear never succeeded in applying the principle of conduct that he had suggested for himself—' to be altogether jelly-fish-fashion, caring for nobody.' Rather he cared too much. Unable to present to the darts of misfortune a slippery surface of armour, his vulnerability made him a too helpless victim of every kind of onslaught : joined with the nervous instability and the tendency to melancholy that were almost certainly a result of his epilepsy, it handicapped him severely in his dealings with life and injured any hope of

lasting happiness. In these last few years such resistance as he had weakened before the repeated blows of fortune : formerly his attacks of melancholy had alternated with periods of contentment, of enthusiasm, of absorption in his work ; but now, his ill-health contributing, he settled into a state of almost unrelieved depression. This was aggravated by financial worries. The Villa Emily, which he had expected to sell easily for a good sum, remained for a long time unsold. At last it was let to two English ladies who wished to start a school ; but, the school not materializing, they absconded without paying the rent. Finally, after three years, it was sold ; and though the price fell far short of what he had hoped, it was a relief to be rid of it, and to be able to pay off a part, at any rate, of what he owed to Lord Northbrook. The villa was eventually converted into a Home for Invalid Ladies of Limited Means. (Before this, and soon after it was sold, Mr. and Mrs. John Addington Symonds took it for a short time. Their eldest daughter Janet, whom Lear had amused with his 'nonsenses' at Cannes sixteen years before, had been sent to the Riviera for her health. But Symonds detested San Remo—'this most despicable dreary watering-place,' he called it—and they did not stay long. Janet, a hopeless invalid, died four years later at Davos.)

Lear's main preoccupation during the last few years of his life was the long-cherished scheme of the Tennyson illustrations. So hopefully conceived thirty years before, the plan had now become a burden to him, and he continued his work on it more, perhaps, from obstinacy than from any conviction that his dream would be realized. ' I go on irregularly at the A.T. illustrations,' he wrote, ' vainly . . . seeking a method of doing them by which I can eventually multiply

my 200 designs by photograph or autograph or sneezigraph or any other graph.' Underhill, the young artist whom Lear had commissioned to lithograph the drawings, continued with his work, in spite of many difficulties and discouragements. In 1885 Lear sent for him to come and stay at the Villa Tennyson for two or three weeks, and the whole project was endlessly re-discussed. Underhill sent Lear specimens, but Lear was again in despair. 'The fact dawns upon me gradually,' he wrote a few months later, 'that *nobody* can fully enter into my topographical notions and knowledge— and I am coming to the conclusion that unless I can get absolute facsimiles of my own work, the whole thing must be given up.' He decided to cut down the number to one hundred : then changed his entire plan again ; till the unfortunate Underhill was also in despair. Finally Lear gave up hope : he sent a printed list of the whole two hundred illustrations to Lady Tennyson, at the same time admitting that they could never be completed. Very depressed, he wrote to Fortescue : 'I do not work, having nothing to work on, for the great 200 A.T. illustrations have come to grief.' This was just over a year before his death : and it was the first time in his life that he had ever said, 'I do not work, having nothing to work on.' There was a flicker of hope a little later, when an American publisher visited him and the possibility of an American edition was discussed : but this too came to nothing, and Lear never saw the realization of his dream. A year after his death a small volume appeared, in a limited edition of one hundred copies. It contained three poems by Tennyson—'To E.L. on his Travels in Greece,' 'The Palace of Art,' and 'The Daisy'—twenty-two of Lear's landscape illustrations reduced to a very small size, and a memoir of Lear by Franklin Lushington. Each copy

was signed by the Laureate—the condition of the publisher's acceptance of the book : ' much as he disliked signing his name,' his son Hallam recorded, ' he signed it in affectionate memory of his old friend.'[1] The little volume has become a collector's piece : but it would hardly have satisfied Lear.

When he moved into the Villa Tennyson, Lear had started his ' Wednesdays ' again. San Remo's popularity as an English winter resort was increasing, and many people used to come and look at his gallery. Very few of them bought pictures, however : again and again he recorded in his diary, ' No sail, no sail.' He began to find these receptions, with their ' irruption of vulgarian unknowns ' (many of whom no doubt came to look at the author of the Nonsense Books rather than at his landscapes) more and more irritating and fatiguing : the method he adopted of dealing with his visitors has been described by a friend who stayed with him at this time. ' Early in the afternoon he told me that he had sent his servants out, and was going to open the door himself. . . . As the afternoon advanced a ring at the door-bell was heard, and Mr. Lear went to open the door. Sitting in the gallery, I heard the voice of a lady inquiring if she could see the pictures, and I could hear Mr. Lear, in a voice of the most melancholy kind, telling her that he never showed his pictures now, he was much too ill ; and from his voice and words I have no doubt the lady went away with the idea that a most unhappy man lived there. Mr. Lear came back to the gallery with much satisfaction at the working of his plan, which was so far superior to the servant's " Not at Home," as by his method he could send away bores and let in people he liked. Later on, some friends he wanted to see came, and the melancholy

[1] *Tennyson: a Memoir.* By His Son.

old man, too ill to show his pictures, changed into the most genial host.'[1]

Finally, however, driven to desperation by the arrival, in one afternoon, of two bishops and a German band, he barricaded his door ; and henceforth his pictures could only be seen by appointment. Otherwise the monotony of his solitude was broken only by the rare visits of friends—and these were his greatest delight. Both Lushington and Fortescue came to stay with him—Lushington two or three times during these last years. To Lear his visits were an ' infinite pleasure' ; yet even now, as in the old days of Corfù, the time spent together was not without its difficulties. Lushington was still the same silent, self-absorbed man : he was ready to do anything for his old friend, if it was of a practical nature—such as sending him books, or thirty bottles of champagne (which the doctor would not allow Lear to drink) : but he was still too inarticulate, too reserved, to give Lear the satisfying companionship and sympathy which were the things he craved. During his last visit, little more than a year before Lear's death, though he realized that he would probably never see him again, he was yet incapable of giving him even a glimpse of the affection which, in his own way, he felt for him—' one of the dearest friends I have ever had,' he called him. After this visit Lear wrote to Lady Tennyson (though confessing that he was ' feeling like a periwinkle who has swallowed a penwiper and 2 pounds of cayenne pepper ') : ' I was very sorry when he left me. Nevertheless, you can well understand that the depression and sadness of my life in these days was not much relieved by Frank who you know is often silent for days together.

[1] Henry Strachey, Preface to *Later Letters of Edward Lear* (ed. Lady Strachey).

In the present case no wonder, for he got a bad cold. . . .
So the visit was not generally luminous so to speak.' Lord
Northbrook and his daughter were more cheerful visitors :
so also was young Henry Strachey, himself a painter, son of
Lear's old friends Sir Edward and Lady Strachey, with whom
he had stayed in Somersetshire : and an old Miss Perry, who
had been a friend of the alarming Mrs. Cameron and recalled
old days at Farringford. She lunched with Lear and passed
a great part of the day looking over his Tennyson illustra-
tions ; and he even found himself able, as he had not for a
very long time, to sing some of the old Tennyson songs for
her. And there was a moment when Lear was thrown into
agitation by the possibility of a visit from his former pupil,
Queen Victoria, who was staying at Mentone. Lord Spencer,
who was in attendance on Her Majesty, came to lunch with
him, and rumours spread round San Remo, so that one day
' over a hundred owly fools came up and stood all about
my gate for more than an hour.' But there were difficulties :
the Queen's visit would have meant Italian deputations and
other formalities, and she did not come. Lear was relieved :
' I dislike contact with Royalty as you know,' he wrote to
Fortescue ; ' being a dirty landscape-painter apt only to
speak his thoughts and not to conceal them.' Yet, that
same year, at Monte Generoso, he was much pleased to renew
his acquaintance with the Princess Royal and her husband.
' Distinctly Princess Victoria is the most absolute duck of a
Princess imaginable,' he noted in his diary, ' so natural and
unaffected, with a real simplicity one feels is not an affectation
of simplicity.' He went for a walk with them, and they
thanked him for ' showing the views so well.'

The visitor who gave him most pleasure, and who still
had the power to agitate his mind, was Mrs. Parker—Gussie

Bethell. Her husband had died not long before : ' I wish I were not so dam old,' Lear had remarked. She came with two nieces to stay at an hotel at San Remo in 1883, and spent most of the days with Lear. He was still strangely obsessed with the idea of asking her to marry him : all his old hopes revived, but still he said nothing. On the day she left he picked ' as good and large a nosegay as he could for dear G. and two others for the nieces and having made them up into parcels took them up to the Royal,' where he saw and took leave of her. ' I miss her horridly,' he wrote after she had gone. ' So ends the very last possible chance of changing this life. Many causes occasion this, my old age the least among them.' Still later, when he felt that his end was gradually coming near, he wrote and asked her to come to San Remo so that he might see her once more before he died. Again she came : again—within a year of his death—the idea of matrimony possessed him, more strongly, perhaps, than ever before. ' I am perplexed as to if I shall or shall not ask G—— to marry me,' he wrote in his diary after she had arrived. ' Once or twice the crisis nearly came off, yet she went at 5 and nothing occurred beyond her very decidedly showing me how much she cared for me. . . . This,' he added later at the bottom of the page, ' I think, was the death of all hope.' She went back to England : they wrote frequently to each other and she sent him a Wordsworth, in which he often read ; but he never saw her again.

Gradually his health was weakening. The periodical attacks of illness grew worse, the intervals shorter. Yet such was Lear's vitality that during these intervals he was sometimes able to rise at four-thirty and work for ten or twelve hours a day. He was busily engaged in painting an enormous ' Enoch Arden,' fifteen feet long by nine feet high, which

was to be a present for Lord Tennyson, and again, indomitably, within three months of his death, he started work afresh on the two hundred Tennyson illustrations, 'large size.' The purchase of his big picture 'Argos from the Citadel of Mycenae,' which was presented to Trinity College, Cambridge by a number of members of the College (including Tennyson and Franklin Lushington) pleased him very much, as did a long and complimentary article on the Nonsense Books in the *Spectator*, and a paragraph about himself in W. P. Frith's recently published *Autobiography*. (Frith had been a friend and fellow student of Lear's in his younger days.) But dearest of all to his heart was the praise that Ruskin gave him in a letter to the *Pall Mall Magazine* on 'The Choice of Books.' 'Surely,' he had written, 'the most beneficent and innocent of all books yet produced is the *Book of Nonsense*, with its corollary carols—inimitable and refreshing, and perfect in rhythm. I really don't know any author to whom I am half so grateful, for my idle self, as Edward Lear. I shall put him first of my hundred authors.' Lear was delighted : he wrote at once to Ruskin offering to send him his other three books of Nonsense. He also sent him a manuscript copy of 'My Aged Uncle Arly,' which he had just completed—' the last Nonsense poem I shall ever write,' he says, ' —stuff begun years ago for Lady Emma Baring,' Lord Northbrook's daughter. Copies were sent also to other friends, including Wilkie Collins— whom, Lears tells us, he resembled so closely in appearance that he was often mistaken for him.

Ruskin's praise did more than anything else to comfort Lear during the last two years that remained to him. All his life he had been haunted by a persistent sense of failure, but now, acclaimed—as a nonsense-writer, if not as a land-

scape-painter—by England's foremost critic, he could feel
that something, after all, had been achieved. As he sat, old
and frail, on the rose-hung terrace of the garden that he had
made and loved, with his tame pigeons fluttering about him,
there were moments when a kind of peace dissipated the
melancholy and loneliness of his soul. He had failed in
many things : for his painting, perhaps, the life-work to
which he had devoted himself, he might not be remembered ;
his friendships had not brought him all that he had desired
of them ; he had never married, never had children of his
own—he who all his life had loved and understood children ;
yet he could feel, after all, that the talent that he knew himself
to possess had not been wasted, that it had found an expression,
its true expression, in his nonsense poetry. Into it—though,
to his friends, he had spoken of it lightly, though he had
laughed at himself for it—he had put far more real feeling, far
more of his true self, than into his great Enoch Ardens and
Bassaes, his views of Greece and Italy and India. In his heart
of hearts he had always known this, and one or two of the
more discerning of his friends knew it also. For that he was
justly acclaimed, for that he would perhaps be remembered.

Lushington's last visit was in November 1886. Lear had
been very seriously ill at Lucerne that summer, after his visit
to Barzano, and though his life had been despaired of, he
had again rallied and was much better. But Lushington,
writing to Hallam Tennyson, described him as ' sadly aged and
feeble—very crippled at times with rheumatism—totters about
within the house—hardly goes out at all even on his terrace
just outside the windows—has to be dressed and undressed
by his manservant Luigi—and goes to bed by 6 o'clock. A
great deal of the day he passes on his sofa—and all that he
does do is only done by short fits and starts. . . . I doubt

if he is likely ever to do much more work as a painter—
and it is a grievous pity to see the large picture of Mount
Athos which has been for so many years on the verge of
completion and which I have always thought one of his
finest subjects, standing on its easel with its foreground
incomplete and with (as I fear) no chance of its completion.
The only point in which he is quite his old self is his intense
interest in all his friends and his pleasure in hearing from
them. . . . He is grown considerably more deaf—which
always throws a man more in upon himself—and he leads
a horribly solitary life here. The only consolation is that
he has a thoroughly good doctor and a thoroughly good
and attentive manservant.'

Left alone again, Lear sank back into depression. ' My
life seems to me more and more unsatisfactory and melancholy
and dark. . . . I live all but absolutely alone. . . . I miss
Lushington extremely. . . . On the whole I do not know
if I am living or dead at times. . . . I trust you will write
by way of charity if for no other motive,' he wrote to
Fortescue. But his health improved slightly, and in the
summer he was able to go up to Biella in Piedmont for two
months. This did him good for a time, but, back at San
Remo in the autumn, he soon relapsed into his former state,
further depressed by the death of his cat Foss, his ' daily
companion ' for nearly seventeen years. This time there was
to be no recovery. He grew steadily weaker and his memory
began to fail : soon his walks in the garden ceased and he
remained in his bedroom, at last taking altogether to his
bed. On January 29th, 1888, he died.

His end was peaceful and without suffering, and for some
days before he seems to have been fully aware of its approach,
for a marked change was visible in him, and an increase of

EDWARD LEAR

tenderness in his manner to all about him. Only the doctor and the chaplain were with him when he died : none of his friends had been able to come. But it was of them he was thinking, of the three, especially—Lushington, Northbrook, Fortescue—who had meant so much to him for many years. An hour or two before he died he called his manservant to him and gave him a message for them. "My good Giuseppe," he said, "I feel that I am dying. You will render me a sacred service in telling my friends and relations that my last thought was for them, especially the Judge and Lord Northbrook and Lord Carlingford. I cannot find words sufficient to thank my good friends for the good they have always done me. I did not answer their letters because I could not write, as no sooner did I take a pen in my hand than I felt as if I were dying." These were the last words he spoke.

THE END

APPENDIX I

1812 Birth at Highgate.

1832–36 KNOWSLEY.

1835 Tour in Ireland.

1837 Milan—Florence—Rome.

1838–48 LIVING IN ROME. (VISITS TO ENGLAND).

1838 Naples and Amalfi. England—Frankfurt—Rome.

1842 Sicily.

1843 The Abruzzi.

1847 Sicily—Calabria—Campania—Basilicata.

1848 Corfù—Ionian Isles—Athens—Tour in Greece—Constantinople—Salonika—Tour in Northern Albania—Malta—Egypt.

1849 Cairo—Suez—Mount Sinai. Malta. Tour in Greece and Southern Albania.

1849–53 LIVING IN ENGLAND. (LONDON, HASTINGS, etc.)

1851 Tour in Devon and Cornwall.

1853 Gibraltar—Malta—Egypt.

1854 Assiut—Thebes—Philae, etc. Malta—England. Tour in Switzerland.

1855 England.
Cologne—Leipzig—Dresden—Prague—Vienna—Trieste—Corfù.

1855–58 LIVING IN CORFÙ.

1856 Tour to Mount Athos. Dardanelles—Troy—Smyrna.

1857 Tour to Janina, etc. Venice—England. Ireland. Paris—Strasburg—Heidelberg—Dresden—Vienna—Corfù.

1858 Alexandria—Cairo—Jaffa—Jerusalem. Expedition to Petra and Dead Sea. Jerusalem—Jaffa—Beyrouth—Lebanon—Damascus—Baalbek. Corfù. England. Rome.

1858–60 LIVING IN ROME.
 1859 England.
1860 England.
1861 Turin — Florence — Lucca — Pisa — Viareggio —
Spezia—Vaudois Valleys—Courmayeur—Aosta—Vevey
—Ferney—Geneva—Chamonix, etc. England. Corfù.
1861–64 LIVING IN CORFÙ.
 1862 Paleocastrizza. Malta—England.
 1863 Tour of the Ionian Isles. England.
1864 Athens—Crete. England. Nice. Walking tour to
Genoa and back.
1865 Nice. England. Venice—Malta.
1866 Malta—Gozo. England. Egypt.
1867 Egypt—Nubia. Abou Simbel—Abydos—Assouan, etc.
Cairo—Memphis—Gaza—Jerusalem. Alexandria—
Brindisi—London. Cannes.
1867–70 LIVING AT CANNES.
 1868 Tour in Corsica. London.
 1869 Paris—England. Cannes.
1870 .Cannes. San Remo.
1871–81 LIVING AT SAN REMO. (VILLA EMILY).
 1871 Tour to Rome—Naples—Bologna—Padua, etc.
 1872 England. Suez. San Remo.
1873–75 Tour in India and Ceylon.
 1877 Brindisi. London. Corfù.
 1878 Monte Generoso.
 1879 Monte Generoso.
1880 Last visit to England. Varese—Monte Generoso.
1881–88 SAN REMO. (VILLA TENNYSON.)
 1881 Monte Generoso.
 1882 Monte Generoso.
 1883 Monte Generoso. Tour to Abetone and Perugia.
 1884 Vicenza—Recoarò—Salso Maggiore—Milan.
 1885 Barzano.
 1886 Milan—Barzano—Lucerne.
 1887 Biella.
 1888 Death at San Remo.

APPENDIX II

Edward Lear's Works Published during his Lifetime

TRAVEL BOOKS.

Views in Rome and its Environs. 1841.
Illustrated Excursions in Italy. 1846.
Illustrated Excursions in Italy. Second Series. 1846.
Journal of a Landscape Painter in Greece and Albania. 1851.
Journal of a Landscape Painter in Southern Calabria. 1852.
Views in the Seven Ionian Islands. 1863.
Journal of a Landscape Painter in Corsica. 1870.

NONSENSE BOOKS.

The Book of Nonsense. 1846.
Nonsense Songs, Stories, Botany and Alphabets. 1871.
More Nonsense. 1872 (published Christmas, 1871).
Laughable Lyrics. 1877.

OTHER PUBLICATIONS.

Illustrations of the Family of the Psittacidae. 1832.
Gleanings from the Menagerie at Knowsley Hall. 1846.
Tortoises, Terrapins and Turtles. 1872.

INDEX

Lear, Edward,
Mount Athos, visit to, 100–1
Thoughts of marriage, 108,
164–6
Palestine, visits to, 110–12, 168
Petra, visit to, 112–19
death of his sister Ann, 136–7
Cannes, living at, 170–2, 207–8
Corsica, tour of, 172–9
Lear and the Surrealists, 200
goes to live at San Remo,
213 et seq.
his garden, 214, 237
India and Ceylon, tour of,
223–34
San Remo, his life at, 237 et seq.
Last visit to England, 252
Death, 267
Lear, Eleanor (Mrs. Newsom), 5, 6,
26, 76, 123, 143, 238, 250, 258
Lear, Frederick, 6, 143
Lear, Harriet, 42, 131
Lear, Henry, 6, 143
Lear, Jeremiah, 2–5
Lear, Jeremiah, Mrs., 2–5, 30
Lear, Mary (Mrs. Boswell), 5, 6, 42,
142
Lear, Sarah (Mrs. Street), 2, 5, 6, 12,
207, 209, 228
Lear, Sussex family of, 5.
Lebanon, 121
Limericks, 18–21, 195–6
Louise, Princess, 213
Lubbock, Sir John, 14
Lucerne, 266
Lucknow, 225
Lushington, Edmund, 68, 93
Lushington, Franklin, 68, 69, 83, 89,
93, 95, 122–3, 134, 186, 212, 238,
250, 260, 268
Lear's friendship with, 33,
64–7, 101–3, 108–10, 143–4,
218, 262
Lear's meeting with, 64
Tour in Greece with Lear, 66–7
in Corfù with Lear, 96 et seq.

his marriage, 143
Visits Lear at San Remo, 218,
241, 262, 266–7
Lushington, Gertrude, 241
Lushington, Harry, 64, 90, 94–5
Lydford, 76
Lyons, Lord, 177

Madras, 231
Mahabalipur, Seven Pagodas of, 231
Malabar, 232–3
Malta, 49, 63, 64, 90, 161–3
Margate, 8
Martineau, Robert, 77, 79
Memphis, 168
Mérimée, Prosper, 172–3, 179
Millais, Sir J. E., 77, 78, 81–2, 87,
91, 92
Monastir, 58
Monckton Milnes, Richard, 168
Monte Generoso, 240, 246, 256, 263
More Nonsense, 19, 218
Morier, Robert, 107
Murchison, Sir Roderick, 182
My Aged Uncle Arly, 197, 200, 247,
265

Naples, 29, 49
Newsom, Mrs. William—see Lear,
Eleanor
New Zealand, 5, 6, 42, 207, 238,
245
Nice, 158–9
Nightingale, Florence, 131
Nonsense Songs, Stories, Botany and
Alphabets, 209, 211
Northbrook, Earl of, 48, 49, 129,
146, 221–2, 226–9, 232, 243, 249,
259, 263, 268
Nubia, 167

Oatlands Park Hotel, 135
Osborne House, 35–6, 146
Owl and the Pussy-Cat, The, 195,
203–5, 210, 231, 247